EDGE
OF
DESIRE

RECENT ART IN INDIA

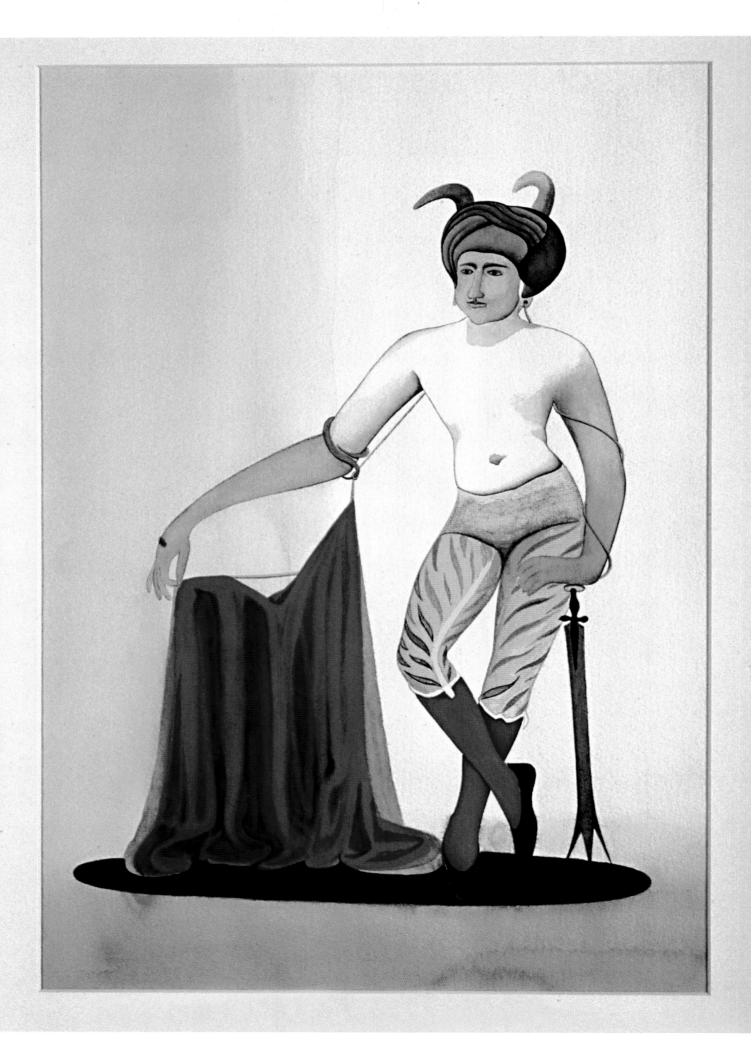

EDGE OF DESIRE

RECENT ART IN INDIA

CHAITANYA SAMBRANI

WITH CONTRIBUTIONS BY **KAJRI JAIN** AND **ASHISH RAJADHYAKSHA**

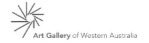

This book has been published in conjunction with the exhibition Edge of Desire: Recent Art in India

EDGE OF DESIRE: RECENT ART IN INDIA and related pro-grams are made possible with support from The Reliance Group, Confederation of Indian Industries (CII) and India Brand Equity Foundation (IBEF), The Andy Warhol Foundation for the Visual Arts, Inc., National Endowment for the Arts, MAP Fund, State Bank of India, New York, HDFC, Purnendu and Amita Chatterjee, Gita and Sonny Mehta, Indra and Raj Nooyi, Cadwalader, Wickersham & Taft LLP, Catherine Gamble Curran, Skadden, Arps, Slate, Meagher & Flom LLP, Sullivan and Cromwell, Bose Pacia Gallery, and Sir Dorabji Tata Trust. Additional support is provided by the Asia Society's India Fund, whose major donors include Rohit and Katharine Desai, Tara and Victor Menezes, Harish Raghavan and Ramaa Reddy Raghavan, Sribala Subramanian and Arvind Raghunathan, Lakshmi and Sandy Chandra, John P. and Jennifer Clay, Dr. Angela Anand Cobra and Dr. Suryanarayan Anand.

Art Gallery of Western Australia, Perth, September 25, 2004 – January 16, 2005
Asia Society Museum and Queens Museum of Art, New York, March 1 – June 5, 2005
Tamayo Museum, Mexico City, August 18 – November 20, 2005
Museum of Contempory Art (MARCO), Monterrey, January 26 – April 30, 2006
National Gallery of Modern Art, New Delhi, 2006
National Gallery of Modern Art, Mumbai, 2006

First published in 2005 by
Philip Wilson Publishers, 109 Drysdale Street,
The Timber Yard, London N1 6ND

Distributed in the United States and Canada by
Palgrave Macmillan, 175 Fifth Avenue, NY 10010

Distributed in Europe and the rest of the world by
I.B. Tauris, 6 Salem Road, London W2 4BU

United. Preferred airline of Asia Society.

☰ UNITED
Preferred airline of Asia Society

Helen Abbott, Project Manager
Vajra Kilgour, Deanna Lee, and Neil Liebman, Editors
Rymn Massand, Designer
Photography, unless otherwise noted, by Greg Woodward
Printed and bound by Craft Print, Singapore

Jacket/cover: Nilima Sheikh, *Firdaus II: Every Night Put Kashmir in Your Dreams*

Frontispiece: Surendran Nair, *Precision Theatre of the Heavenly Shepherds, Taurus*

Page six: Vivan Sundaram, *Memorial* (top); N. N. Rimzon, *Speaking Stones* (bottom)

Library of Congress Control Number 2004115846
ISBN 0-87848-100-1 (softcover)
ISBN 0 85667 581 4 (hardcover)

CONTENTS

Foreword

Edge of Desire: Recent Art in India focuses on contemporary Indian art of the past decade, a period marked by enormous social, cultural, and economic change that counted political violence and rapid economic growth brought about by liberalization and foreign investment among the most significant. These issues and others form the context for the works of the artists in this exhibition, co-organized by the Asia Society and the Art Gallery of Western Australia. The artists come from all around India, from the metropolises of Delhi and Mumbai to the rural regions of Kondagaon, and regional and local differences within this vast country are reflected in the diversity of the themes expressed as well as the selection of media and artistic practices. For example, the evolution of visual traditions in *adivasi*, or folk craft practices (Swarna Chitrakar's scrolls and Ganga Devi Bhatt's paintings), is shown alongside works in international contemporary art media (Nalini Malani's videos and Shilpa Gupta's installations). By bringing together these streams of practice, this exhibition stands in contrast to previous shows that have sought to focus exclusively on the work of the more familiar international artists from urban centers.

Discussions held in Delhi nearly four years ago between leading artists, curators, and critics prompted this different curatorial approach. From the perspective of the organizers, it was imperative that the genesis of the exhibition be in India. As when any group comes together, divergent opinions were expressed. However, there was consensus on three issues: first, that the exhibition should present a different view of Indian art from ones staged during the previous five years in Europe; second, that it not only feature artists with well-established international careers; and third, that it seek out a new generation of artists and curatorial voices.

With this in mind, we enlisted Chaitanya Sambrani as curator. Chaitanya has come to prominence in the past few years with his critical writings on modern and contemporary Indian art. Although the discussions in India shaped aspects of the exhibition, Chaitanya's vision must be credited for its curatorial premise and the selection of artists. He has brought great insight and an enormous enthusiasm to this project. To assist Chaitanya, an advisory panel was established that included Kajri Jain and Ashish Rajadhyaksha. We are

appreciative of their support and advice.

We would like to thank the artists in this exhibition for lending their works, many of which were created for the show. Private collectors have been equally generous, including Shumita and Arani Bose. Others also deserve special thanks: Estate of Rummana Hussain; Rajeev Lochan, National Gallery of Modern Art, New Delhi; Saryu Doshi, National Gallery of Modern Art, Bombay; Peter Mueller; Anupam Poddar; Nitin Bhayana; Usha Mirchandani; Vikram Sardesai; Jamshyd Sethna; Naveen Kishore, The Seagull Foundation for the Arts; and David Szanton, Ethnic Arts Foundation. For their assistance with securing loans, we also thank Gallery Chemould and Sakshi Gallery.

Edge of Desire represents a decade-long emphasis on the presentation of contemporary Asian art at the Asia Society. As one of the first American museums to undertake a consistent program in this field, the Asia Society has presented groundbreaking exhibitions and works previously unseen in the United States. Exhibitions of note include *Asia/America: Identities in Asian American Art* (1994), *Traditions/Tensions: Contemporary Art in Asia*

(1996); *Inside Out: New Chinese Art* (1998); and *Conversations With Traditions: Shahzia Sikander and Nilima Sheikh* (2001). *Edge of Desire* is part of a three-month long focus on contemporary India called *India: The Future Is Now,* comprising artist panels, business briefings, lectures, and other cultural events.

This is the first time the institution has worked collaboratively across its diverse programming groups—including the Policy and Business, Social Issues Programs, and External Affairs divisions as well as Cultural and Public Programs and the Museum—to produce a cohesive strategy for one season. The initiative would not have been possible without the leadership of Robert Radtke and his colleague Judi Kilachand. The success of a project like *Edge of Desire* is largely due to the dedication of the museum staff, and we would like to acknowledge Helen Abbott, Nancy Blume, Joshua Harris, Deanna Lee, Neil Liebman, Hannah Pritchard, Clare Savard, and Clayton Vogel. Helen Chen, Sandhini Poddar and Murtaza Vali assisted with research for the catalogue. Perry Hu's wonderful exhibition design for both New York locations, Asia Society and the Queens Museum of Art, deserves special mention. Our colleagues in Cultural and Public Programs also deserve thanks: Rachel Cooper, Linden Chubin, Nancy Bulalacao, Anne Kirkup, La Frances Hui, and Sèbastian Haizet; in addition to those in External Affairs: Carol Herring, Todd Galitz, Julie Lang, Jeannine Glazewski, and Lisa Shah. Lai Montesca designed the elegant printed materials for the Asia Society's presentation, and Rymn Massand provided the handsome design for the catalogue, which was expertly edited by Vajra Kilgour.

The Art Gallery of Western Australia is in Perth, the only Australian capital city situated on the rim of the Indian Ocean, and *Edge of Desire* embodies the institution's commitment to the art and culture of the region. The Art Gallery has fostered the development of exchanges and dialogues in the region that have influenced the direction of the State Art Collection and its artistic and public programs.

None of this would have been possible if the Gallery staff had not enthusiastically embraced this mission. Each staff member shares immense credit for his individual and collective care, resourcefulness, and professionalism. At the Art Gallery of Western Australia we would like to acknowledge Robert Cook, Corine van Hall, Natalie Beattie, Philip Burns, Lynne Hargreaves, Greg Woodward, Andrea Tenger, Robyn Walton, Tanja Coleman, Maria Canjuga, Maria Tagliaferri, and Vanessa Roth. The work of the installation crew showed an extraordinary perseverance to a technically demanding exhibition, successfully addressing the needs of the artists and our visitors.

In New York, we would like to acknowledge Tom Finkelpearl, Director of the Queens Museum of Art, who showed commitment to this project from an early stage, while Valerie Smith, David Dean, David Strauss, Jaishri Abhichandani, and Prerana Reddy also deserve special thanks. After the presentation of the exhibition in Perth and New York it will travel to Mexico, where it will be shown at the Tamayo Museum in Mexico City and the Museum of Contemporary Art (MARCO) in Monterrey. Thanks to the directors of these two museums, Ramiro Martínez Estrada and Nina Zambrano respectively.

In New York *Edge of Desire: Recent Art in India* and related programs are made possible with support from The Reliance Group, Confederation of Indian Industries (CII) and India Brand Equity Foundation (IBEF), The Andy Warhol Foundation for the Visual Arts, Inc., National Endowment for the Arts, MAP Fund, State Bank of India, New York, HDFC, Purnendu and Amita Chatterjee, Gita and Sonny Mehta, Indra and Raj Nooyi, Cadwalader, Wickersham & Taft LLP, Catherine Gamble Curran, Skadden, Arps, Slate, Meagher & Flom LLP, Sullivan and Cromwell, Bose Pacia Gallery, and Sir Dorabji Tata Trust. Additional support is provided by the Asia Society's India Fund, whose major donors include Rohit and Katharine Desai, Tara and Victor Menezes, Harish Raghavan and Ramaa Reddy Raghavan, Sribala Subramanian

and Arvind Raghunathan, Lakshmi and Sandy Chandra, John P. and Jennifer Clay, Dr. Angela Anand Cobra and Dr. Suryanarayan Anand.

The presentation of *Edge of Desire* at the Art Gallery of Western Australia was made possible through the generous support of the Australian High Commission India, the Government of Western Australia, 96FM, the Australia India Council, the Gordon Darling Foundation, and Aalto Colour; and principal partner Wesfarmers Arts, and annual sponsors The West Australian, Marketforce, Qantas, Channel 7 Perth, and Mirvac Hotels and Resorts.

VISHAKHA N. DESAI, *President*
Asia Society

MELISSA CHIU, *Director of the Museum*
Asia Society Museum

ALAN R. DODGE, *Director*
Art Gallery of Western Australia

GARY DUFOUR, *Deputy Director*
Art Gallery of Western Australia

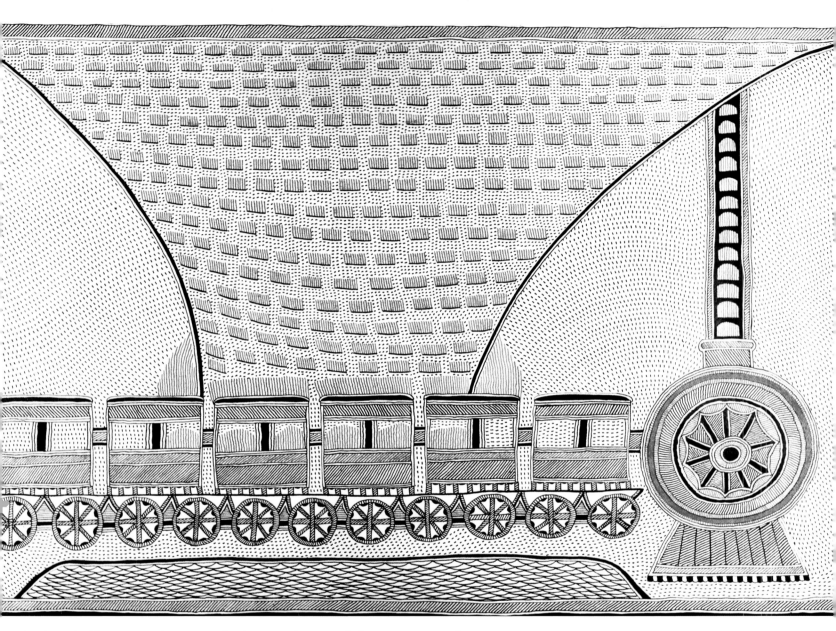

Santosh Kumar Das, February 27, 2002, Railway Station in Gudhrat, Gujarat, 59 Hindus Dying in Tocherd Train, 2003 (Cat. no. 14). Ink on paper, 15 x 22 in.

Preface

As we unpacked crates and pulled out works at the Art Gallery of Western Australia in September 2004, there were exclamations of joy and wonder. It had been nearly three years that *Edge of Desire: Recent Art in India* had been coming together; even longer since an exhibition of contemporary Indian art had been thought of at the two institutions responsible for its organization. Nobody—in India or overseas—had seen all of this work in the one place, and it was a feeling of utter pleasure and fulfilment that we were able to share. The artists and lenders had sent us great treasures. Those that had made new work for the exhibition had exceeded all expectations in what they had achieved. With those whose earlier work I had selected for the exhibition, the work remained strong and pertinent, sometimes a full decade after it had first been seen—not something one can say easily about contemporary art.

At one level, all art making and every exhibition, is about desire. The artist's desire—even need—to be acknowledged and sustained by audiences is matched by desire on part of audiences to learn, see, consume, or simply to be entertained. It is a two-way contract; it entails

effort on both sides; in the best instance, the effort enriches both parties. This exhibition makes, unreservedly, certain demands on its audience. Over the two or more years as it travels in Australia, the United States, Mexico, and Canada before returning to India, the works in this exhibition are going to meet diverse audiences, who bring their own desires, expectations, and presumptions to the encounter. Some will find the work exhilarating and challenging. Others may feel exasperated, even offended, or let down. My own conviction is that whatever their reaction, visitors to the exhibition will leave having met some surprises, and readers of this book will close it having learned something unexpected. As an exhibition and a book, *Edge of Desire* proffers visual delight. It also poses questions about the world we inhabit, in India and elsewhere.

An exhibition of this size and ambition could only have been organized through the goodwill and enthusiasm of many people. First on that list are the artists represented here. Some of them were asked to make or complete work specifically for this exhibition, while others facilitated loans either from their own collections or from other lenders. I am extremely

grateful to all of them for the skill, imagination, faith, patience, and perseverance they have brought to *Edge of Desire*. I would also like to add my thanks to all the lenders who have parted with cherished companions over the period of this travelling exhibition.

This exhibition was not born so much in my office as "in the field," travelling through various parts of India over four months in 2002–03 and again for a month at the end of 2003, meeting artists, academics, curators, galleries, and collectors—looking, reading, listening, arguing, learning. I am grateful to the Gordon Darling Foundation, without whose generous assistance this fieldwork would not have been possible. I am also grateful to a large number of people in India who were generous with advice and logistical assistance: Shireen Gandhy (Gallery Chemould), Geetha Mehra (Sakshi Gallery), Deborah Thiagarajan (Madras Craft Foundation), Navjot Altaf, Jaidev Baghel (Shilpi Gram), P. R. Rajen, Sanjoy Mallik, Bhupesh Tiwari (Saathi), Neeti Sethi Bose, Suresh Jayaram, and Vidya Shivadas.

Ashish Rajadhyaksha and Kajri Jain have been advisors to this project and have also contributed substantially to this book. Both

have provided intellectual support throughout the project, asking difficult questions and offering comments on my formulations. Geeta Kapur has been a preceptor, sounding board, and teacher. I have learned from her example and experience in many ways. Jyotindra Jain has been illuminating in his own work and generous with his time. I have been fortunate in having had the experience of living and learning in India and, more recently, the experience of displacement and being both within and without in India and in Australia, my new home. Over the last six years of living away from India, I have been able to travel back and forth and participate in projects in both countries. In addition to friends and colleagues in India who have continued to welcome me back, I thank my colleagues at the Australian National University who have supported this project in many ways over the last three years. To David Williams, Adam Shoemaker, Nigel Lendon, Gordon Bull, Helen Ennis, and Anne Brennan, many thanks.

Finally, my gratitude to all the staff of the Art Gallery of Western Australia and the Asia Society for having worked long and hard to realize this project. Vishakha Desai and Gary Dufour have been passionate in their belief and infectious in their enthusiasm for the project. Mounting an exhibition of this scale has of course involved logistical and intellectual challenges. For their tremendous efforts in making this possible, my special thanks to the Director, Alan Dodge, as well as Robert Cook, Natalie Beattie, Philip Burns, Corine Van Hall, Maria Tagliaferri, and the entire install crew at the Art Gallery of Western Australia. Thanks also to the good grace and sound judgement of Melissa Chiu and Helen Abbott at the Asia Society, and to the expertise of Helen Chen, Deanna Lee, Joshua Harris, Perry Hu, Clare Savard, Rymn Massand, Vajra Kilgour, Sandhini Poddar, and Murtaza Vali.

CHAITANYA SAMBRANI
Lecturer, Art Theory Workshop
The Australian National University

CHAITANYA SAMBRANI

On the Double Edge of Desire

ENGAGING PLACES. *How are we—in India, and elsewhere—located in a time of globalization and fundamentalist politics? What do we aspire to, and how do our locations channel or limit aspiration? Indeed, what are the limits of imagination in such a context, and in what ways is it possible to push at these limits? How does the work of contemporary artists participate in questions of location and desire? What are the relationships between location, desire, art practice, and an*

immanent politics of life? For surely, location and desire, taken as sensory, ideological, historical and existential categories, remain significant for the visual artist, especially when all other certainties are evacuated.

Edge of Desire: Recent Art in India presents the work of contemporary Indian artists to audiences in Australia, the United States, Mexico and Canada. The thirty-six artists and two collectives in this selection come from a wide range of generational and social contexts, and their work spans professional, material, and disciplinary boundaries. The oldest among them was born in 1924, the youngest in 1976.

Of these, there are some who have rarely strayed outside their district, and have never participated in the cultural life of India's university-educated elite. There are others with de-facto world-citizenship, and major international reputations. Some have written books and taught generations of art students, while others have never been past primary school. A few don't even identify as artists, no matter how broadly that category may be defined. Linguistically, the services of an interpreter would be required for some of these artists to converse with each other.

While embracing these diversities within the

frame of a single exhibition is significant to this project, the viewer will not find here a survey of contemporary Indian art. *Edge of Desire* does not pretend to a "potted history" of recent Indian art. Rather, it is hinged on a particular—and necessarily partisan—perspective on recent history; it results from a specific intellectual and emotional investment in the field. While aspiring to speak to a diverse audience, this exhibition offers an invitation to enter into the dialogues and arguments presented here, through a selection of work that is as polymorphous as it is sensual, challenging as well as uplifting. The questions that the artists repre-

sented here are concerned with are not only significant in India; they have something to do with the purposes of art in the world today.

The decade (roughly 1993–2003) addressed by this exhibition has been a time of upheaval in India. Within a national framework, this decade has seen the undermining of certitudes and aspirations fundamental to the struggle for self-determination and the establishment of a secular, socialist democracy. Meanwhile, this period has also seen a growth in India's international prominence as a military, economic, and technological power. These factors have inevitably influenced major changes in visual culture. While it is possible to fetishize the plurality and the fantastic spectacle that characterizes visual culture in India,[1] it is not my intention to use art to illustrate this decade in the manner of an ethnographic exposition. This would only play into the commodification of the contemporary to feed the ocular desires of institutions and audiences in the developed world. Nor does this project indulge in what has been termed "ambulance chasing" in another context.[2] Instead, I have chosen to ground the argument of this exhibition in the interplay of two binaries: historical processes of globalization and fundamentalism, and ideational forces of place and desire. Reciprocities and causal linkages are implicit here: fundamentalist claims to place are fed by insecurities wrought by globalization and its accompanying exposure to other economic and cultural forms.[3] Concurrently, internal tensions generated by rising economic inequalities and perceptions of inequity enroute to economic restructuring have led to a retreat into racial, religious, and regionalist specificities in an expression of a desire for cultural security and purity.[4]

Place as a marker of location, of belonging and identity, is a complex accretion of factors ranging from gender and sexuality, language, class, caste, and religion to education and market access. Location as an act of choice or a force of circumstance forms the matrix for our comprehension of individual subjectivity and how it addresses the world. And while place and location afford a measure of belonging, they also convey a sense of limits: together with positive aspects of rootedness and empowerment, a physical, cultural, or historical locus also implies boundedness, containment, and limitation.

Desire and longing are corollaries to a sense of place and location. Desire as a category of the imagination has always played a major role in the ways individual subjectivity addresses itself to the world. At one level, all art-making has to do with the desire to transcend boundaries of the self and of historical location. Articulated variously in terms of sexuality, spirituality, politics, language, and the use of materials, desire and longing span the gamut of human activity, from the gutter to the heights of epiphany. Desire forms the necessary condition for creative endeavor. Desire is also volatile and susceptible to perversion. It has a double edge; with the potential for violence always near at hand. Longing can manifest in the will to power—over ideas, places, objects, and persons. Place and desire thus emerge as primary factors in a complex of relationships through which human beings engage with the world.

India is notoriously a multiverse of often-conflicting realities. Extreme conditions routinely coexist here, famously manifesting sensory overload, for seasoned inhabitants as well as visitors.[5] The nation's recent history has been dominated by forces that seek to regulate

(ART) HISTORIES AND GEOGRAPHIES

this plurality: the twin exigencies of economic globalization and political fundamentalism have distinctly altered relations of power, cultural identity, and aesthetic values both within and between communities. Across the globe, these exigencies, coupled with regimes of repeated reification—played out through over-saturated media that reduce reality to spectacle—have drastically transformed the ground rules for engagements with alterity.

The role that the artist may play in this network of over-determined signification shifts constantly between that of sham/shaman and witness/confessor. Much contemporary art practice, executed tongue firmly in cheek and irony perpetually writ on the brow, seems to reflect this. Some works play with "faking it," casting the self as pretend representative of ideas or communities. Others rely on the dream of life-transforming action (when such transformation is manifestly already impossible). Occasionally, they essay the more earnest role of the witness, much like Walter Benjamin's angel of history, who is blessed with some paranormal or mystical faculty of vision that pierces through the veils of history. It is also this assumed, illusory, elusive vision that allows artists to play the role of confessor and healer, or of the fool who speaks the truth, albeit through subterfuge and humor.[6]

While not unprecedented, a project that presents varieties of the Indian contemporary—urban and rural, metropolitan and Adivasi (tribal indigenous),[7] fine art and folk art—within a single curatorial project remains experimental and contingent, since most institutions concerned with Indian art—art schools, museums, exhibitions, and publications—continue to maintain a degree of segregation in their practices.[8] These institutional divides reflect a deeper ontological divide implicit in the very nature of the discipline of art history as it is traditionally understood and practiced, in India and elsewhere.

Within regimes of global exposition, contemporary art—especially when it comes from a non-Western context—inevitably risks being projected as spectacle. The lure of the spectacular is central to the international reception of art from areas relatively unknown within First World economies of cultural production and consumption. The curatorial project inescapably involves mediations, reformulations, and translations across disparate contexts, sometimes implying a violation of contextually specific meanings. This is especially so if the audience is offered objects as visual artifacts (purportedly representative of a scantly understood culture) without the objects being anchored, their meanings readable through a set of historical filters. The desire for visuality implicit in an exhibition needs to be tempered with historical nuance to shift the gaze away from mere spectacle into a thematically linked argument about cultural practice.

Depending on who is looking, and from what vantage point, visual creativity in contemporary India can present seemingly irreconcilable facets. This faceting is one of the reasons for the longevity of the trope—primarily articulated by those observing Indian culture from a distance—about India being a welter of sensations, a succession of riotous spectacles always a little bit beyond the ken of rationality. But where kaleidoscopic variegation may present "a carnivalesque spectacle of contradictions"[9] from a distance, it can also resolve into a highly segregated spectrum with impermeable barriers between different areas of practice from points of view more invested—and therefore entrenched—in local economies of cultural production.[10]

There are historical reasons for this, which can be found in the particular means through which consensus on Indian history, including art history, was manufactured over the nineteenth century. The quasi-Enlightenment project of archaeology that the British Raj undertook in India led to the rediscovery of ancient monuments such as Ajanta, and their subsequent canonization in a mainstream classical trajectory emphasizing Hindu and Buddhist art, with the later addition of imperial Mughal culture. As Tapati Guha-Thakurta has argued with respect to nineteenth-century publications on Indian architecture, a concern with pre-Islamic Buddhist and Hindu heritage dominated the antiquarian search for the "authentic" tradition of India. Participants in this process included not only British administrators and Indophiles, but also, significantly, members of the Indian elite who were eager to stake a claim to a classical and highly cultured past.[11]

Indeed, what we understand as modern or bourgeois Indian cultural identity is rooted in this epistemological project, routed through the modalities of historiography, observation and travel, survey, enumeration, museumization, and surveillance.[12] The process through which the newly unearthed glories of ancient and medieval India became a vehicle for nationalist resurgence in the face of colonial rule also effected a divorce between the "great" and "little" traditions in Indian art history. The enterprise of fine art as it evolved through the late nineteenth-century struggle between academicism and revivalism thus ended up centering on a tussle between the polar opposites of Western influence and classical Indian culture. There has until recently been little space in such a historical model for folk, Adivasi, and popular visual culture to be taken seriously as art.[13] A major argument against this situation was developed through the exhibition *Other Masters: Five Contemporary Folk and Tribal Artists of India*, organized by Jyotindra Jain (then Senior Director of New Delhi's state owned Crafts Museum). The exhibition presented a powerful case for the ability of non-modernist work to participate in innovative contemporary practice on its own terms. In Jain's words, *Other Masters* was concerned with "the sensibility of those contemporary folk and tribal artists . . . who neither see themselves as belonging to an imaginary 'traditional' society

nor as waiting outside the precincts of the world of 'modern' art to be absorbed and recognized on the latter's terms. . . ."[14]

Despite a systemic segregation between folk/tribal and modernist art, Adivasi and folk traditions have remained a point of reference for a number of urban artists, whether as a recollection into modernist gallery spaces of the artist's own rural origins, or as a voluntarist invocation of folk forms in combination with modernist techniques as a means of generating an indigenist modernism.[15] More rarely, there have been artists like Meera Mukherjee, who immersed herself in the male-dominated *dokra* (a process of lost-wax casting involving spirals of wax built over a clay and sawdust armature) tradition of casting in the Bastar district, working through resistance both from her urban high-art antecedents and the reluctance of the master craftsmen of Bastar to allow her entry into their restricted sphere of knowledge.[16] A number of artists (including K. G. Subramanyan, featured in this exhibition) worked as designers for the state-owned Handloom Board early in their careers; even more have looked to the robust forms of folk and Adivasi art as sources for indigenist principles in their own work.[17] As Subramanyan put it, "The fulfillment of a modern Indian artist's wish to be part of a living tradition, i.e., to be individual and innovative without being an outsider in his own culture, will not come of itself; it calls for concerted effort."[18] With the help of a grant from the India Foundation for the Arts (IFA) in 1998, the Mumbai (formerly Bombay) artist Navjot Altaf has been working with a group of local artists from Kondagaon, in the Bastar district of Chattisgarh state. Among the outcomes of this project have been group exhibitions of the work produced in Kondagaon at Mumbai's Sakshi Gallery, marking a rare moment when Adivasi art has been exhibited as contemporary art in a mainstream gallery. Two of the artists in this group—Ganga Devi Bhatt and Raj Kumar—are featured in this exhibition.

DESIRE—GLOBALIZATION—FUNDAMENTALISM

Fundamentalism and globalization as historical processes operate on the emotional economies of place and desire. The appeal of fundamentalism relies on a sense of loss, premised on the myth of a pure past and the yearning for a glorious future. Through an invocation of racial, religious, or cultural purity, fundamentalism seeks to generate and enforce a narrow, sectarian version of national history. This perversion of desire manifests in a search for absolute power to eradicate difference and silence dissent. Globalization also subsists on a sense of location and limitation, especially in the Third World. A sense of disenfranchisement common to postcolonial contexts is made all the more acute by exposure to the lures of consumer culture. Remedies for limitations occasioned by underdevelopment are sought in globalization and its promise of prosperity.

The early 1990s in India saw the simultaneous emergence of specific economic and political conditions. With the inauguration in 1991 of the New Economic Policy, the nation-state began to divest itself of the role of regulator in a quasi-socialist model. Investment opportunities were opened up in an unprecedented manner to private capital, domestic and international. Multi-national interests were quick to target the Indian consumer market, and a new lifestyle based on consumption and big-name labels became available to the aspiring urban bourgeoisie. The impact of these transformations on public visuality has been immense in the last decade, and has been felt most acutely in popular visual culture: from a new slickness in the production standards of India's mammoth film industry—the emergence of Bollywood—to advertising, television, and the preferred look among the young urban professional class.[19]

Simultaneously, the early 1990s witnessed a rise in the power of the Hindu Right in electoral politics. Perhaps the most decisive marker of this rise was the demolition of the sixteenth-century Babri Mosque in Ayodhya on December 6, 1992. Claimed by Hindu zealots

as the birthplace of Rama, an incarnation of Vishnu, the mosque became central to a systematic mobilization campaign on the part of the VHP, or Vishwa Hindu Parishad (the self-styled World Hindu Council)—along with its affiliates, including the BJP, or Bharatiya Janata Party (Indian People's Party). The BJP headed a coalition government in New Delhi until the elections of May 2004, when a secular coalition, the United Progressive Alliance, gained power. The destruction of the mosque took place at the hands of a mob with pickaxes and spades, in contravention of a court order and with the police standing by. Perhaps no single event has contributed so largely to the loss of the secular values on which state policy and nationalism in India had been predicated from the time of the anticolonial struggle. Waves of violence preceded and succeeded the demolition, manifesting in systematic pogroms against minorities, especially Muslims.

Although globalization may presume to remove barriers and encourage a more thorough intermingling of practices and forms from different parts of the world, it also operates as a homogenizing force, making the survival of local cultures—not to speak of countercultures—increasingly unlikely. Simultaneously, it invests "authentic" forms of (foreign or ethnic) cultures with added value in the consumption apparatus of metropolitan venues. Aijaz Ahmad has defined this tendency as the ideology of culturalism, which "treats culture not only as an integral element in social practices but as the *determining instance.*" For Ahmad:

> It is one of the great ironies of ideological production in our time that precisely in the historical moment when capitalism has finally penetrated the farthest reaches not only of economic but also cultural production itself . . . we witness the rise of an ideology, propagated from all the famous pulpits of the Western academy, which shifts the locus of determination from the field of political economy to that of culture.[20]

Vasundra Thozhur, Secret Life: Tiger, 2000 (Cat. no. 5c; detail). Oil on canvas (3 panels); 229 x 49 cm, 225 x 152 cm, 229 x 86 cm. Collection of Vikram Kiron Sardesai.

This privileging of authentic ethnic flavor may indicate a potential for heterogeneity within globalizing processes. It remains, however, an illusory heterogeneity, in that the survival of cultural forms—be they cuisine, languages, or visual art—can only be guaranteed insofar as these forms can neatly be assimilated into structures of marketing and consumption. To take Ahmad's argument further, to partake in culturalist rejoicing, indulging in an orgy of spectacles (where yesterday smug ignorance reigned) would imply unawareness of ongoing operations of imperialist domination that brook no dissent.

This exhibition explicitly rejects an "authentic" vision of Indian art. Instead, it argues against the dogmas and gimmicks of authenticity, foregrounding practice that is unabashedly cunning in sampling and in playing it cool, or otherwise so rooted in a multiform culture as to make an invocation of a singular authenticity untenable. National essences and traditions are manifestly inventions. Received knowledge is always already mediated, being produced from a commingling of several pasts and partaking of many truths in its production of authoritative fictions. Stylistic and ideational manifestations that are supposed to be uniquely Indian may in fact be of foreign—or at any rate mixed—derivation. The history of culture on the subcontinent is an eminent instance of syncretism. It is precisely this syncretism that flies in the face of homogenization.[21] As Hobsbawm has it, tradition is "essentially a process of formalization and ritualization, characterized by reference to the past, if only by imposing repetition."[22] He argues that with the rapid transformation of society and the obsolescence of earlier traditions, this process of reinvention occurs with increasing frequency. The invention of tradition thus presents a Janus face: the emancipationist desire for a securely authenticated historical trajectory, or for a *fully mandated map of belonging* that tradition implies, is constantly beset by tendencies that seek to define tradition along insular, sectarian lines.

Tradition has remained a fraught notion, not least because of the manner of its constant reinvention in an unstable political climate. The Hindu Right mobilized the most strident of such reinventions in support of its reactionary and violent agenda of a *Hindu Rashtra* (Hindu Nation). Majoritarian communalism rests its appeal precisely on an insecure sense of Indianness that demands a purified, singularized tradition purged of both the libidinal unruliness of the bazaar and the syncretistic, polymorphous character of indigenous cultures. Concurrently, stressing the plurality of a dynamic, mobile tradition as a defense against the unitary fantasies of the Right, resuscitating elements of tradition that offer means of resistance, has become a growing concern for cultural practitioners. Indeed, as this exhibition suggests, some of the most formally innovative and historically significant work produced by Indian artists in recent years has had to do with mediations, improvisations, and reclamations of various aspects of tradition.

LOCATION / LONGING

Desire for place can be articulated as both a relationship with current locations and an aspiration for real or imagined places in which the artist has made an emotional investment. Engagements with location and desire are perhaps all the more intense on the subcontinent, where national illusions of cultural continuity are most dramatically undermined by the occurrence of radically distinct formations under a purportedly homogenous rubric.

The experience of working-class life on the outer fringes and inner wastelands of a Third World metropolis has been a consistent theme in Sudhir Patwardhan's paintings and drawings since the early 1980s. Rooted in a Marxist perspective on social change, Patwardhan's paintings have borne witness to conditions perennially on the cusp of the heroic and the depraved. His investment in representations of the subordinated has resulted in a series of

remarkable large-scale works that capture the complexity of human interactions and political relations having to do with place. *Lower Parel* (2001; Cat. no. 3) presents a neighborhood under duress. Lower Parel is part of central Mumbai's textile-mill district; once the industrial heart of the city, and home to the most powerful labor movement in the country, it has been eviscerated through a policy of privatization and disinvestment following a doomed textile workers' strike in 1982.[23] The mill district is now a space of disenfranchisement, where mushrooming high-rise apartment blocks for the elite dot a surreal landscape of poverty and dysfunction.

Evisceration and disenfranchisement are raised to a keening poetry in Nilima Sheikh's painted scrolls addressing the issue of Kashmir (2003–04; Cat. no. 4).[24] Kashmir figures here as more than the contested Himalayan province ravaged by state policy and militancy. Kashmir is a marker of guilt, an object of desire, and a dream, its beauty rendered doubly unreal by its improbability and the violence of its recent history. Kashmir is an earthly paradise aflame, a shimmering fabric rent asunder.[25] For the artist, the sheer beauty of Kashmir necessitates a response beyond the banality of Bollywood;[26] hers takes the form of a series of hanging scrolls made specifically for this exhibition. Making references to several centuries of writings inspired by Kashmir, Sheikh seeks to merge the poetic with the political in a deeply felt and fluidly articulated response to a contemporary tragedy. Incorporating references to the writings of ancient scribes (Kalahana and Fa Hian) as well as modern poets and novelists (Agha Shahid Ali and Salman Rushdie), she paints a relationship to Kashmir as an extended meditation on desire and loss.

The selection from Vasudha Thozur's series *Secret Life* (1997–2001; Cat. no. 5) installed here creates spaces suffused with symbolic imagery, presenting edited metaphors for life. Thozhur infuses the language of oil painting with something approaching an apotheosis of a self that exceeds the everyday real, even as she takes on the task of painting into being a home

for an itinerant, wandering between the enunciation of public life and the ineluctability of private obsessions. Obsessive desire for a narrative rooted in the intensely cultivated private self propels Thozhur's *Secret Life* across generic associations of still life, portraiture, and symbolic imagery. It partakes of and transcends a reiteration of heroic self-representation; it entertains the phantasms of places once inhabited and left behind, to manifest an accretion of alchemical transformations. Here, then, is proof that "imagination augments the values of reality," through a house that "furnishes us dispersed images and a body of images at the same time."[27]

Self-representation as a matter of cultural indeterminacy, of marginality produced by displacement and travel between cultures, emerges from Umesh Maddanahalli's video *Between Myth and History* (Cat. no. 2). The artist's agency here appears as the playful, mock-serious mediator between two varieties of truth and authority, sacred and secular. A temple priest from Bangalore, resplendent in beard and robes, holds forth in Kannada on the significance of a cave beneath a temple that will lead the faithful to sacred places in the north of India, several thousand kilometers away. The T-shirt-clad artist, candle in hand, ventures forth into the gloom and emerges from

an abandoned mineshaft in Austria, to complete his journey shivering and barefoot amid bemused stares. A social historian at the other end presents a gloss—in German—on the historical significance of the defunct mine in relation to World War II.

N. S. Harsha, in an ambitious new work made for this exhibition, *For You My Dear Earth* (2004; Cat. no. 1), reflects on location through the cultural meanings of plants. Plants are manifestly located in a way that animals, including humans, are not; rooted in the earth, they convey a secure, physical notion of belonging. Paradoxically, plants have traveled widely, from the ubiquitous floating coconut in the

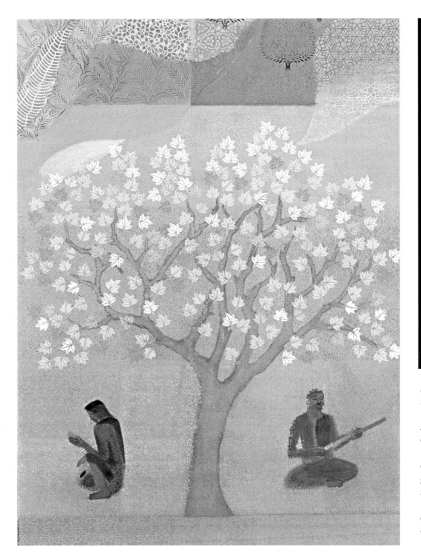

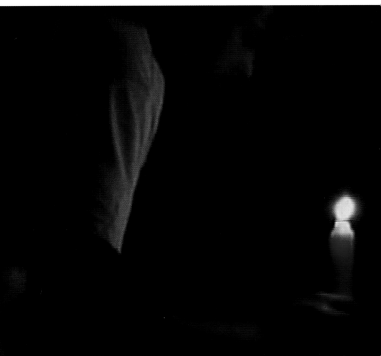

Left: Nilima Sheikh, Firdaus III: Gathering Threads, 2003–04 (Cat. no. 4c; detail). Casein tempera, stencil on canvas; 300 x 180 cm. Collection of the artist.

Above: Umesh Maddanahalli, Between Myth and History, 2001 (Cat. no. 2; still). DVD: 12 minutes (with audio). Collection of the artist.

Opposite page (top): N. S. Harsha, For You My Dear Earth, 2004 (Cat. no. 1; detail). Acrylic on cotton duck, canvas moun plywood with goldleaf (in three parts); 137 x 563 cm, 137 x 563 cm, 137 x 46 cm, 137 x 1,172 cm (overall). Private Collec New York. Courtesy: The Artist and Talwar Gallery, New York.

Opposite page (below): Subodh Gupta, 3 Cows, 2003 (Cat. no. 7b; detail). Bronzed bicycles, aluminum-plated milk cans; Collection of Arani and Shumita Bose.

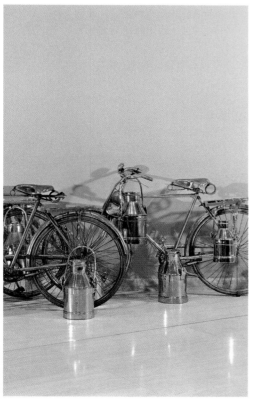

tropics to introduced species like corn and potatoes. A history of plants reveals much about culture in that some are regarded as weeds—unwanted foreign beings—while others are prized for their sustaining or healing properties. Harsha's involvement with the language of miniature painting and botanical rendering is located firmly in his surroundings in southern India. He associates the plants he draws with expressly local notions of pestilence and deification. His work rounds off the exhibition's engagement with location through an expansive contemplation of intertwinements between natural and cultural realms.

Though various exigencies following on the death of Bhupen Khakhar have made it impossible for his work to be featured in this exhibition, I place it here emblematically: Khakhar's work demonstrates that (be)longing can be a matter of fantasy, or of experience acutely perceived and reconstituted in reverie. Khakhar's ruminations on Sri Lanka (2002–03)—undertaken during the last two

years of the artist's life—are characterized by a dialogue between painterly effervescence, and a concern with mortality bordering on the morbid.[28] Like Nilima Sheikh's Kashmir, Khakhar's Sri Lanka is a land of unreal beauty, a place of fable, adrift between a bounteous past and a violent present. Khakhar's water colors are a luminous and ecstatic perspective on a visitor's relationship to the Golden Isle; focusing on sites of Buddhist pilgrimage, his approach to place and desire may seem altogether more straightforward than Sheikh's, and devoid of the self-questioning that she has engaged in. Playing the role of a naïve genius, Khakhar leads us on, as though without guile, into a fantastic place of dreaming Buddhas, serene monks, mysterious caves, waving palms, and trumpeting elephants. His approach to place is so overtly one of fabulation as to highlight the disjunctions between desire and physical location—between the Sri Lanka of the artist's dream and the contemporary reality of a nation torn by civil war.

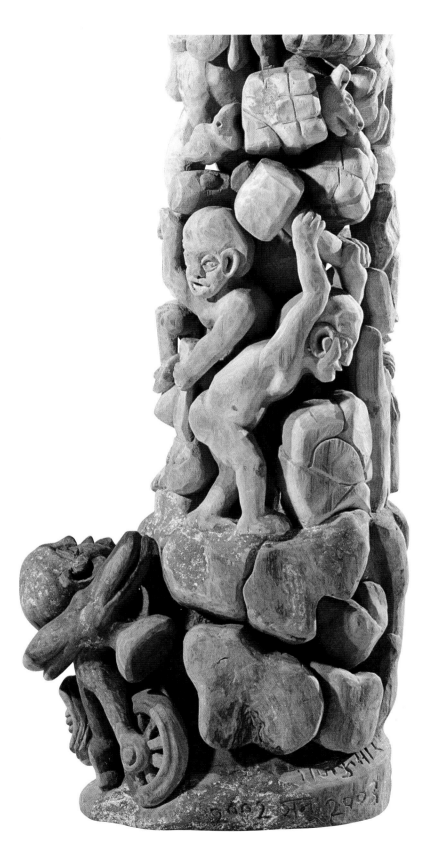

Raj Kumar Koram, Apne Zindagi Ka Khambha (The Pillar of My Life) 1, 2002–03 (Cat. no. 10a: detail).
Teak, iron wire, PVA sawdust; 207 x 85 x 35 cm. Collection of the artist.

TRANSIENT SELF

Migration and transience are major features of contemporary experience. Even as economic processes, demographic movements, and technological change create new ways of envisioning the self, they provide renewed impetus for older contentions, such as the place of individual subjectivity and the construction of collective identities.[29] While taking into account physical movement within India, I interpret transience more broadly, in terms of psychological and social movement associated with individual aspirations for transformation. Works included under this theme range from realist commentaries and personal histories to fabulations that metamorphose the self into a zone of wonder and a site for historical agency.

Transformations of the self emerge as the leitmotif of Sonia Khurana's work in video, photography, and installation. She consistently tweaks self-representation, in order to make it rise to the task of self-transformation while continuing to emphasize the materiality of the body and the limitations of the flesh. In the performance video *Bird* (1999; Cat. no. 9), the inarticulate corporeality of the body meets the desire for transcendence in a ragged dance of metronomic movements. Khurana invokes notions of sexual difference, bringing her own naked body into interaction with the viewer's expectations of physical presence. At the same time, *Bird* becomes the scene of confession and abjectness—a recognition of limitations. Shot in grainy black-and-white and making use of a Man Ray-like look of solarized contours, *Bird* presents a remarkable contrast between the austerity of its form and the visual excess signaled by agitated corporeality.

Among Indian artists, Subodh Gupta is one of the few urban sophisticates who exhibits an uninhibitedly rustic persona. Gupta's work can be read as an extended commentary on his migration from his native Bihar (with all its associations with backwardness and corruption) to upwardly mobile Gurgaon and a kind

of world citizenship. *Bihari* (1999) and *Vilas* (2000–03; Cat. no. 7) mark two distinct points on this passage: *Bihari* makes use of rural materials (cow dung, which has figured in a number of Gupta's projects) and low-tech gimmickry.[30] The blinking LED that appears as the label for a mug-shot self-portrait ensconced in a surface of hand-smeared cow dung spells out "Bi-Ha-Ri," a common term of abuse in India, implying stupidity and uncouthness. On the other side, the artist appears in a life-size photographic self-portrait as a Vaseline-smeared nude reclining in regal, erotic *vilas* (splendor) on a faux-leather couch. Gupta infiltrates the establishment of high art (dis)guised in dung or in slick lubricity. *Three Cows* (2003–04, Cat. no. 7b), a group of three life-size *doodhwalla*'s (milk supplier's) bicycles completes Gupta's scrupulously irreverent play on the bucolic in contemporary life.[31] Cast in brass (and completelyl nonfunctional), the bicycles along with shiny bronze milk cans complete a cheeky return to a low-tech substratum, mock monuments to the omnipresent milkmen from the "cow belt" of rural northern India.

Transience is given a remarkable dimension in Raj Kumar Koram's autobiographical wooden pillars, *Apne Zindagi ka Khambha* (*Pillar of My Life*, 2002–03; Cat. no. 10). Derived from a tradition of memorial pillars from Bastar,[32] these contemporary sculptures are used by Kumar much in the manner of narrative reliefs, on which he carves the story of his life. Carving in vertical and helical succession on the surface of a tree trunk, he fashions a heroic individuality for himself—a role rarely, if ever, associated with an Adivasi artist.[33] Raj Kumar's story, which he performs in the manner of an itinerant storyteller turning the pillar to highlight episodes, moves from his sojourn as a poor laborer breaking stones with a sledgehammer, exploited by a motorcycle-riding contractor,[34] to his interest in folk theater and gravitation toward a career as a sculptor as part of a team working on the IFA project. Raj Kumar's work extends across wall paintings (his own home has a remarkable series of life narratives

Vivan Sundaram, Memorial, *1993/2000 (Cat. no. 21; detail). Mixed media; 18 x 10 m. Collection of the artist.*

painted on the walls) and public projects such as the *pila-gudi* (a shrine for children), one of a number of playschool spaces in and around Kondagaon.

Artist-activist Tushar Joag presents an enmeshed genealogy of the self in his video *Phantoms* (2002–04; Cat. no. 8). The artist has used a low-end editing technique on shaky footage shot with a hand-held camera to produce a narrative of his own life as abject victim and perpetrator—which is nonetheless suffused with the romance of heroic individual subjectivity. Made up of a jerky series of inter-cuts between the everyday rush of Mumbai's bursting commuter trains, pilgrims' illustrated maps of sites of belief, and scenes of violence (such as occurred in Ayodhya), the video is presided over by the apparition of the artist sitting on a chair as though in a bare interrogation chamber, placing the audience in the position of inquisitors behind one-way glass. The artist's voice leads us on a confessional journey between events in his personal life (an unre-solved relationship with an absent father, for example) and the violence of recent history, enunciated as a series of numbers that could be

dates, or successive bids in the auctioning of a personal history that implicates the self fully in broader histories.

A serialized rendition of autobiography characterizes Ganga Devi Bhatt's two-sided works on paper *Vyaktigat Itihaas* (*Personal History*, 2002; Cat. no. 6). Bhatt, a self-taught artist from Kondagaon, comes from a Hinduised Adivasi background and started making art two years ago. Her sophisticated use of color and composition in this series marks the emergence of a completely new idiom in the tradition of Bastar. We are led through what seems like a fairly straightforward story of a young woman's life in an Indian village, until we realize the import of her vividly reimagined episodes. Here are stories of love and brutality, of domestic violence and separation, all rendered with an unnerving equanimity. In a gesture of unsettling generosity, she shares with us the breakdown of an abusive marriage, her struggle to keep custody of her child, the humiliation of judgment by the (male) elders of the village and subsequent thoughts of suicide, and the spring of new love and new resolution. Bhatt's paintings represent the sublimation of

Pushpamal N. and Clare Arni, Native Women of South India: Manners and Customs: Lady in Moonlight (Raja Ravi Varma), *2002–03 (Cat. no. 11h).*
Manual photographic print on metallic paper (edition of 20); 70 x 57.5 cm (framed). Collection of the artists.

psychological scarring and the assertion of an independent subjectivity that again challenges urban notions of the simplicity and collectivity of rural life.

Public visual culture invariably subsists on generalizations, which frequently veil entrenched relations of power between objects of representation and their consumers. Using self-images that transit between markers of collective identity, Pushpamala N has collaborated with photographer Claire Arni to produce *Native Women of South India* (2002–04; Cat. no. 11). The artist appears in the photographs clad in the various garbs of a "native" woman, playing the roles of a Toda tribal, a villager carrying a pitcher, a camp film coquette being courted by an equally camp hero, a supernatural seductress from a Deccani miniature, and the nineteenth-century artist Raja Ravi Varma's representations of Indian goddesses and beauties, which have been raised to the status of canon through their oleographic reproductions.[35] Using crude devices of studio photography in small-town India, such as painted backdrops, the photographs display the seams of their manufacture, gesturing toward the pervasive fabrication of images in the public realm. Some of the guises are subjected to fake anthropometry to evoke strategies of classification, enumeration, and hierarchizing, which, although introduced in colonial times, have demonstrated remarkable longevity as popular stereotypes in contemporary India.

CONTESTED TERRAIN

I have argued earlier that contemporary Indian culture is beset by formidable pressures spawned by globalization and religious fundamentalism.[36] More than any reason intrinsic to art practice, it has been political change and the need to respond to the communalization of Indian politics—the politicization of membership in religious and ethnic groups and resultant violations of cultural values and human rights—that have propelled a

Sonadhar Viswakarma, Babri Masjid – Ramjanmabhoomi, 2003–04 (Cat. no. 22; detail). Iron; 175 x 200 cm. Collection of the artist.

number of artists away from conventional art practice.

Beginning in the early 1990s, artists began to move into the interactivity and play of multiple signifiers through video and installation art, often contesting the closed address of gallery-based practice. Simultaneously, the international funding and reception of experimental practices—in itself a by-product of economic and cultural globalization—has fostered the emergence of projects that are not financially viable within a domestic market enamored of more familiar objects. In a sense, works grouped under the theme "Contested Terrain" function as bridges between the concerns articulated by artists represented under the two headings on either side. A range of responses to fundamentalism is presented here, spanning the decade since the demolition of the Babri Mosque signaled the triumphant march of the Hindu Right to political center stage.

One of the first projects to confront the waves of violence unleashed by the demolition was Vivan Sundaram's installation *Memorial* (Cat. no. 21). First shown in New Delhi in 1993, *Memorial* is being reinstalled for this exhibition. Sundaram was inspired by a photo of the crumpled body of an unknown victim of a riot lying in a smoldering street, taken by Hoshi Jal and published in the *Times of India*: in Sundaram's work, this fallen mortal becomes an everyman, and his death symbolizes the demise of a nation founded on equality and secularism. Through gestures of memorialization involving the construction of a modernist pyramidal cenotaph for a life-size plaster representation of the fallen man, and a ceremonial archway made of weathered tin trunks, typically used by migrants and refugees on the subcontinent, *Memorial* evokes the unfolding of a continuing tragedy. Vitrines around the transparent cenotaph subject the photograph to a meticulous process of museumization. The

photographed body of the innocent dead is wreathed in iron nails: in death, it is afforded an iron shield, a prickly coat of armor, and provided with a funeral pyre of nails.

The work of the late Rummana Hussain occupies a singular space in the narrative of contemporary art's confrontation with fundamentalism. The riots of 1992–93 impelled her to alter her practice dramatically, from allegorical figurative painting to performance and installation. Implicit in this transformation was

two terms in her title in a relationship of opposition and conflation, Hussain sought in this work to invoke not only a national space, but also a more personal domestic one, exploding the certitudes of their presumed meaning while simultaneously holding forth the self as a site of contestation, the arena and psychological space where the battle for a secular home was and still is being waged.

Both Sundaram and Hussain take on the role of witness in their installations addressing

face and eyes, in the midst of a circle of rough stones. Surrounded by these ruins, the abject figure personifies a sense of helplessness coupled with a refusal to countenance barbarism in the name of religion. At one level, the stones are ruins, symbolic of the destruction of the Babri Mosque. They speak at the same time, of shattered lives, broken homes, and the impossibility of piecing together what has been sundered. Each of the stones rests on a partly concealed laminated image, documentary photographs from a variety of sources highlighting persons and events in India's decline into sectarian violence during the 1990s.

Nevertheless, resistance to fundamentalism is not the sole preserve of an urban, university-educated intelligentsia. Sonadhar Viswakarma is a senior artist from Kondagaon, Bastar; along with some colleagues, he spent several days in Kolkata (formerly Calcutta) while tension gripped the city following the demolition of the Babri Mosque. His response to the destruction came years later, in the form of an ironwork partition *Babri Masjid-Ramjanmabhoomi* (2002–04; Cat. no. 22) that contains a compressed narrative of the events leading up to December 6, 1992. Viswakarma is one of a number of artists from Chattisgarh who works with scrap metal—heating, cutting, and beating it into functional or decorative objects, primarily for an urban market eager to consume authentic tribal artifacts.[38] Viswakarma has used the form of a folding partition—the kind inspired by carved wooden screens from Rajasthan and used in middle-class Indian homes to divide living spaces—to create a flowing narrative that can be read in rows from the bottom up. We are shown the mobilization of people and animals through *rath yatras* (chariot processions),[39] resulting in rioting and finally in the attack on the mosque itself, with the three domes overrun by pickaxe-wielding mobs while armed policemen/demons keep watch.[40]

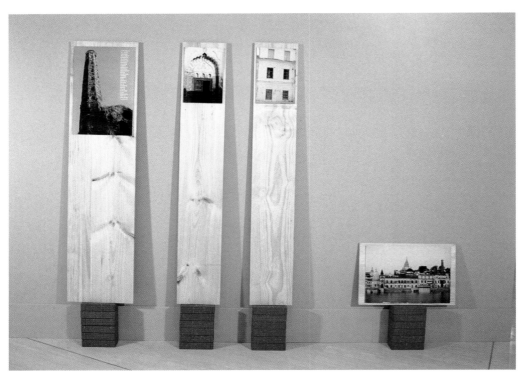

Rummana Hussain, Home Nation, *1996 (Cat. no. 17; detail). Multipart installation (including wooden planks, plastic folders, photographs, glass bottles, cloth); 5.6 x 4 m. Courtesy of the Estate of Rummana Hussain.*

a radical realignment of the artist's persona: Hussain began pitching herself as Muslim, woman, Indian, and artist, in a gesture of channeling political expression through a visceral exhumation of a complex, multilayered historical self. *Home/Nation* (Cat. no. 17) first shown in Mumbai's Gallery Chemould in 1996, made use of photographs alongside text and ephemeral materials examining the notion of belonging in a fragmented world. Placing the

contemporary violence. The work of N. N. Rimzon also poses questions about the role of the witness, fore-fronting the presence of the citizen-subject in our democracy. This presence for Rimzon, is hardly a heroic one, is marked distinction to the euphoric valorization of the citizen in nationalist and state-sponsored representation.[37] *Speaking Stones* (1998; Cat. no. 20) presents the normative citizen in the form of a crouching, life-size male figure shielding its

Santosh Kumar Das's work offers another instance of a mutable store of traditional knowledge and techniques in transformation.

As an artist with family links to the celebrated Madhubani paintings of Mithila, Bihar, Das is among the few folk practitioners to have been through university-based art education, having studied at Baroda's famous Faculty of Fine Arts. Returning to his maternal idiom of Madhubani painting, his work as artist and teacher is geared towards finding contemporary relevance for tradition in a highly commercialized domain where Madhubani immediately evokes visions of ritual and religious paintings produced on paper in response to constant demand from urban consumers. Das's 2003 series of work responding to communal violence in Gujarat is represented here (Cat. no. 14). The works make use of the notational figuration of the Madhubani tradition in juxtaposing recent events with historical figures such as Mahatma Gandhi, whose ideals of peace and non-violence are being undermined in the state of his birth.

Nalini Malani's practice, characterized by a fluidity of materials and techniques, is represented here through *The Sacred and the Profane* (1998), an installation using the low-tech devices of a shadow play to construct an array of transient images that envelops the viewer. With sources culled from the paintings of Raja Ravi Varma and the early modern folk forms of Kalighat painting,[41] Malani reflects on the irrevocable fusion between the sacred and the profane in Indian traditions of narrative and imagery. Images painted in thin acrylics on transparent Mylar cylinders merge to create a palimpsest that challenges notions of separation and insularity. Their shadows on the wall conjure up a parallel proto-cinematic experience. Two single-channel video works represent a continuation of Malani's formal and ideological concerns in a time of systematized brutalization. *Stains* (2000; Cat. no. 18) presents a constant coalescence and dissolution of forms that is mesmeric in its organic beauty, even as it evokes the fascination with pervasive violence that perpetuates its recurrence. *Unity in Diversity* (2003) takes as its leitmotif Raja Ravi Varma's painting *Galaxy of Musicians* (ca. 1889), which orchestrates typically attired

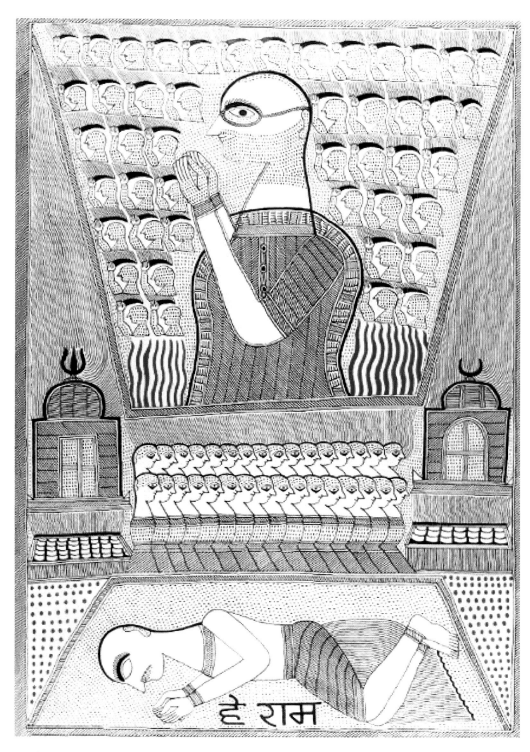

Santosh Kumar Das, Chief Minister Narendra Modhi Inciting Religious Intolerance While Gujarat Burns and Gandhi's Death is Forgotten, 2003 (Cat. no. 14b). Ink on paper; 38.1 x 55.9 cm. Ethnic Arts Foundation.

women from diverse ethnic and religious groups from across India in an allegory of national unity.[42] The presumed harmony of Ravi Varma's composition dissolves into the brutality of the anti-Muslim pogrom of Gujarat in 2002, implicating the failure of the state to guarantee a secular and syncretistic culture, but also hinting at more basic failings—hatred, violence, greed, jealousy—to which we are all inherently susceptible.[43]

Swarna and Manu Chitrakar are members of a community of *patua* (scroll-maker) painter-performers from the village of Naya in West Bengal, who use *pat* (painted scrolls) for story-telling. (The surname "Chitrakar," meaning "painter," is a trade name that all painters from this community use.) While their work tends to be categorized under the rubric of folk art, with implications of decorative, naïve, and unchanging practices, Swarna and Manu have harnessed their traditions and skills to articulate responses to contemporary situa-

tions, much as other contemporary artists have done. The communist government of West Bengal has often made use of their skills and their access to rural communities in campaigns of public education aimed at removing discrim-ination against the *shishu kanya* (girl child), for example. The *Shishu Kanya* narrative is a prominent presence in Swarna's practice, and became the starting point for her interaction with another woman artist, Archana Hande from Mumbai, also featured in this exhibition. Swarna's work—and that of other painters in the community including her brother Manu—is not, however, confined to traditional story-telling or to issues of social justice. There is something of an anarchic freedom in her appropriation of seemingly foreign narratives, as demonstrated in her scrolls based on the Hollywood blockbuster *Titanic* (2001–03; Cat. no. 13). Manu Chitrakar is represented here by a scroll responding to the war in Afghanistan (Cat. no. 12). Presenting a strong case for the

inherent fluidity and flexibility of a traditional idiom, Manu is able to use the episodic format of the vertical scroll and the notational simplic-ity of *pat* painting to enlarge the potentials of contemporary art practice within a rapidly transforming society and information economy. The vertical format of the scroll allows for a narrative laid out in horizontal registers or bands. The Chitrakars use this format to isolate key moments in their chosen narrative, which are then sung aloud, while the scroll functions as a sort of proto-cinematic device, one hand rolling it from the top while the other unrolls it from the bottom.[44]

In response to the work of the Chitrakars of Midnapur, Mumbai-based artist Archana Hande has undertaken a video and artist book project for *Edge of Desire*. Hande and Swarna Chitrakar met in late 2002, and have been in regular contact since. Working parallel to each other, the two artists have explored through their individual media issues surrounding fundamentalist violence, disenfranchisement, and the continuing oppression of women in a patriarchal society. Hande's *An Epic* (2003–04; Cat. no. 16) presents a formal as well as struc-tural foil to the vertical narratives in Swarna and Manu Chitrakar's scrolls. Featuring docu-mentary footage from India's recent history interleaved with interviews with various contemporary *patuas*, Hande's work presents layers and registers of imagery to create a complex, polymorphous narrative. The work addresses systemic violence against women and minorities in contemporary India, as well as political affiliations and creative concerns on part of the artists of Midnapur. The other of Hande's videos—*A Tale*—is a more immediate accompaniment to the scrolls, illuminating for viewers the context for this practice and the immediacy of its responses to a volatile public sphere.

Since its establishment in 1999, the Open Circle (Cat. no. 19) artists' group has organized public actions, exhibitions, and workshops aimed at bridging the divide between institu-tionalized spaces of art practice and the wider sphere of political activity. The concerns

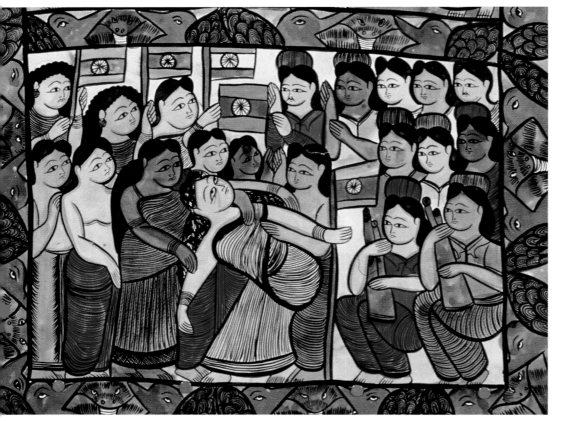

Swarna Chitrakar, Shishu Kamya (Girl Child), 2004 (Cat. no. 13a; detail). Poster pain on paper; 240 x 75 cm. Collection of the artist.

articulated in their public projects span protests against corporate globalization and consumerism, disenfranchisement of marginal communities in the name of development, as well as against the drive of fundamentalist politics. Through the production of cheap, mass-produced objects, such as posters, T-shirts, and stickers, coupled with large-scale hoardings and public action, Open Circle has worked with trade unions, students, and nongovernmental organizations (NGOs) in Mumbai. This exhibition brings their projects into Australia and North America, where some of their concerns will readily find echoes in the current unease over corporate globalization and the dispensations of interventionist international policy. Taking the form of a three-dimensional soundscape using simultaneous playback of multiple recordings, this project introduces aural elements of manifestly "foreign" or "exotic" origins into public environments.

Shilpa Gupta's *Blame* project (2002–03; Cat. no. 15) was formulated in the wake of such recent events as the conflict in Kargil when India and Pakistan came perilously close to all out conflict, the U.S.-led "war on terror," and the violence against Muslims in Gujarat. The *Blame* project was part of *Aar-Paar 2002*,[45] an artists' initiative linking Mumbai, India and Karachi, Pakistan: once neighbouring ports on the Arabian Sea, crossroads of economic and cultural interchange, now rivals in a fratricidal conflict between twins separated at birth.[46] Riding on commuter trains, Gupta posed as a salesperson for blame—a commodity in mass-produced oversupply in our times. Commuters are offered packaged blame in little bottles filled with a blood-red fluid, much in the manner of hawkers of cosmetics and panaceas that frequent suburban transport in India. Save that Gupta hawks the very effective product—proven by recent history—that ensures an illusion of security obtained through an apportioning of blame onto others, who are out there, but also, constituents of here; in your "home." The associated poster or label expounds the soothing virtues of blame ("Blaming you makes me feel so good: so I

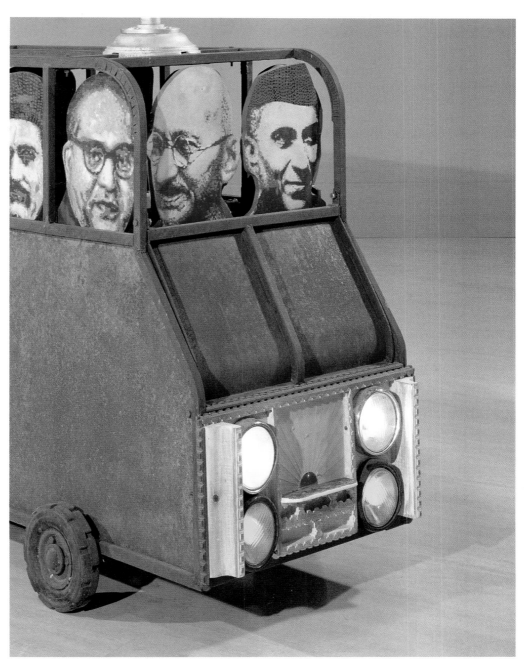

Nataraj Shamra, Freedom Bus (Or a View from the 6th Standard), 2001–04 (Cat. no. 26a; detail). Iron, wood, electrical motor, oil and enamel paint on paper, ink jet prints, rubber tires, electroplating; 103 x 237 x 76 cm. Collection of the artist.

blame you for what you cannot control . . .") in an inversion of the grotesque machinations of contemporary policy whereby those designated as other—nations, communities, belief systems—are held responsible for present ills in any given condition. Gupta has explored

the potentials of presenting *Blame* in a gallery setting, with the *Blame* bottles accompanied by a TV monitor that continuously spells out a message expounding the cure-all properties of this magical potion, and documentary footage of the artist's interactions with the public.

RECYCLED FUTURES

As I have suggested earlier, *Edge of Desire* is not some sort of shorthand for contemporary Indian visual culture; this exhibition does not purport to offer a survey of masterpieces from the last decade of Indian art. Experimental and contingent work that may not have been possible under normal market circumstances is a vital aspect of this project. I want to suggest here that the contradiction in the title of this section—that futures are a matter of recycling, and also that small-scale, semi-official economies of recycling are physically vital to our continued existence—is indicative of our historical condition. A conflation of recycling and renewal introduces a body of work that is playful in its use of tradition, even as it offers a sharply satirical account of consumer culture in the modern metropolis. For what is tradition but everyday practices legitimized as universal through their omnipresence? And how shall we separate the urban weakness for consumption from its more rustic counterparts? In the course of achieving this, all kinds of objects and imagery that constitute the stuff of daily life get subsumed within the category of the traditional, explicitly highlighting the mobile nature of this term.

Subhash Singh Vyam comes from a family of Adivasi artists who have migrated to the city of Bhopal, capital of Madhya Pradesh. Alongside work as a clerk in a government office, Subhash Singh maintains a prolific art practice, mainly in drawing. Executed on commercially available paper with Rotring drafting pens, these drawings preserve the "look" of traditional craft within a contemporary market economy. Vyam's work represented here originated in a series of drawings the artist made in response to the terrorist attacks of September 11, 2001. There is of course no dearth of responses to September 11, artistic and otherwise. In Subhash Singh's work, however, it is not the event that is paramount, but a meditation on technology and the natural world. In a large canvas executed specifically for this exhibition

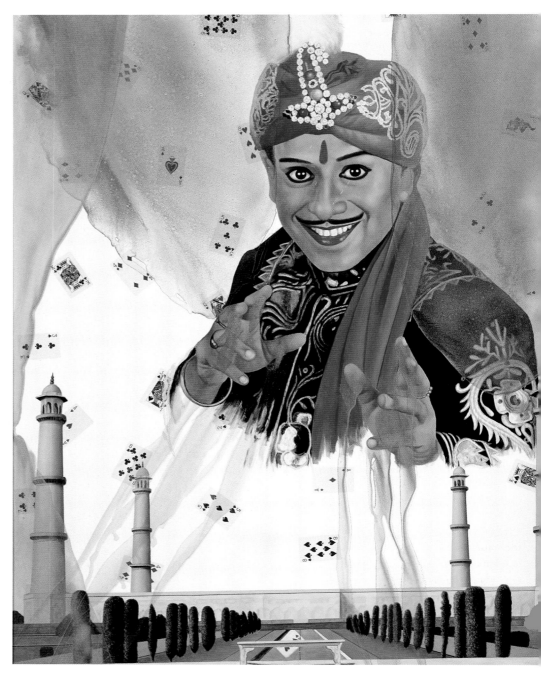

Atul Dodiya, Tomb's Day, 2001 (Cat. no. 29; detail). Enamel paint, varnish on laminate; 191 x 129 cm (framed, each panel).Collection of the National Gallery of Modern, Delhi

(Cat. no. 28), the artist presents us with the somewhat cryptic image of an aircraft tangled among the topmost branches of an immense tree—a tree of life, so significant across a number of Indian artistic traditions. At the base of the tree are assembled all kinds of denizens of the forest, as though in wonder at this extraordinary spectacle.

Sharmila Samant's practice, like that of several of her colleagues, is rooted in a critique of consumer capitalism, the major revolution that her generation has experienced personally

Left: K. G. Subramanyan, *Black Boys Fight Demons* (*Cat. no. 27a; detail*). *94 x 63.5 cm. Collection of the National Gallery of Modern Art, Delhi.*

Right: Ravi Kashi, *Everything Happens Twice, 2002–04* (*Cat. no. 31; detail*). *100 % cotton rag acid-free paper, gauze cloth, photocopy transfer and acrylic lettering, stamps, plyvinyl acetate glue; 158 x 220 x 2.5 cm (overall, 9 units, each unit 40 x 60 cm). Collection of Peter Mueller.*

while growing up during the 1980s. With *A Handmade Saree* (1998; Cat. no. 25), Samant takes the language of conceptualist art and infuses it with a political charge that points to the status of the handmade in economies built on a superabundance of surplus mass-produc-tion. Painstakingly crafted from eighteen-hundred Coca-Cola bottle caps fastened together with steel shackles, *A Handmade Saree* is draped over a display stand in the manner of a boutique display. The patterns on the "fabric" are immediately recognizable as traditional mango motifs: it is only on getting closer to the work that the nature of its constituent parts can clearly be discerned. On the floor, three framed texts à la Joseph Kosuth inform us of the formal meanings of the terms "handmade," "saree," and "coke," teasing out the complexity of their meanings.

Nataraj Sharma's *Freedom Bus: or a view from the 6th standard* (2002–04; Cat. no. 26) draws on images of Great Leaders as legitimized in textbooks (he actually refers to his daughter's sixth-standard history text) to concoct a galaxy of two-dimensional cutout national heroes within the confines of a school bus—an iron-framework contraption that carries, in addition to its flattened and illustrious occupants, a dysfunctional megaphone and lights that flash on and off periodically. The liberties that Sharma's work takes with nationalist nostalgia, veneering it with cool cynicism mingled with trenchant political critique, makes it unique to our time, in the sense that such work would not have been possible even a decade ago. On the other hand, perhaps Sharma's cynicism is born of a generation that has experienced the presumed euphoria of liberation, and its undoing within a decade. Sharma is also repre-sented here by a set of drawings begun in 2000, in which he continues his dialogue with the fraught relationship between urbanization, the

landscape, and human presences at the inter-stices of modernity. Simultaneously ephemeral and enduring, *Mumbai Structures* present vignettes of an urban environment in the throes of transformation, ensconced within the doubled figures of human survival and the persistence of technologically obsolete structures.

Kausik Mukhopadhyay's practice presents a different play with the idea of recycling—among other things, his work signals pervasive practices of recycling in the Third World, where nothing goes to waste in a structure of ethnically determined employment.[47] Working with discarded or outmoded objects such as household implements and utensils, basic elec-trical and electronic devices, and other urban detritus, Mukhopadhyay offers up a mobile collection of modern aids to urban survival and happiness (Cat. no. 23), laced with humor in the manner of the Japanese Chindogu group.[48]

Mounted on a trolley linked to a tricycle rickshaw, these quasi-functional gadgets offer solutions to all kinds of issues significant to the contemporary bourgeoisie, from insomnia to fitness, and from alienation and loneliness to personal hygiene and appearance—all presented as commodities that can be acquired by professional members of an urban middle class constantly seduced by the latest fad, their lives suspended between morbid reality and impossible fantasy.[49]

Variously a medieval city, an agglomeration of semi-urbanized villages, an imperial capital, and the seat of economic and political muscle, New Delhi over the last decade has been reinvented through ever more brash financial clout. A group of intellectuals working at Sarai, a new media laboratory and research and publication center, have taken on the task of comprehending the changing status of the citizen-subject in this new scenario.[50] The Raqs Media Collective (Jeebesh Bagchi, Monica Narula, and Shuddhabrata Sengupta), physically based at Sarai, collaborated with Mrityunjay Chatterjee to create the web-based work *Global Village Health Manual* (1999; Cat. no. 24). Rigorously chaotic and multifocal in its sourcing of imagery, the *Manual* greets the on-line visitor with images from the *bat-tala* prints of early modern Bengal, and product packaging from the nineteenth-century, using these as frontispieces to an eccentric array of linked "pictures, stories, news and rumor, speculations and skirmishes in info-wars, databases and image banks, hard facts and harder fictions" from the contemporary arena. The *Manual* quotes Walter Benjamin's assertion that "in principle a work of art has always been reproducible,"[51] before employing the anarchic right of the web-browsing subject to appropriations that embrace the past, and project a manifestly recycled future.

Where Raqs' digital work makes use of opportunities afforded by popular prints at the turn of the last century, K. G. Subramanyan's dazzlingly inventive oeuvre spanning five decades has been concerned with the mutable nature of culturally defined narratives, including religious ones. Subramanyan's work is marked by a fluid trespass between the incidental and the universal, between folk and fine art, between the sexual and the sacred. His work has embodied the desire for roots in what he has called a "living tradition," even as he advances a trenchant critique of a modernist history focused on the autonomous practice of individual geniuses.[52] Over his long career as an artist, teacher, designer, historian, and critic, Subramanyan has opened out new challenges to understanding the nature of Indian visual traditions.[53] Subramanyan's work in this selection (Cat. no. 27) reinterprets mythological narratives in a contemporary setting, transporting the revels and adventures of the child Krishna, or the battles of the goddess Durga, into settings populated by mechanical demons or scenes of political rioting. Characterized by a peripatetic, notational figuration that is anarchic in its sourcing of imagery, his work stands here in dialogue with Swarna Chitrakar's *Shishu Kanya* and with Nalini Malani's *The Sacred and the Profane*. As a testament to the mobility and dynamism of tradition, his work demonstrates

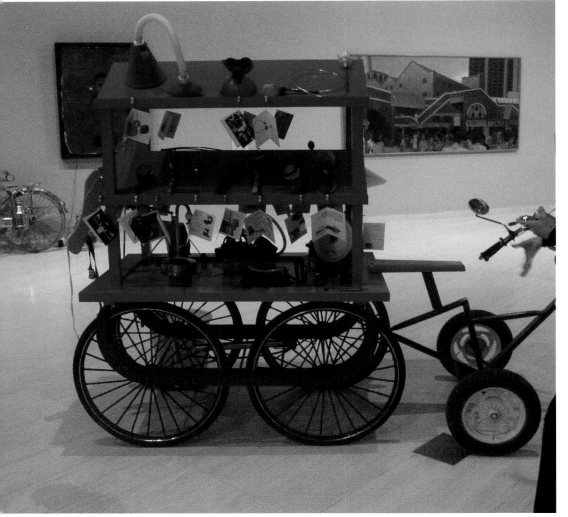

Kausik Mukhopadhyay, Assisted Readymades: Alternative Solutions, 2003–04 (Cat. no. 23; detail). Handcart, tricycle, assemblages of discarded household objects with manuals; 180 x 306 x 92 cm. Collection of the artist.

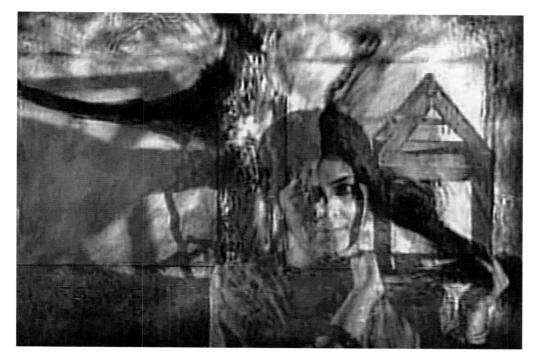

Ranbir Kaleka, Windows, 2002 (Cat. no. 30; still). Video/sculpture with sound; 243.8 x 121.9 x 121.9 cm. Collection of the artist.

UNRULY VISIONS

This section of *Edge of Desire* is concerned with artists' involvements with the many guises of popular culture in contemporary India: the visual culture of television, news and advertising, cinema and Bollywood, museums, mausoleums, shrines, and the unruly, mixed-up visuality that characterizes the street. This unruliness does not, however, imply a lack of sophistication: as Kajri Jain indicates in her essay in this volume, the unruliness of the popular is subject to its own semantic codes and referential orders. The emotional economies of place and desire that this exhibition is premised on are closely tied up in the manufacture of unruliness.

Ravi Kashi's set of nine cast-paper televisions, *Everything Happens Twice* (2002–04;

the intrinsic overflow across the categories of past and future, affirming the manifold character of contemporary Indian experience, born as it is of the interleaving of convention and invention.

Cat. no. 30) inverts the relationship between television as witness of the everyday and the artistic imagination in its concern with a broader sweep of history. Taking the impulse of the readymade image to its logical conclusion, Kashi refuses to draw or create new imagery. His visual material is entirely derived from elements of popular visual culture such as news reportage, advertisements, and movies. In direct contrast with this use of the readymade image is his practice of paper casting, which demands meticulous attention to manual craftsmanship. Evoking multiple television sets ranged in a shop, each offering an unending stream of tragedies and triumphs for voyeuristic consumption, Kashi's work conjures up the ultimately farcical effect of living in an image-saturated environment, where an image of a man begging for his life holds only as much weight as one promoting a new brand of lifestyle clothing.

Atul Dodiya's triptych *Tomb's Day* (2001; Cat. no. 29) makes parodic references to the status of one of India's stereotypical icons, the Taj Mahal, as a symbol of a civilization. The

tomb is glorified by visits from the Clintons, the Putins, and, finally, by the famous Indian illusionist P. C. Sorkar, who promptly makes it dematerialize. The possibility of reading the title as "doomsday" and the juxtaposition of images of world leaders with an illusionist suggests alternative readings. Is this work about the webs of illusions and falsehoods that politicians foment? Is it about the status of civilizational icons in a media-saturated environment (imagine versions featuring, say, the Tower of Pisa, the Great Pyramid at Giza, the Hagia Sophia in Istanbul, or New York's Twin Towers)? Is it about the culture of diplomacy and the furor that the successive visits of Clinton and Putin created in India, read as a recognition of India's increasing international clout? Executed in the language of billboard painting, using clichés and gimmicks particular to the trade, and deliberately exposing the incomplete translations between photographic image and painted surface, Dodiya's work claims connections with all of these questions and more.

Mallikarjun Katakol is a photographer and graphic designer based in Bangalore. His professional work places him at the coalface of the urban elite's desires for transmogrification in globalizing India, complete with glamorous models promoting glitzy products. A more personal involvement has been with the garish, awkward, and fantastic imagery populating the interiors and exteriors of auto-rickshaws—motorized three-wheeled taxis that can be found in every Indian city and small town—in Bangalore and Mysore. Katakol's photographs bring into the gallery space a prolific area of subordinated visual culture, which features the work of master painters whose clients, the rickshaw owners, line up to have their vehicles decorated with messages, including aphorisms about broken hearts, slogans about religious harmony, and the inevitable images of heroes and heroines. That these painters are represented here by proxy, through Katakol's agency, is perhaps an indicator of how the marginal finds its way into the mainstream (and vice versa): the interpenetration of "high" and "low"

cultural forms shapes a matrix of fraught issues having to do with the power to represent, in which the curatorial project is also implicated.

Part of the systems regulating popular visual culture is the marshalling of images of national heroes by the intellectual apparatus of museums and memorials to create shrines that invite obeisance, theaters where rituals of patriotism and faith may be played out. Dayanita Singh's photographs addressing memorialization (1999–2000; Cat. no. 36) create a meta-narrative about the simultaneous presence and absence that these regulated spectacles construct around the image and belongings of a departed leader. Ubiquitous images of a grinning Mohandas Gandhi and a pensive Jawaharlal Nehru are in fact by-products of a project of national imagination. Though set up by official sanction, the reincarnation and dissemination of these imaginary currencies often takes place in the common realm: a *dalit*[54] cobbler hangs a portrait of Dr. Bhimrao Ramji Ambedkar, the *dalit* architect of India's constitution and the founding figure of *dalit* resistance in modern politics, amidst a display of footwear, even though the association of footwear with such images in other circumstances has led to violence: garlanding an image with footwear implies desecration, and incidents involving images of Ambedkar have resulted in rioting in recent years. Tableaux of museumized, mummified leaders in Singh's work are juxtaposed with another set of tableaux that cast the spectacular in celebratory aggrandizement. Heroic soldiers climb to victory on the heights of Kargil in Kashmir; the Taj Mahal rubs shoulders with the Eiffel Tower in a wonders-of-the-world backdrop to a wedding. Finally, screen idols Twinkle Khanna and Ajay Devgan recline on a crescent moon in the festering eroticism of Bollywood, in a dream sequence on the sets of the film *Jaan*.

The introduction into India of global satellite television in the early 1990s created one of the greatest visual revolutions in recent history. The average urban home now boasts several dozen channels streaming locally produced and imported content in about a dozen different

Surendran Nair, Precision Theatre of the Heavenly Shepherds, 2002–03 (Cat. no. 33b; detail). Watercolor on paper, 65 x 50.5 cm. Collection of Nitin Bhayana.

languages. State censorship and regulation seem to be always two steps behind this revolution, which constantly stretches the boundaries of acceptable morality and civilizational values. The entry in 1996 of MTV in its Indian avatar into this heady mix was a pivotal event in fostering a new yuppie imagination. Cyrus Oshidar and the creative team at MTV India are represented in this exhibition by a selection of fillers and promos produced over the last decade (Cat. no. 34). Housed in a street-side small-goods shack, the monitor plays a riotous

succession of colorful noise in a display of irreverent takeoffs on sacred and profane material from public visual culture. The footage features invented characters that blur the distinctions between historical and mythical, actual and fantastic: political satire mingles with faux fetishism, lissome models transmute into goddesses, Elvis is Indianized to hawk events, and didactic tales are subverted through cheap jokes. There is a story to be told here about how the *desi*—South Asian living abroad[55]— becomes "cool," and how bourgeois

Cyrus Oshidar/MTV India, Video Filler Compilation
(Cat. no. 34; DVD still). DVD, cigarette/small goods stall roadside shop
(complete), wooden bench, television monitors; duration 30 minutes (approx);
installation: 240 x 126 x 187 cm. Collection of MTV India.

culture mutates into local strands, shedding all pretensions to universality in the context of globalization.

A significantly different take on the song-and-dance vitality of popular culture is embodied in the thoughtful, joyous as well as melancholic work of Ranbir Kaleka. His video *Windows* (2002; Cat. no. 30) features here under a colorful circus tent, and is projected on a wheeled screen, as though ready for travel as part of a wandering village show. *Windows* can be read as a bittersweet love story, with its evocative soundtrack of lilting melodies from vintage Hindi movies. It is at one level a commonplace story without heroic grandeur. At the same time though, the work suggests potential for the extraordinary. Kaleka takes up everyday dreams, joys and sorrows as his material, and extracts from it an essential, existential sorrow, and a meditation on the fleetingness of emotion even as light fleets across the screen to create images. Kaleka's work in video is distinguished by its insistence on holding the momentary, acknowledging its passing nature, meditating on its impermanence, gently grinding away at two ends of the video—first as incomplete narrative and then again as impermanent apparition.

The location of "fine art" within such a seemingly dislocated, multifocal spectrum of possibility remains an unsettled question. Recent challenges to the institutionalized nature of gallery-based practice—often articulated by artists who are themselves operating within the gallery—have made for a concocting of unfamiliar brews. Surendran Nair's practice as a painter participates in this maelstrom of influences and attributions. Through an intensely located study of sources, he distils a growing pantheon of images, partaking equally of the profound and the nonsensical. His *Precision Theatre of the Heavenly Shepherds* (2002; Cat. no. 33) seemingly personifies signs of the zodiac. Each of these invented personae is sourced in historical antecedents, including identifiable iconographies from Indian art history, a play of riddles and quotations that invites solutions. At the same time, the images taken together represent a fusion of European ideas of celestial forces with Indian forms of the divine, invoking the presence of one in the other, and arguing gently that given our histories, to be precise about essences and directions is a fallacy. His *Mephistopheles* (2002; Cat. no. 33a) represents the thirteenth sign for this zodiac, the sign of our times—the age of falsehood. Derived from the image of the Buddha calling upon the earth to witness the moment of his enlightenment, *Mephistopheles* becomes a personification of the violence, deviousness, and secrecy by which rulers across the world have distinguished themselves in recent years.[56]

L. N. Tallur's inflatable vinyl installation *Made in England: A temple design for India* (2000; Cat. no. 37) addresses itself to the mania for shrines, the search for roots and concrete fountainheads of the faith.[57] Made during his postgraduate studies in Leeds, Tallur's temple is an inflatable contraption complete with Nandi, Shiva's bull-vehicle, which shudders in compressor-induced tumescence, playing on the phallic associations of vertical constructions that are not necessarily limited to Indian temples. Brightly colored, like a fairground canopy, and inviting the viewer to enter its darkened sanctum sanctorum to study graffiti-like drawings, this is a temple seemingly on the move. Expressly designed for travel, its presence within the gallery already announces its impending departure: it's all ready to be deflated, boxed, and reinflated at its next location on a tour of the world.

Traveling shrines are of course not unknown in India. There are traditions in western India of village storytellers who carry on their torsos miniature shrines with unfolding panels that can be successively opened out to reveal painted narratives, so that the performer's body becomes a stage—a practice that within its folk forms crystallizes the philosophical attitude of seeing the divine in all, and all in the divine. Gulammohammed Sheikh, whose work as artist, teacher, and historian has drawn on the itinerant and persistently porous spirit of Indian culture, has created a series of four traveling shrines for this exhibition (Cat. no. 34). Addressing various aspects of contemporary culture—mobility, knowledge, places, and desires—these shrines signify a traveling compendium, a multifaceted distillation of painting languages that are supple and polymorphous enough to address contemporary experience in India. Also implicit in Sheikh's shrines are observations on recent Indian history, which unfold as successive layers of painting are revealed through an opening out of doors that is at once a practical device and a symbolic one.

EPILOGUE

As the first major appraisal of contemporary Indian art to be commissioned by either of its two organizing museums, *Edge of Desire* represents a significant development in the institutional consideration of its subject in Australia and the United States.[58] Economic and political developments over the last two decades have contributed to a signal shift in the appraisal and consumption of contemporary art from non-Western contexts—especially from Asia and the Pacific—in the art institutions of the developed world; as the Thai art historian Apinan Poshyananda pointed out more than a decade ago, "'selling nations' as works of art has become like slippery lubricants that make political mechanisms function with ease."[59] It is now commonplace for high-profile international exhibitions to feature several members of Asia's new globetrotting artist elite, who are routinely executing projects via e-mail, living between serialized productions across a burgeoning number of art hubs. For a while, there may have been cause to celebrate this newfound visibility. However, under current regimes of commodification and marketing, uncritical celebration may be at best naïve—and at worst, obfuscatory and condescending.[60] To celebrate this phenomenon unconditionally would presuppose that we remain shy of questioning the motivations and modes of cultural traffic, with platitudes replacing analysis. We would also fall prey to renewed exoticization under the garb of a shallow multiculturalism: the cultural policy of globalizing states. This is what would imply an attitude of condescension, with newly visible practices (and practitioners) being reduced to the status of fragile, immature entities from partly comprehended places, in need of the benevolence of the more enlightened.

It is impossible to explain the increasing international visibility of Indian art unless we consider several historical factors. Coupled with the more generalized gravitation toward contemporary art from non-Western contexts (in itself concomitant with economic globalization), these factors have included India's emergence as a major market for Western consumer goods; its emergence as a regional military power; and paradoxically, the intensification of separatism, sectarian conflict, and human-rights abuses over the last two decades. The occurrence of this exhibition needs to be firmly placed within economic and political processes that have altered the lineaments of power both nationally and internationally.

This exhibition is predicated on diversity and celebrates the survival of pluralistic cultural forms. Engaging with a diversity of contemporary practices and creative conditions, it seeks to question cultural structures that segregate and hierarchize visual practices. It argues for both/and rather than either/or, making a case for a polycentric aesthetic of difference rather than the rhetoric of identity and development.[61]

Polycentrism and a rejection of institutional hierarchies cannot, however, imply an unbiased survey of visual production. My own biases as curator are obviously on display here. I am also aware that it may be only a matter of time before "polycentrism" as a term, or as a slogan—like "multiculturalism," "marginality," and "postcoloniality"—comes to be assimilated into existing vocabularies and catchphrases to the extent that it loses any critical edge.

At a time when the avant-garde is supposedly long exhausted, or has been co-opted into simulacral projects that preserve only the look of insurgency, and when any potential for art practice to make the heroic statement (except by way of the clever pun, or asides addressed to the knowing, which are still very fashionable) has been leached away, it may be useful to consider the work of artists active in India and similar locations. Work from such contexts often tends to be appreciated for its fantastic look—for its continuing vitality—but it is important to remember that the fantastic is in itself a troublesome category in postcolonial histories. Recourse to the fantastic and the magical patently offered postcolonial artists a route into historical empowerment, but it cannot be allowed to become yet another of those stereotypes that are used to categorize, tame, and therefore control Otherness. This irreducible Otherness, with its propensity toward unpredictability, its ability to say several things at once, and its infuriating tendency away from the singular and canonical toward the multiple and heretical, can be raised as a bulwark not only against Orientalist homogenization and exoticization, but also against the anti-pluralist strictures of globalization and fundamentalism.

I have worked on this exhibition with colleagues in Perth and in New York over the last three years. The preceding catalogue text has been formulated over this time, through successive revisions. In May 2004, India conducted a General Election (reputedly, the largest exercise in participatory democracy anywhere in the world). Broadly speaking, the Elections of May 2004 resulted in an increase in representation for the Left and Centrist parties, at the expense of the Right. A coalition of fifteen political parties, the United Progressive Alliance formed government under the leadership of the Congress party. Dr. Manmohan Singh, a member of the Sikh community who had served previously as Finance Minister, became Prime Minister.

Certainly, at the level of Parliament and Central Cabinet, there has been a major transformation in recent months. This transformation has been reflected in state rhetoric as expressed in the Common Minimum Programme of the United Progressive Alliance, and in the Prime Minister's statement of vision spelled out most recently, in his Independence Day speech delivered from the ramparts of Delhi's Red Fort on August 15, 2004, which emphasized an equitable, prosperous and peaceful India.[62] Given the agenda of secular politics, economic "development with a human face," and an allocation of resources toward employment, education, and welfare of India's poor majority, it would seem that there is still hope for the secular ideals of independent India. It may be that history would consign the previous decade and half of violence and inequity to the status of an aberration. But

that is yet to be seen. There has been a change in government in New Delhi, but tensions and fractures at communal, sectarian and regional levels continue to dominate local politics.[63]

Like any exhibition with an ideological position, *Edge of Desire* has sought to situate the work of participating artists within an intellectual and historical framework. However, it remains true that great art invariably escapes such attempts at framing. Not only are works of art not built to a "program," they also involve a degree of excess, a surplus of meaning that curatorial or art historical devices cannot hope to fully encapsulate. And that is how it should be. Among other things, this excess allows works of art to be meaningful to audiences that may be far removed from those of their "home" culture.

Edge of Desire: Recent Art in India is certainly about a certain period in India's recent history, and has resulted from specific preoccupations. More important perhaps, it is about artists making art in difficult times; it is about artists harnessing myriad traditions from different parts of the world; it is about artists responding to immediate realities with degrees of organic fluidity and passion that are uplifting.

NOTES

[1] See Thomas McEvilley, "Exhibition Strategies in the Postcolonial Era," in *Contemporary Art in Asia: Traditions/ Tensions,* New York: Asia Society Galleries, 1996, pp. 54–59. See also Ajay J. Sinha, "Contemporary Indian Art: A Question of Method", *Art Journal* (Fall 1999), pp. 31–39.

[2] Alexandra Kuss, et. al., "Curators' Introduction," *Awas! Recent Art from Indonesia,* Yogyakarta: Cemeti Art Foundation, 1999, p. 11.

[3] Claims to place have found various articulations in calls for the "liberation" of holy places like Somnath and Ayodhya, militarist fantasies of a greater India encompassing neighboring nation-states, assertions that India is the exclusive homeland of Hindus, and the persecution of minorities.

[4] This retreat into insular identities and the phenomenon of sectarian violence resulting from this is not particular to India. Similar situations can be observed in Indonesia and Thailand, among other places. See Jayati Ghosh, "Perceptions of Difference: The Economic Underpinnings," in K. N. Panikkar, ed., *The Concerned Indian's Guide to Communalism,* New Delhi: Viking, 1999, pp. 112–13.

[5] As Gulammohammed Sheikh put it, "Living in India means living simultaneously in several cultures and times. One often walks into 'medieval' situations, and runs into 'primitive' people. The past exists as a living entity alongside the present, each illuminating and sustaining the other." "Among Several Cultures and Times," in Carla Borden, ed., *Contemporary Indian Tradition,* New York: Smithsonian Institution, 1989, p. 107.

[6] I am thinking here of a very diverse body of practice, which includes some of the artists represented here (Umesh Maddanahalli, Shilpa Gupta, Sharmila Samant, Pushpamala N, and Subodh Gupta, for instance), and others active elsewhere (Yasumasa Morimura, Mella Jaarsma, Dadang Christanto, and Christian Boltanski).

[7] Adivasi (literally "first dwellers") is the generic term for the large number of tribal societies that live in India, for the most part quite separate from caste Hindu societies. Though subject to constant transformation in recent years—including aggressive assimilation into the lower orders of caste Hinduism which does play a role in the articulation of contemporary Adivasi identities—in recent years, Adivasi societies have been characterized either by nomadism or by an economy based on subsistence agriculture and food-gathering, as distinct from largely settled, intensively cultivated or pastoral settlements and, more recently, industrial development in the mainstream. Adivasis, racially classified as Dravidian people, have presumably lived on the subcontinent since before the arrival of Sanskrit-speaking "Aryan" peoples from the northwest, in about 1500 B.C.E. These distinctions, it must be stressed, are by no means settled, and remain subject to debate. The fact remains, however, that contemporary public policy, itself of British colonial origin, continues to classify Adivasi peoples separately under "Scheduled Tribes," "Nomadic Tribes," etc., and that in terms of indices of development, education, life expectancy, and access to government services, Adivasi peoples constitute some of the most disenfranchised groups in the world.

[8] The divide between art and craft is quite pronounced in India, manifesting not only in institutions, but also in ontological structures—the strength of art-historical research, for example, which rarely, if ever, ventures into the crafts. The most prominent museums devoted to visual art in New Delhi, for instance, give evidence of a division of responsibilities commensurate with the ontological divide. The Crafts Museum concentrates on folk and tribal traditions, and exists as a separate institution under the jurisdiction of the Office of the Development Commissioner for Handicrafts. The National Museum and the National Gallery of Modern Art, governed by the Ministry of Culture, are devoted to the classical traditions of Indian art and urban fine art, respectively. The only major institution in India to collect and display urban and Adivasi art under a common umbrella—albeit in discrete spaces—is the Roopankar Museum at Bhopal's Bharat Bhavan arts complex, established in 1982. Its inaugural director, artist and ideologue J. Swaminathan, argued passionately for a recognition of contemporary Adivasi art as contemporary art. See his *The Perceiving Fingers,* Bhopal: Bharat Bhavan, 1987.

[9] See Ajay J. Sinha, *op. cit.,* p. 35.

[10] See Kajri Jain, "Identity, Indigeniety, Dissonance: Sonabai at the APT" *Artlink,* vol. 20, no. 2, July 2000, pp. 52–55.

[11] See Tapati Guha-Thakurta, *The making of a new 'Indian' art: Artists, aesthetics and nationalism in Bengal, c. 1850-1920.* Cambridge: Cambridge University Press, 1992, pp. 118–20.

[12] Bernard S. Cohn, *Colonialism and Its Forms of Knowledge: The British in India.* Princeton: Princeton University Press, 1996, pp. 5–11.

[13] A small number of recent exhibitions have featured folk and Adivasi art alongside urban practice. See *India Songs,* curated by Victoria Lynn, Art Gallery of New South Wales, 1993; and *New Indian Art: Home-Street-Shrine-Bazaar-Museum,* curated by G. M. Sheikh with Jyotindra Jain, Manchester Art Gallery, 2002. Sheikh and Jain were also involved in the selection of Indian artists at the *Third Asia-Pacific Triennial,* Brisbane, 1999, where Rajwar artist Sonabai was featured alongside urban contemporaries, albeit in a separate section, *Crossing-Borders,* whereas the urban artists were represented under the national label. Implicit here was the acknowledgement that Sonabai's inclusion was indeed a crossing of boundaries, at least within the institutional apparatus of Indian art.

[14] *Other Masters: Five Contemporary Folk and Tribal Artists of India,* New Delhi: Crafts Museum and The Handicrafts and Handlooms Exports Corporation of India, n.d., p. 14.

[15] The Tagorean elite of the Bengal School started collecting folk objects in the early twentieth century, as artists and as connoisseurs. (Jaya Appasamy, "The Folk inspiration in Modern Indian Painting," *Lalit Kala Contemporary 34* [New Delhi], 1987.) Writing in 1908, E. B. Havell, British administrator and advocate of the Bengal School, pointed to the "survival of genuine folk-art" in India, exhorting Indians to "take an intelligent and serious interest in them, [as they] would be the surest foundation on which to build up the revival of Indian painting." (E. B. Havell, *Indian Sculpture and Painting*, London: John Murray, 1908, p. 239 [cf. second edition, 1928]). The interaction between urban fine art and traditions of folk, tribal, and popular art remains one of the

most fraught aspects of modern art in India. The careers of artists such as Abanindranath Tagore, Nandalal Bose, K. K. Hebbar, Meera Mukherjee, and Bhupen Khakhar present evidence of this unsettled relationship, which nonetheless has been productive of a significant portion of the modern Indian canon.

16 For more information on the late Meera Mukherjee, see Tapati Guha-Thakurta, "Meera Mukherjee: Recasting the Folk Form," in Gayatri Sinha, ed., *Expressions and Evocations: Contemporary Women Artists of India,* Mumbai: Marg Publications, 1997, pp. 48–55.

17 See Appasamy, *op. cit.*

18 K. G. Subramanyan, *The Living Tradition,* p. 85.

19 I use the word Bollywood here to denote the post-liberalization transformation in the Indian film industry. As Ashish Rajadhyaksha has argued in this volume, "Bollywood . . . can be validly seen as an industry that is not so much *about* the cinema as an evocation of cinema for the purposes of creating a slew of new culture industries including fashion, music, consumption, tourism, advertising, television and the internet–industries that, as it were, reproduce the cinema outside the movie theatre.

20 Aijaz Ahmad, "Globalization and Culture," in *On Communalism and Globalization: Offensives of the Far Right,* New Delhi: Three Essays Press, 2002, pp. 95–96.

21 For an analysis of syncretism in one aspect of Indian tradition—miniature painting—see G. M. Sheikh, "The Making of a Visual Language: Thoughts on Mughal Painting," *Journal of Arts and Ideas* 30–31 December 1997; special issue, "Sites of Art History: Canons and Expositions," guest editor Tapati Guha-Thakurta), pp. 7–32.

22 Eric Hobsbawm, "Introduction: Inventing Traditions," in Hobsbawm and Ranger, eds., *The Invention of Tradition,* Cambridge: Cambridge University Press, 1983, p. 4.

23 About 250,000 workers from Mumbai's (then) 60 textile mills went on strike over a period of 18 months commencing January 1982, demanding better working conditions, wage raises and the abolition of the *badli* system for hiring temporary workers. The eventual failure of this strike, led by Datta Samant, is regarded as the death knell of the organized labor movement in India, and its repercussions can still be felt.

24 The artist's recent work, in miniature format, has been engaged with understanding the reality of Kashmir through painted responses to the poetry of Agha Shahid Ali. See Nilima Sheikh, *The Country Without a Post Office: Reading Agha Shahid Ali,* exhibition catalogue, Mumbai: Gallery Chemould, 2003, text by Peter Nagy.

25 The Mughal emperor Jehangir (1605–1628) is said to have exclaimed, "If there is paradise on earth, it is here, it is here, it is here!"

26 Conversation with the author, Baroda, 1 February, 2003.

27 Gaston Bachelard, *The Poetics of Space* (tr. Maria Jolas) Boston: Beacon Press, 1994, p. 3

28 At the time of writing, loan agreements pertaining to the inclusion of Khakhar's work in the exhibition were still in progress.

29 This exhibition does not engage with the work of expatriate Indian artists living in other countries; that would be a separate field of study in itself. Some projects, however, especially those made by the younger artists here, were made during residencies, typically in art institutions from the developed world.

30 As an everyday material of rural life, cow dung finds myriad uses: it is used to plaster walls and floors, as an insect repellent, and as fuel in the form of sundried cakes. The format of Gupta's *Bihari* of course also signals the official document—the identity card, passport, or police record.

31 Gupta has also cast other "vehicles" in metal, including a Vespa scooter complete with the jute sacks used by small-town merchants to carry goods to market.

32 There is a tradition of memorial pillars across several Adivasi groups in the Bastar region. Memorial pillars of the Maria people, as noted by Swaminathan, are elaborately carved with images of animals, birds, plants, and humans, and are frequently painted in bright colors. Set by the wayside so that passersby can see them and reflect on their own lives, these pillars routinely merge local reality with influences from the outside world, as well as creatures of myth and fable. See Swaminathan, *The Perceiving Fingers,* p. 44.

33 It is one of the great myths of modernism that tribal artists live in an abstracted, depersonalized collective consciousness, and that their art is a reflection of a pre-linguistic consciousness articulated through a timeless zone of innocence and childlike wonder.

34 As in other Adivasi areas in India, it is commonplace in the Bastar, where Raj Kumar comes from, for disenfranchised Adivasis to work as itinerant laborers for a paltry daily wage; their employers are contractors who are almost always non-Adivasi caste Hindus. With limited access to education and government services, and lacking entrepreneurial resources (capital, training, and infrastructure), Adivasi societies have continued to rely on external sources for wage employment as well as manufactured goods. In the market street of Kondagaon, for instance, every one of the shops that provides packaged and manufactured goods is owned by Jain or Hindu traders from outside Bastar, though it must be pointed out that they are descendants of migrants from other parts of the country who moved to Bastar as early as the fourteenth century CE. For further details, see Michael Postel and Zarine Cooper, *Bastar Folk Art: Shrines, Figurines and Memorials,* Mumbai: Project for Indian Cultural Studies, 1999.

35 See footnote 37 below for a note on Ravi Varma and his significance to Indian visual culture.

36 For an introduction to these pressures, see Pannikar, *op. cit,* and C. T. Kurien, *Global Capitalism and the Indian Economy,* New Delhi: Orient Longman, 1994. For the rise of religious fundamentalism, see Tapan Basu, et. al., *Khaki Shorts and Saffron Flags: a critique of the Hindu Right,* New Delhi: Orient Longman, 1993.

37 India is not unique in having produced a large body of revolutionary images, in sculpture, print, and film that project the everyday anonymous citizen as hero, as an agent of inevitable social transformation, as a force for good.

38 That this practice of metalwork is peculiarly modern both in terms of the materials used and in its relationships with market forces and mass-produced objects—seems not to deter consumers enamored or enchanted by the appeal of "age-old crafts." The work of Bastar metalworkers—or for that matter any number of producers of folk and Adivasi art—provides an acute barometer of urban culture and the aspirations of the

upwardly mobile. See Jyotindra Jain's texts on the exhibition *New Indian Art: Home Street Shrine Bazaar Museum,* published in *Art South Asia,* Manchester: Shisha, 2002.

39 Several of these *yatras* were mounted by the BJP and allied organizations to stir up fanatical devotion to the cause of *Ramajanmabhoomi,* the presumed birthplace of the Hindu god-king Rama. Bypassing the several hundred temples in the town of Ayodhya that claim the distinction of marking the spot, the Hindutva brigades pinpointed the site of the Babri Mosque as the one true birthplace, where a magnificent Rama temple is to be built. Hinduism, it should be emphasized, is a manifestly polymorphous body of belief; its consolidation into a singular religion is of relatively recent manufacture. With its multiple (and often conflicting) deities, and its plethora of holy places and holy texts, Hinduism may seem intrinsically opposed to fundamentalist perversion; in this sense, the narrow, monotheistic version of Hinduism championed as the ideology of Hindutva patently goes against the grain of the Hindu ethos.

40 Viswakarma's workshop in Kondagaon has been producing several versions of this work in response to a growing demand from urban collectors. That this remarkable narrative has been crafted out of the form of a decorative element in the middle-class homes that are representative of the largest vote bank in fundamentalist politics adds to the poignancy of the work.

41 Kalighat painting: a signal manifestation of modernity in Indian art, created by painters catering to a new market in the bylanes around the Kalighat temple

42 Raja Ravi Varma (1848-1906) hailed from a minor princely family in Travancore, Kerala, and is known as the first Indian painter to master the technology of European illusionism. Working in oils on canvas, Ravi Varma was able to sustain himself as a professional painter with commissions from aristocratic families and princely states in the late nineteenth century.
His project of recasting Indian mythology and ethnic types in a neo-classical garb, as well as his portraits of wealthy patrons, can be seen as part of a significant tendency in colonial culture, where appropriating the cultural values and forms of the coloniser becomes a route to national consciousness. See *Raja Ravi Varma:*

New Perspectives, New Delhi: National Museum, 1993?. See also Geeta Kapur, *When Was Modernism: Contemporary Cultural Practice in India,* New Delhi: Tulika, 2000.

43 For a longer discussion of Malani's recent work, see my "Apocalypse Recalled: the recent work of Nalini Malani" in *Nalini Malani: Stories Retold,* exhibition catalogue, New York: Bose Pacia, 2004.

44 It is important to note that Swarna and Manu Chitrakar are illiterate and their knowledge of the world has relied on images and oral narrative. Television is quite new to their experience, and their understanding of phenomena such as Hollywood films or global affairs has been mediated via cable television.

45 Aar-Paar = here and there, this side and the other, across borders. Coordinated by Shilpa Gupta from Mumbai and Huma Mulji from Karachi, the 2002 edition of the project involved artists from either side of the border producing graphic work which was emailed to their counterparts, to be mass-produced as offset prints and inserted within the public domain in the form of leaflets, newspaper inserts, and posters.

46 The separation at birth I refer to is, of course, Partition, which came as a necessary condition of Independence from Britain in 1947. For details on the *Aar-Paar* project, including images of artwork from participating artists from India and Pakistan, see http://members.tripod.com/aarpaar2. See also my "Printing across borders: the Aar Paar project," *Art Monthly Australia,* July 2004.

47 Thousands of recyclers work the streets, railway tracks and garbage bins of every major Indian city everyday, collecting refuse in woven plastic sacks to sell to recycling contractors. Sifting through all manner of refuse from the industrial to the intimate, these workers supply the world's largest recycling industry with its daily fuel. Other kinds of recycling consist in the innovative use of scrap and outdated machinery which is used to construct new contraptions by street-side mechanics, welders, and fabricators.

48 *Chindogu:* chin=odd; dogu=tool. A phenomenon initiated in the mid-1990s by Kenji Kawikami. See his series

of publications including *101 Unuseless Japanese Inventions* and *99 More Unuseless Japanese Inventions* (tr. Dan Papia) London: Harper Collins, 1995 and 1997 respectively.

49 It is interesting to note the appearance within the art gallery of vernacular forms of transport from the Third World during recent years. From Asia alone, there has been truck art from Pakistan (through the work of Durriya Kazi and David Aelsworth), cycle-rickshaws (Jun Nguyen-Hatsushiba's *Memorial Project Nha Trang, Vietnam, towards the complex for the courageous, the curious, and the cowards,* 2001), and *tuk-tuks* motorized three-wheeled taxis—from Thailand (Navin Rawanchaikul's project featured in *Cities on the Move* (1999) and other exhibitions). Mukhopadhyay has also previously worked with cycle-rickshaws in 2000.

50 The name Sarai comes from the Persian Serai or Caravan-serai, meaning a wayside inn, a place of pause, a temporary residence, a place of meetings. See http://www.sarai.net for details on various projects and publications produced by Sarai and their collaborators.

51 Walter Benjamin, "The Work of Art in the Age of Mechanical Reproduction" (1936), in Hannah Arendt (ed.), *Illuminations: Essays and Reflections,* New York, Schocken Books, 1969, p. 220.

52 In perhaps the most celebrated of his books, Subramanyan has written, "Most of us in the modern art world have a slightly exaggerated image of our creative independence." *The Living Tradition,* Introduction, Kolkata: Seagull, 1987, unpaginated section.

53 Subramanyan has written several books, including *Moving Focus,* New Delhi: Lalit Kala Akademi, 1978; *The Living Tradition,* Kolkata: Seagull, 1987 and *The Creative Circuit,* Kolkata: Seagull, 1992. For commentaries on Subramanyan, see Geeta Kapur, *K G Subramanyan,* New Delhi, Lalit Kala Akademi, 1987; Nilima Sheikh, "A postcolonial initiative," in G. M. Sheikh ed. *Contemporary Art in Baroda,* New Delhi: Tulika, 1997; and R. Siva Kumar, *K G Subramanyan: a retrospective,* New Delhi: National Gallery of Modern Art, 2002..

54 *Dalit*: literally, downtrodden. A term of political identification used by members of communities from the

lowest strata of Hindu caste hierarchy. Though social-religious strictures that imposed untouchability on these communities have long been outlawed, direct and indirect discrimination remain endemic, and it is still not common for persons of *dalit* origin to enjoy contemporary bourgeois lifestyles.

55 *Desi;* literally "countryman" or belonging to, or in the countryside—a name South Asians of all backgrounds living abroad use for themselves, as an expression of solidarity. Within the Indian context, *desi* also has derogatory connotations, implying a lack of sophistication.

56 For a discussion of this painting, see my "Under the Skin of Simulation: three contemporary painters," in *Under the Skin of Simulation,* exhibition catalogue, Berlin: The Fine Art Resource, 2003.

57 The Hindu Right's campaign for the "liberation" of sacred sites and the construction of a foundational temple for Hinduism (itself a contradiction for such a multifaceted system of belief) was characterized by posters and stickers depicting a muscular, militant Rama striding forth, with a massive temple in the background marking his presumed birthplace. Large donations to this project came from expatriate Hindus in the United Kingdom, the United States of America, and Canada. A "temple design for India," "made in England," then, carries more than a hint of irony.

58 Both the Art Gallery of Western Australia and the Asia Society and Museum have previously shown contemporary Indian art, and both institutions have works from India in their collections. However, this is the first time that either has mounted a large exhibition exclusively concerned with contemporary Indian art.

59 Apinan Poshyananda, "The Future: Post Cold-War, Postmodernism, Postmarginalia (Playing with Slippery Lubricants)" in Caroline Turner, ed., *Tradition and Change: Contemporary Art of Asia and the Pacific,* Brisbane: University of Queensland Press, 1993, p. 5.

60 I have developed this argument more fully elsewhere. See "Home and Away: contemporary Indian art in the international arena," *Art Monthly Australia,* September 2002, pp. 7–11.

61 Ella Shohat and Robert Stam, "Narrativizing Visual Culture: Towards a polycentric aesthetics," in Nicholas Mirzoeff, ed., *The Visual Culture Reader,* London: Routledge, 1998, pp. 27–49.

62 India's Prime Ministers have traditionally addressed the nation from this location since the moment of Jawaharlal Nehru's famous "Tryst with Destiny" declaration of Independence at midnight on 14-15 August 1947, which announced the birth of the independent nation. The following excerpts from Manmohan Singh's 2004 speech are significant in that they clearly echo the Nehruvian vision of a secular socialist democracy: *"Our strength derives from our unity in diversity. The principles of secularism, social justice and the equality of all before law are the defining feature of our nation . . . Our policies for higher economic growth and modernization will be combined with an emphasis on social justice, communal harmony, rural development, regional balance and concern for the environment . . . We must fight all anti-national and anti-social forces that try to disrupt normal life. Be they terrorists or communal and other such divisive forces."*

63 *Edge of Desire* is certainly not the only exhibition to have highlighted these tensions in recent years, a fact that highlights the tremendous impact of economic and political transformations on an artists' community that has found it imperative to engage in their present environments and to claim a place for art practice as inherently political. This decade has been the subject of at least two other exhibitions in the last few years. The first focused on the city of Bombay/Mumbai. India's primary metropolis during the 1990s was featured in *Century City: Art and the Metropolis in Modern Culture,* the opening exhibition of the Tate Modern in London in 2001. Curated by Geeta Kapur and Ashish Rajadhyaksha, the *Bombay/Mumbai 1992–2001* component of *Century City* presented Bombay as "the stage for acting out fierce contradictions in the nation's encounter with modernity" in the wake of the violence of December 1992 and January 1993. See Geeta Kapur and Ashish Rajadhyaksha, "Bombay/Mumbai 1992–2001" in Iwona Blazwick, ed., *Century City: Art and the Metropolis in Modern Culture,* London: Tate Modern, 2001, p. 19. The second exhibition, *Ways of Resisting* was curated by Vivan Sundaram for the Safdar Hashmi Memorial Trust (SAHMAT, which has organized several events against

communalism over the last decade) at the Rabindra Bhavan Galleries of the Lalit Kala Akademi (India's peak state-owned fine arts institution), in New Delhi in 2002. This exhibition specifically featured work from across the country that had responded to fundamentalism and violence during the 1990s.

LOCATION/ LONGING

N. S. HARSHA

There is something very natural in Harsha's conscious art as it attunes itself to a nearly minimal finesse while achieving a quiet intensity in which the formal permeates the observed as well as the emotive. His art cannot be separated from his life, his individuality from the world he lives in. A contemporary painter who also does installations, site-specific and collaborative events, he carries the memory of the classical Indian heritage like he carries his people and their environment with him. Harsha looks at life as a complex, pervasive entirety, a process rooted in the past, whose fluid present echoes of vast, eternal rhythms and binds the human to the organic, the personal to the cosmic and the social, even

the political. As if a serious scrutinizer of all things actual as well as subtle, he takes a distance and yet retains intimacy. Depicting rudimentary phenomena of existence, he becomes a judge but only to bring out the precious and the values dormant there, to feel part of it all with frankness and with fantasy, with warm, accepting humour and tenderness. Multitudes of minute figures, their layered rows repeated in slight but succinct variations, evoke a universal pulse to which an individual relates. The sketchy realism of the contour merges inherently with a tinge of the school-book illustration naivety but imbues elements of the classic miniature linearity. The aesthetic blend reflects the ethos of

Cat. No. 1, For You My Dear Earth, 2004. *Acrylic on cotton duck, canvas mounted on plywood with gold leaf (in 3 parts); 137 x 563 cm, 137 x 563 cm, 137 x 46cm, 137 x 1,172 cm (overall)*
Private Collection, New York. Courtesy: The Artist and Talwar Gallery, New York.

ordinary folk—real, somewhat rough and awkward, not devoid of follies and idiosyncrasies, still possessing a basic goodness and a link with the tradition and its ritualistic as well as spiritual content. The delicate precision of the line dominates his paintings whose pigments reciprocate by vacillating between clear opacity and gently graded translucence, both responding to the slow, meandering dynamism within each figure and in all the images together. Smaller, painterly brush drawings sublimate the essence of his canvases while enhancing them to the point of pain, pain that offers intuition of the artistic engagement. Harsha often walks alone in the countryside, tracing white shadows of trees and grasses on the ground. These later reappear on gallery walls and sheets of paper as intricate, stirring laces of greenery, which feeds on the sun, generates, sustains, and heals life. Having absorbed and synthetized qualities of concrete plants and of archaic ornamentation, such drawings sense the fragile strength of every twig and rhizome and their unity in a wider scheme of things.

By Marta Jakimowicz

UMESH MADDANAHALI

Umesh Maddanahalli's recent work has been executed in an expressly itinerant mode between southern India and northwestern Europe, where the artist has had several residencies over the last few years. His quasi-migrant mode of life has been accompanied by a move from sculpture into video and performance art.

Umesh trained as a sculptor, and his early work was expressly rooted in the soil, often taking the form of excavations and accretions in the open air, a kind of site-specific and temporal practice of earth-works and environmental art. A major earth-work and installation project that the artist executed outside the city of Bangalore in 1996 featured an acre of field worked over by bulldozers and excavators, onto which the artist made giant drawings in charcoal and white lime and structures in wood and bamboo. The entire sculpted field was lit up like a theater at dusk; one of the wooden structures actually housed live farm cattle. The work existed for five days before being destroyed. Simultaneously evoking the atmosphere of a ritual space and the environs of an Indian village, the project also recalled Umesh's continuing involvement with theatrical stage design.

A sense of theater pervades his current practice, with the artist himself appearing as moderator, conduit, or vehicle for the narrative, often in a workshop-like dialogue with viewers. In his role as traveler between cultures, he has made his work take on a distinctly interrogative aspect, questioning cultural assumptions and ethnocentric values to do with religion, history, mythology, and a contemporary politics of migration between the First and Third Worlds.

As is the case with the work of a number of his contemporaries including Subodh Gupta, Sonia Khurana, Surekha, Tushar Joag, Tejal Shah, and others, Umesh Maddanahalli's work in video retains traces of performance, with the persona and body of the artist explicitly present on screen. In forefronting the persona, body, and cultural context of the artist-as-performer in video works, this generation of artists (largely trained as sculptors) mark a difference from an earlier generation of Indian artists working in video (such as Nalini Malani, Ranbir Kaleka, and Vivan Sundaram, all trained as painters).

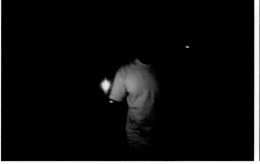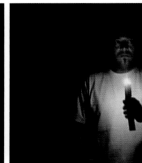

Cat. no. 2, Between Myth and History, 2001 DVD; 12 minutes (with audio). Collection of the artist.

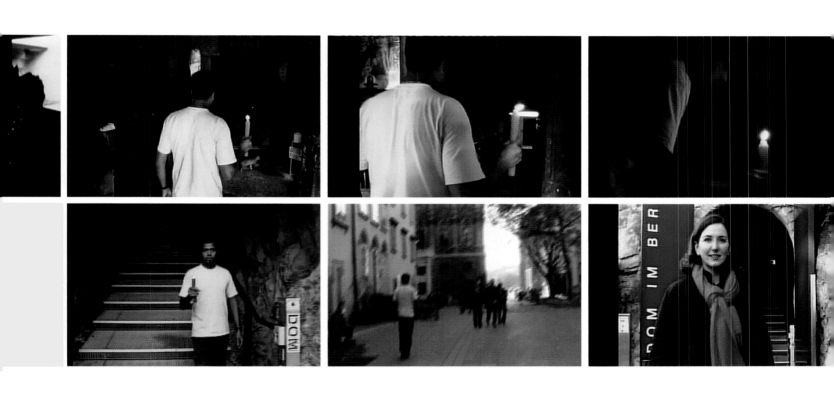

SUDHIR PATWARDHAN

The textile mill areas of central Bombay were an important source of imagery for me in the seventies. In a broader sense, they were the context of my images of workers. In the past few years I have felt a need to return to this source. The towering compound walls of mills, the chimneys, the stone bridges over railway lines, the teeming life around suburban stations—all this continues to excite me as an artist. However, the closing down of many of these mills since the eighties, leaving thousands of workers jobless, has cast a gloom over the area. The high-rise apart-ment blocks sprouting on mill lands in recent years symbolise emergent forces displacing the old order. It is with such impulses and thoughts that I started work on *Lower Parel.*

As the painting progressed, a triangular relation developed between the mill, the skyscraper and the bridge. The mill represented the past and the skyscraper the present. Between these dying and emerging faces of reality, the bridge was the public space in which one saw people live through this transition. As I observed these people moving around the bridge, I sensed the flow of everyday life as a continuum across historical breaks, across change. This softened somewhat the starker contrasts of tone and colour I had started with to represent a place and period in ferment, and left me with a quieter, dimmer light. It was like saying to myself: the pain of change will be borne, the price will be paid, and life will go on.

Sudhir Patwardhan, artist's note from *Sudhir Patwardhan: Paintings and Drawings,* exhibition catalogue, Mumbai: Sakshi Gallery, 2001.

Cat. no. 3, Lower Parel, 2001. Acrylic on canvas; 122 x 244 cm. Collection of Jamshyd R. Sethna.

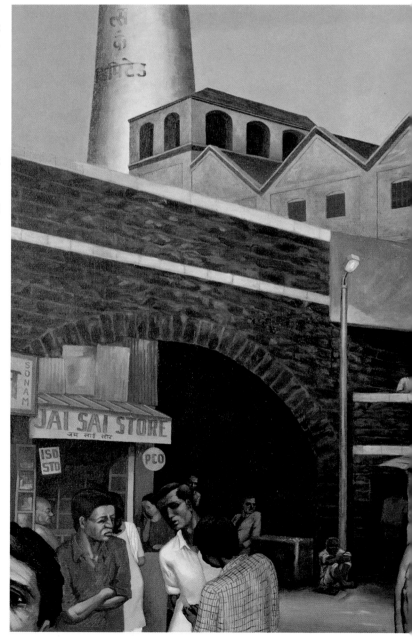

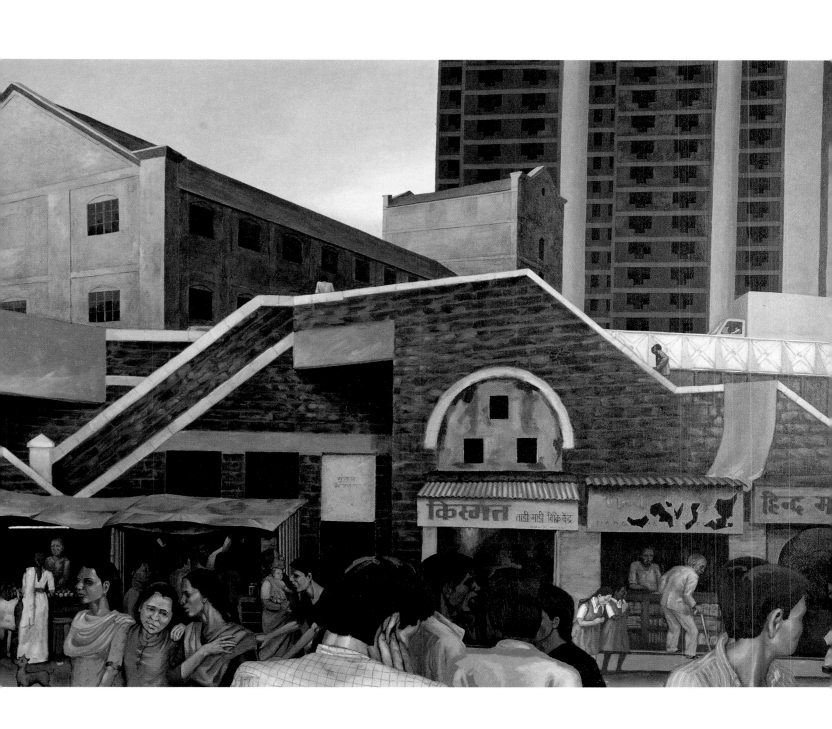

NILIMA SHEIKH

I think I am an artist because I am a painter, not a painter because I am an artist. I find fiddling around with brush and paint a very productive activity and am always amazed at the ways the tools of painting can be made to work." I enjoy the linguistic inflections they yield and marvel at meanings that can be evoked, changed, and perhaps even invented. Despite the presence of an opinion for the most part of my working life that 'painting' had run its course, I don't think I could have chosen a better time to paint. The privilege of painting now is not only in the number of choices but in not having to choose to exclude.

Below, a very slightly modified excerpt from Mala Marwah, "Nilima Sheikh: Human Encounters with the Natural World," in Gayatri Sinha, ed., *Expressions and Evocations: Contemporary Women Artists of India,* Mumbai: Marg Publications, 1996, pp. 120–21.

Nilima Sheikh has worked out a style that has the fresh inventiveness of a combined aesthetic, bringing together the conceptual poetry of the miniature and the compositional clarity and mood of the seventeenth-century Japanese woodcut, while employing naturalistic rendering in the case of specific images, as a figure, animal, or vegetation. There is a coordinative sympathy between her style and her subjects, which refer to nature and incidents from everyday life, the drama of the home, the ambiguities of human relationships, animals, and children at play. Indian painting offers a rich bank of similar experiences contemporary to their own time, as popular legends and ballads, which have currency till today. Nilima refers, among other subjects, to this vital source, locating a timeless human theatre in the present and basing her creativity on experience.

Her style speaks effectively across the technical device of the various media Nilima has chosen to work in, as oil on canvas, tempera both on paper and cloth, as well as drawings for a children's book, theatre design for proscenium and the outdoors, including painting on banners and screens.

Nilima Sheikh: artist's statement from *The Self and the World: An Exhibition of Indian Women Artists,* New Delhi: National Gallery of Modern Art, 1997, p.51.

I have claimed for myself a lineage that engages with tradition and history—a lineage born of pre-independence Indian nationalism but fostered in a climate of 'progressive' internationalism and Asian bonding. Entering the art world in the late 1960s I learnt from my guru K. G. Subramanyan of the polyvalence and plurality of art practice, of the interdependence of plastic and other arts, of a non-hierarchical interweave of craft and folk practice with art, and of the linguistic structures of different systems of painting, their surface and form, mediated by societal and anthropological contexts. From my other mentor Gulammohammed Sheikh I learnt to share his passionate relationship with the art of the world and their histories, and to look for the 'alternative'—in modes of perception, visual structures and the narrativisation of time and space—outside the inevitability of linearity, in the eclectic and the multiple.

I have looked to alternative readings of the painting traditions—of Asia, particularly . . . scale, metaphorised projection, theatric aspiration, the desires of the imagination take their meaning from the context of the intimate, hoping to undo the fixity of boundaries and polarised categorisation, resisting the appropriation of 'tradition' by reactionary forces.

Opposite page: Ca. no. 4, Firdaus I-IV, 2003–04.

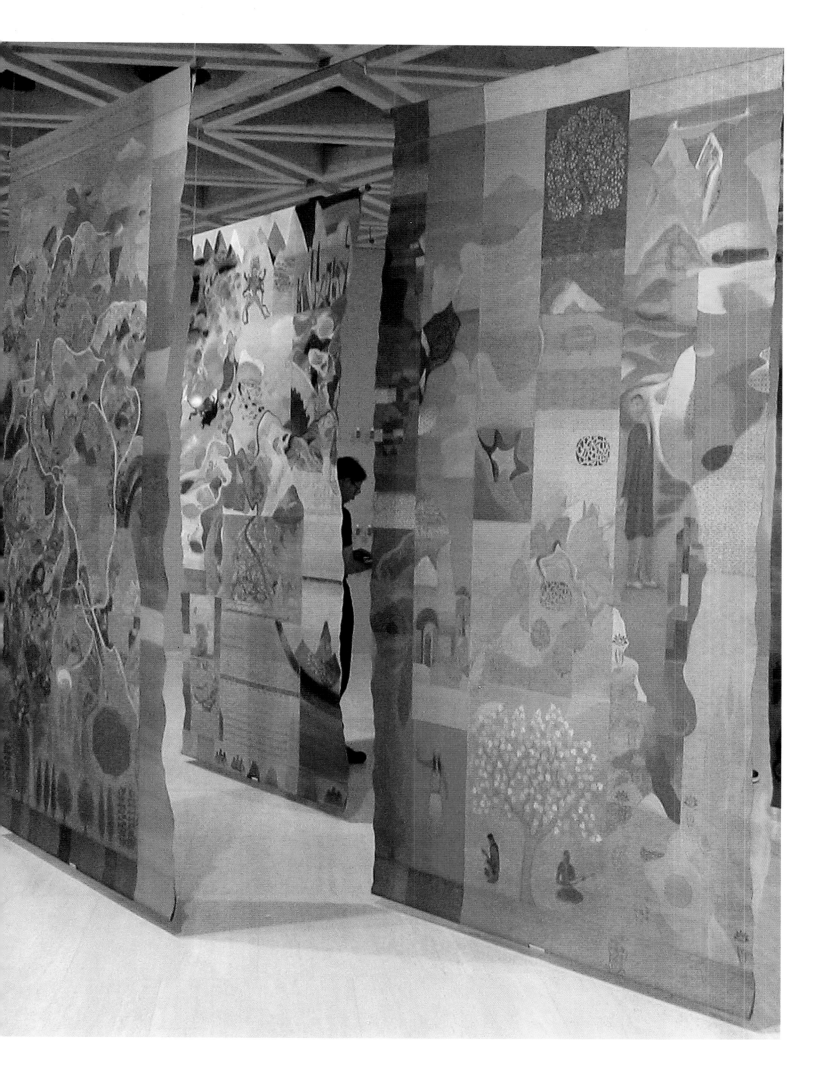

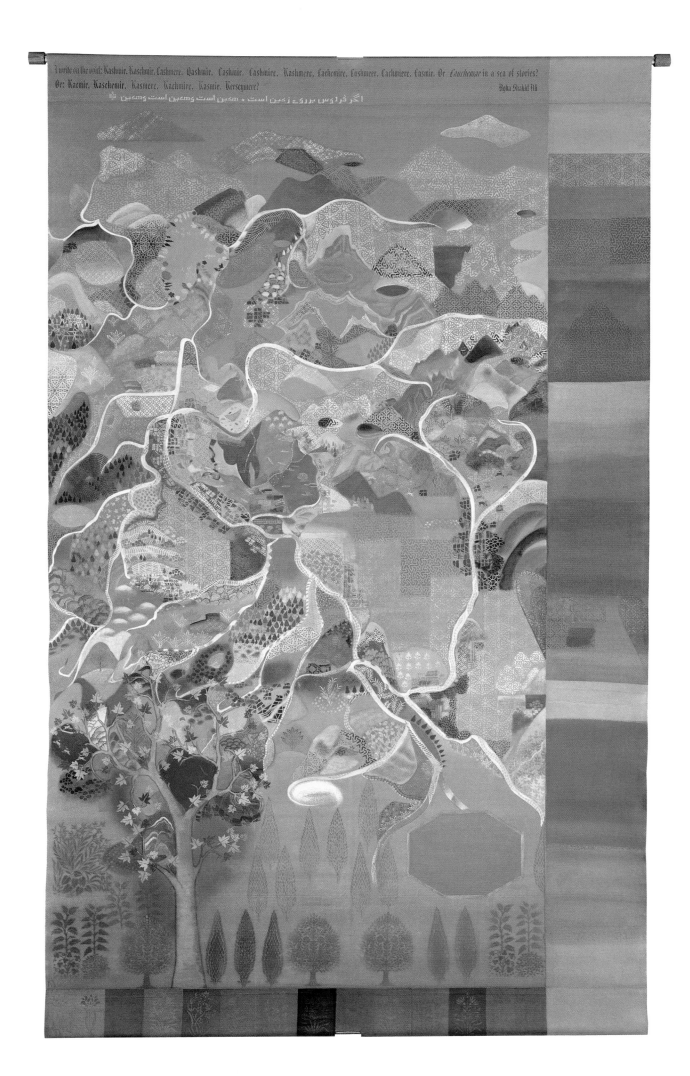

I write on the void: Kashmir, Kaschmir, Cashmere, Qashmir, Cashmir, Cashmire, Kashmere, Cachemire, Cushmeer, Cachmiere, Casmir. Or *Cauchemar in a sea of stories?* Or: Kacmir, Kaschemir, Kasmere, Kachmire, Kasmir. Kerseymere?

Agha Shahid Ali

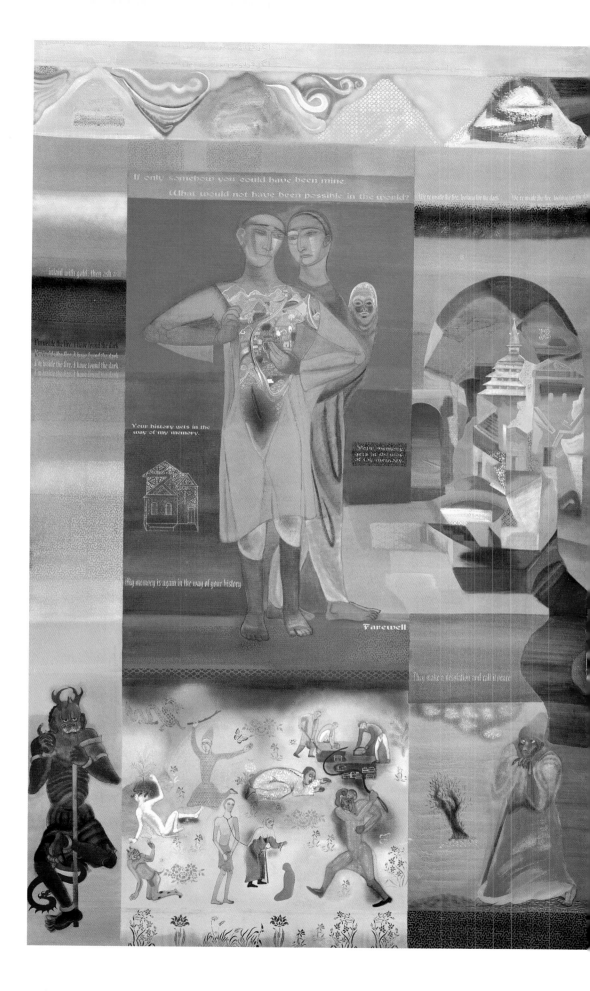

Opposite page: Cat. no. 4a, Firdaus I: Valley, *2003–04.*
Casein tempera, stencil on canvas; 300 x 180 cm.
Collection of the artist.

This page: Cat. no. 4b, Firdaus II: Every Night Put Kashmir in
Your Dreams, *2003–04.*
Casein tempera, stencil on canvas; 300 x 180 cm.
Collection of the artist.

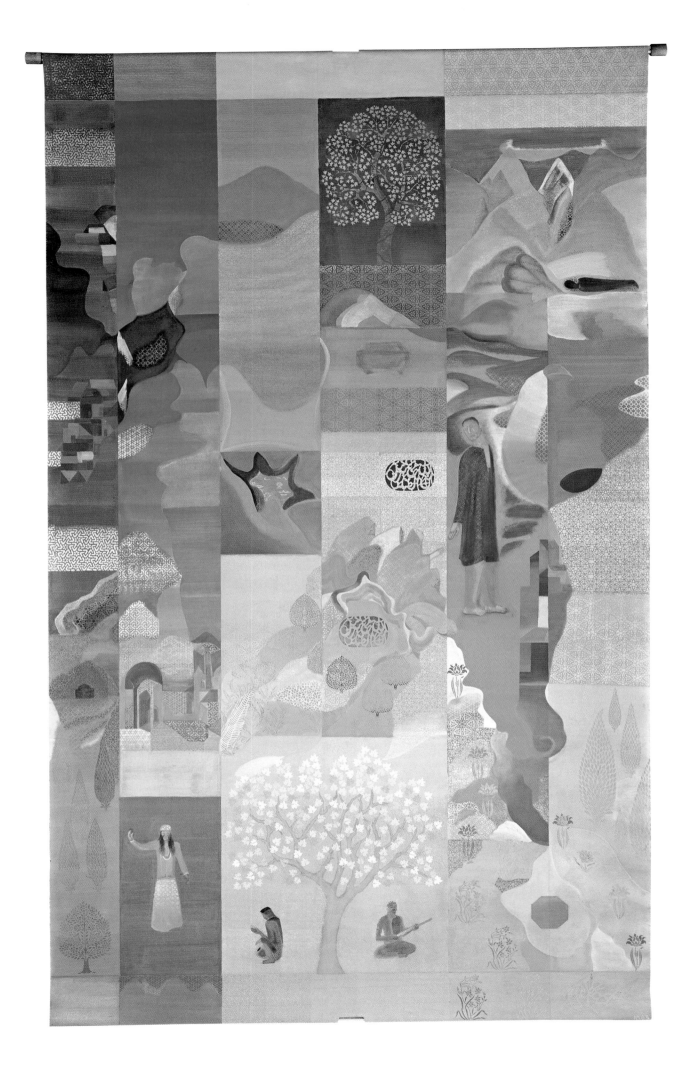

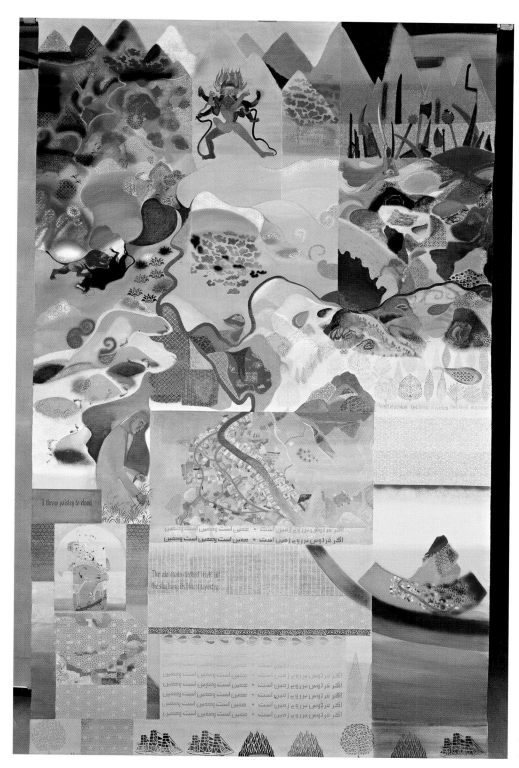

Opposite page: Cat. no. 4c, Firdaus III: Gathering Threads, 2003–04.
Casein tempera, stencil on canvas; 300 x 180 cm. Collection of the artist.

This page: Cat. no. 4d, Firdaus IV: Farewell, 2003–04.
Casein tempera, stencil on canvas; 300 x 180 cm. Collection of the artist.

VASUDHA THOZHUR

Secret Life is a body of paintings made between 1997 and 2001. It was conceived as groups of narrative sequences, involving temporal progression from one frame into another. The matrix, within which individual frames were composed, was based on the idea of a "house" with its many rooms, its different kinds of spaces, metaphoric, and functional. The script for the enactment of the narrative was based on life—aspects of which are an unspoken taboo during the course of "normal" social interaction—and therefore lived in private, subterranean realms. How does one edit life? What are parameters of retention or erasure? Obsession, as an editing tool: the most stringent, the acknowledgment of which means its cultivation and the inherent dangers therein; but when one works with something as large as life, there is no other choice. The origins of obsession are traced back to the self; without its inclinations and impulses there would be no concept and no form, no ideology or attitude; one does not adopt these things as intellectual choices, they have their origins in desire. And therefore I place myself at the heart of my narrative, and my story stems from desire.

One of my paintings shows me seated in my studio at the Cite des Arts, with a tiger at my feet. The idea of a tiger in Paris is of course incongruous, and at a superficial level touches upon the notion of the "exotic;" so too the jewels on the right. It is also a story of loss and enrichment.

My next body of work was *Untouchable*. The idea was spontaneous, but in India the term carries a heavy semantic load, focusing for the main part on caste taboos. I implicate these but widen the context to include other forms of marginalization/exclusion/subordination. My main focus is on the idea of the "Untouchable" as someone falling outside the hierarchy/convenience/status of classification but useful as an intermediary who provides access to the darker, mysterious forces of life (in actual social practice). The first painting in this series is framed within the familiar (in India) act of self-immolation. The broadest and original context remains the self—a personal history that is partially narrated in symbols within the painting, possibly the most inscrutable area. The original impulse is not an intellectual one but one of those things that occurs in a flash, a visual flash in the context of painting, a vision to use a more dramatic word? The analysis comes later, but I notice that if the matrix/structure is strong, there is a convergence of all perspectives, and I see this unfold through my practice. A collective reading is also possible through the use of images, which in India would be identified across all economic and social hierarchies. Symbols of sati and other rituals of purification, rites of passage into states of deprivation, renunciation—the entry points are therefore multiple—social, personal, topical, fantastic, and historical.

A different aesthetic seems possible, neither revivalist nor postmodern, deriving its energy from the contradictions of a turbulent country; capable of expressing the complex and explosive realities of a specific geographical and cultural location here in India and of a life lived within that location.

Cat. No. 5a, Untouchable, 2001.
Oil on canvas; 242 x 192 cm. Collection of the artist

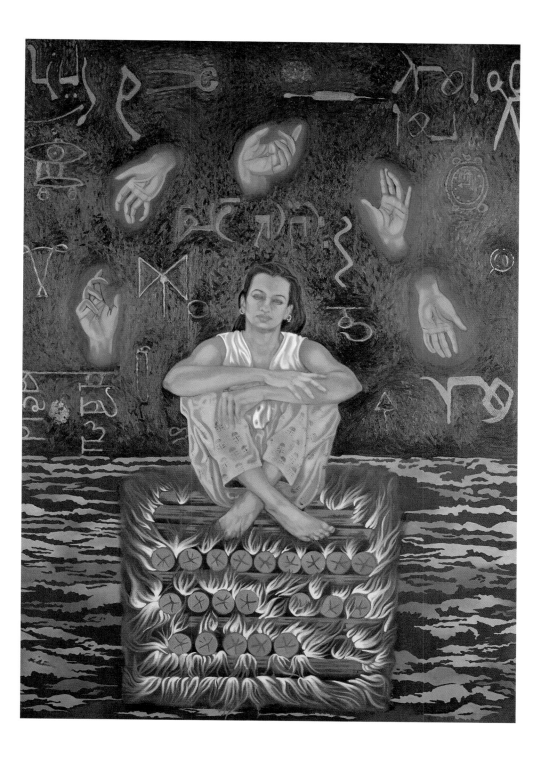

Cat. No. 5b, Lost Years: A Reconstruction (or Portrait of Vishnu), *2003.*
Oil on canvas (3 panels); 244 x 106 cm. 244 x 180 cm, 244 x 38.2 cm. Collection of the artist.

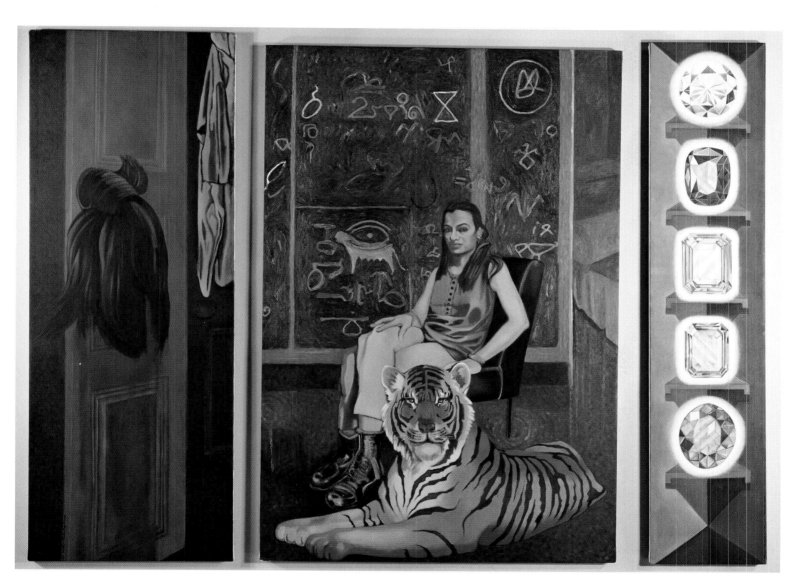

Cat. No. 5c, Secret Life: Tiger, 2000.
Oil on canvas (3 panels); 229 x 49 cm, 225 x 152 cm, 229 x 86 cm.
Collection of Vikram Kiron Sardesai.

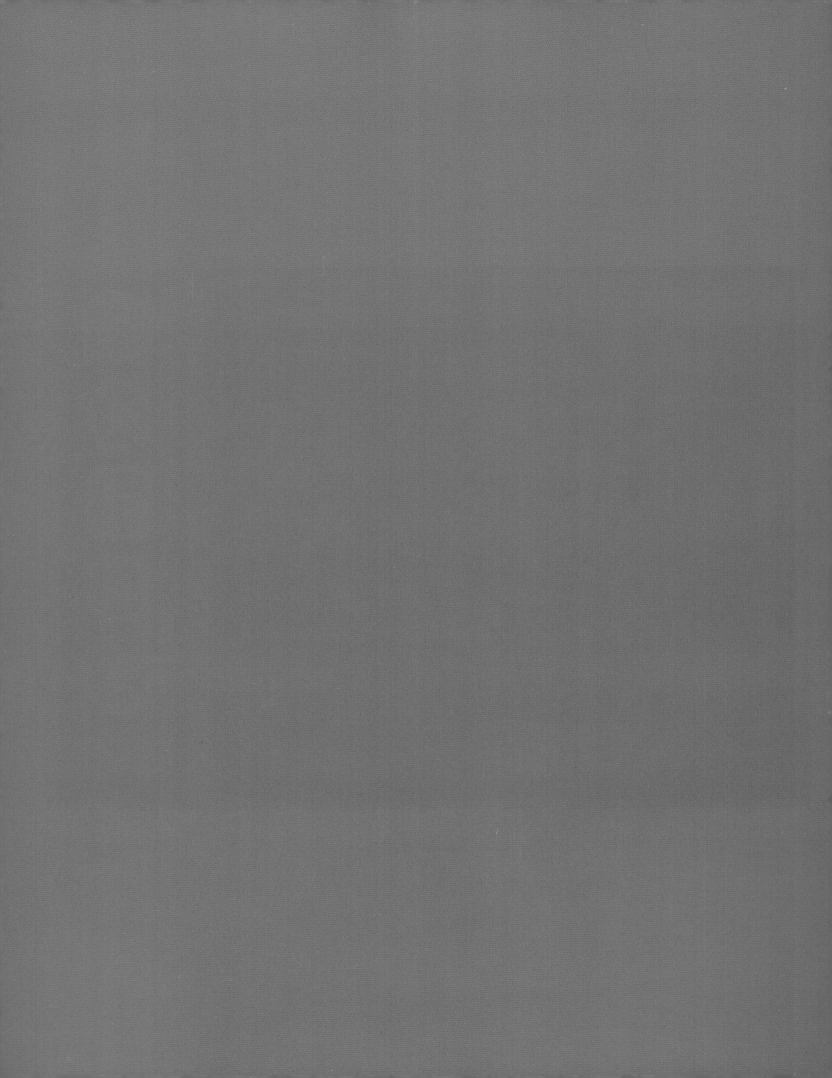

TRANSIENT
SELF

GANGA DEVI BHATT

Ganga Devi Bhatt is a self-taught artist from Kondagaon in the Bastar district of Chattisgarh state. Her involvement with art practice started in 1998 when, along with a group of local women, she started working with the Mumbai artist Navjot Altaf on a project exploring the potentials of collaborative practice between contemporary urban, and Adivasi folk artists.

Along with her colleagues, Bhatt has been working in a cooperative studio environment, making work that has few, if any, formal or institutional precedents. She works in wood-carving and watercolor, alternating between monochromatic, low-relief on tree trunks and planks and effervescent, polychrome watercolors on paper. Her works on paper are frequently executed on both sides of the surface, given how difficult it has been for her to source art materials in her economic and geographical position.

At one level, her work may seem to fit in with all kinds of "outsider art," with the work of "naïve" or untutored artists, strangers to institutionalized art practice. Even more, it may be tempting to classify her work among appellations such as "primitivist" with their implications of a primal, unsophisticated innocence.

A closer look at her *Vyaktigat Itihaas (Personal History)* series however, reveals a startlingly fresh sense of color coupled with a sophisticated sense of composition and narrative. The episodes, sometimes joyous and sometimes excruciatingly painful, that she narrates are all distilled from remarkable developments in her personal life over the last few years. At the same time, these episodes speak of a changing social structure in a rural Adivasi context and the continuing dominance of patriarchal institutions. The direct imaging of personal history in art, of course, has an illustrious history. From the confessional to the fantastic, from the political to the spiritual, autobiographical forms have featured prominently in modernist art histories. In the contemporary context, it is significant that concentrating on personal specificities has become a strategic necessity for artists from marginal backgrounds. As Salman Rushdie once wrote, stories about the self become for the disenfranchised the most secure, if not the only, bedrock on which to stand and face the world.

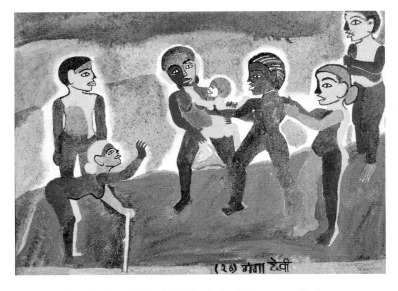 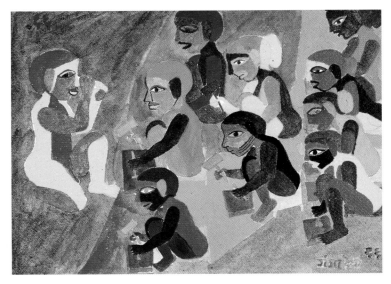

Cat. no. 6, Vyaktigat Itihaas (Personal History), *2002. Pencil and acrylic paint on paper; 28 x 38 cm*
(16 units, 2 one sided, 14 double-sided), 34 x 44 cm (framed each). Collection of the artist.

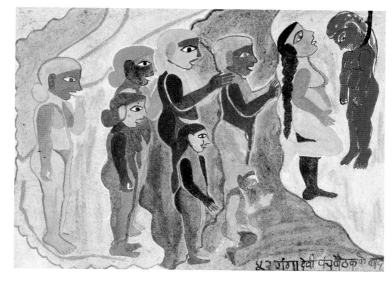

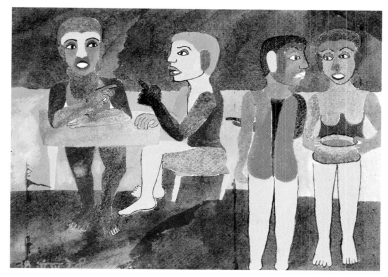

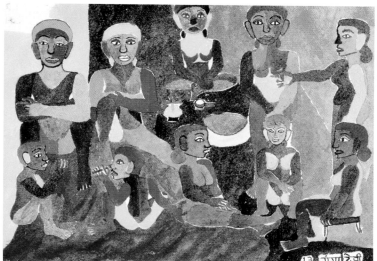

SUBODH GUPTA

Gupta's most compelling and meaningful works to date have combined a theatrical sense of scale along with a performative aspect, be it his own or the audience's, be it literal or subtly implied. . . .

Gupta's increasingly international travel and profile [in recent years] has had a dual effect on his work. First, it has increased [his] hunger to create ambitiously scaled works that communicate to his audience a sense of the enormity and complexity of India as a large country with an even larger population and an overwhelming culture which spans centuries. . . .The second effect of Gupta's travels is re-examination of his own roots within India and a re-appreciation of many things which he had before perhaps taken for granted. Much as Gandhi was able to galvanize precise historical moments and socio-political struggles around the simplest of symbols (as in his use of salt and hand-loomed cloth), Gupta has repeatedly used cows and cow-dung, steel kitchen utensils and religious iconographies in a number of ways and in a variety of settings. By so doing, his art has asked Indians to question their own society and the world to question its perceptions of India. His use of cow-dung, for instance . . . speaks of the anxious terrains inhabited by Indians within their own country and their nation's place within a globalising culture.

It is important for art to engage this process of globalisation for benefit and with dignity, so that it is not a newer form of exploitation and degradation. In the face of this Subodh Gupta has devised a strategic language through his art which can accommodate both international dialogues of forms and materials while addressing subjects of importance to his home, family and immediate community. He has found a way to speak of the local to the global and to teach the disenfranchised the language of the empowered.

Excerpted from Peter Nagy, "Subodh Gupta" in *Sidewinder,* exhibition catalogue, Kolkata: CIMA Gallery, 2002, p. 50.

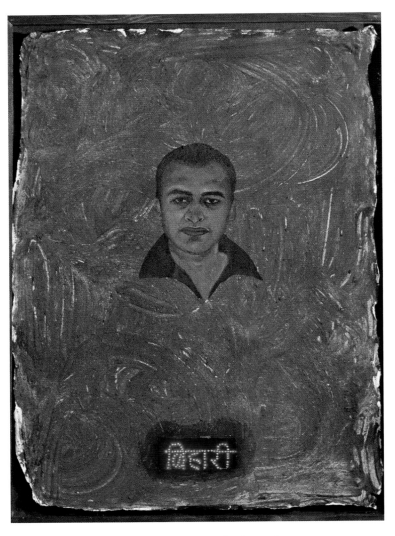

Cat. no. 7c, Bihari, 1998. Handmade paper, acrylic, cow dung in polyvinyl acetate solution, LED lights with timer and transformer; 127 x 96 x 8 cm. Private Collection.

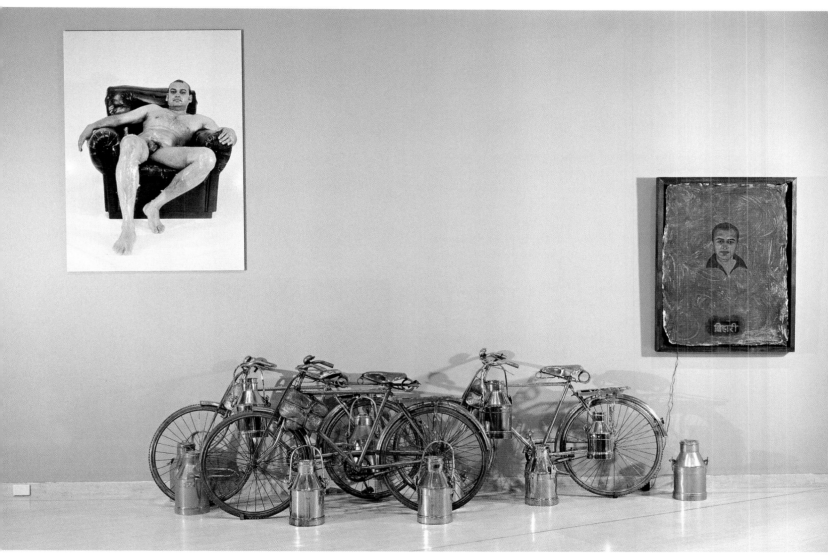

Left: Cat. no. 7a, Vilas, 2000/2003 (print). C-type photograph; 165 x 120 cm. Collection of the artist.

Middle: Cat. no. 7b, 3 Cows, 2003. Bronzed bicycles, aluminum plated milk cans; life-size.
Collection of Arani and Shumita Bose.

Right: Cat. no. 7c

TUSHAR JOAG

A few years ago I went through a predicament wondering, what business art had to exist at all, what use was it to society? I unwittingly seemed to take the blame (as middle-class morality prompts) for the failure of modernism, and thereby art in general. I could not put my finger on any redeeming aspect in the artworks that were around me, including my own. I thought art was not enough, not even if its subject matter was explicitly political—one had to aesthetize politics, not just politicize aesthetics.

After organizing numerous events in the public domain through Open Circle (an artist's initiative of which I am a founding member) over the past four years, I realized that art cannot on its own bring about societal changes—not without a political revolution. But an atmosphere conducive to such a political revolution can only be created by the questions that are raised in the ideological/cultural sphere. Art is responsible for maintaining cultural continuity as well as providing ruptures that bring a fresh outlook through its questioning of the present.

During one of Open Circle's events against communalism in 2002, I did a performance on a suburban railway station in Bombay, where I auctioned my history, in an attempt to disclaim my past, my inherited culture, and genealogy to mimic the stand of the Hindu fundamentalists. The video Phantoms is an extension of the same performance. It moves from a Bombay suburban train to an auction of my personal history. It attempts to grasp the manner in which the emotion of hate operates through some biographical instances and to understand its relationship to the politics of hate that we see surrounding us today in India.

My present work, *UNICELL Public Works Cell* http://www. unicellpwc.org, is a project under an assumed corporate identity. It creates works of art that seek to make interventions in the urban space, by designing and producing objects that are functional and aesthetic. The idea is to bring into focus through *UNICELL* the various concerns of the immediate in a satirical way.

"UNICELL undertakes works on behalf of the citizens and/or the State. It looks into matters as an entity apart from the two, i.e., it is neither a citizen's initiative nor an organ of the state, nor does either commission it. It is an independent body that identifies, studies and implements projects of its own accord."

Cat no. 8, Phantoms, 2002-2004. Mini DV transferred to DVD; 3 minutes, 30 seconds (with sound). Collection of the artist

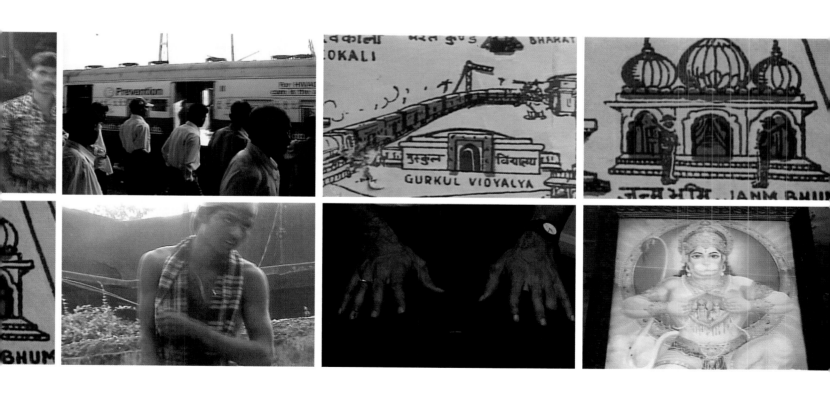

SONIA KHURANA

Bird is the first of a series of very short films that are about the enclosing nature of self-image and the inarticulateness of the body. *Bird* is shot with an often unstable hand-held camera, while in rapid, fluid movement. The "body" within the room is continually shifting, and the entire space becomes an interior for the revelations of a constantly turning body absorbed in trying to defy its limitations. The confluence and conflict of image, intent, content, and emotion perpetually circulates and creates a tragic-comic feeling.

The following excerpts come from a dialogue between the artist and Alka Pande, "Like a Bird on the Wire," *Art India*, Vol. 5, Issue 4, (2000).

Bird is to me the culmination of my recent explorations. It is about the inarticulateness of the body. It brings out most succinctly the sense of the tragic-comic that I inadvertently strive for in my work. . . . Although *Bird* is primarily about an encounter with failed flight, the unusualness of the manner of such a (naked) encounter could, in our given social scenario, easily lead to a sensationalised reading, and I'm not unaware that the self-appointed keepers of people's morality could potentially have a field day.

But *Bird* is about being a body and to express this notion, the clothes had to be left behind. Extending her attention to sexual specificity is one way by which the artist can link her concerns with the body to those of the politics of its representation. For my part, I have discreetly tried to redirect the focus by writing about the work, and through the careful juxtaposition of this work in the gallery space with works that explore similar strands. Beyond that, I have no wish to defend the work. Anyway, it has passed its test. I showed it to my mother (who is very "normal/middle class"). To my delight, she was very moved.

While most [of my] works are mainly poetic intimations that attempt to provoke the heart by leading the mind to avenues of contemplation and self-discovery, there is always a possibility for the space of the political to be laid open. The recent shifts in my own artistic, cultural, and social context have thrown some of these issues into sharp relief and called for negotiating the poetic and the political overlapping of representation.

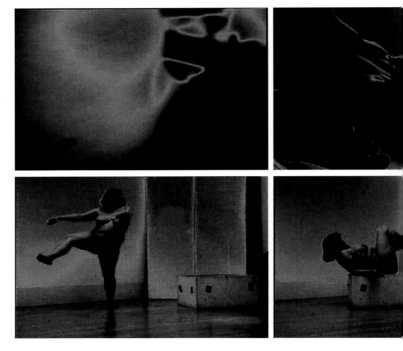

Cat. no. 9, Bird, 2000 DVD; 1 minute, 10 seconds. Collection of the artist.

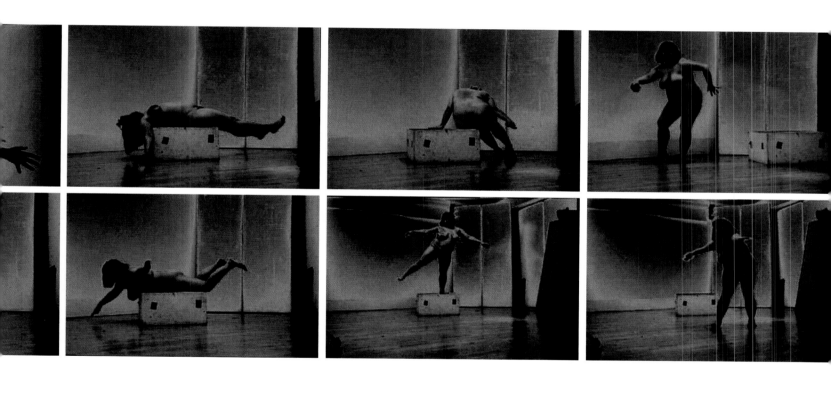

RAJ KUMAR KORAM

Raj Kumar Koram belongs to the *Raj-muria* tribe from the highlands of the Bastar District in the central Indian state of Chattisgarh. Having migrated to the outskirts of Kondagaon, he worked as a casual wage laborer before attending a training camp for local artists at the Shilpi Gram arts center in Kondagaon. Raj Kumar works across several media, though his greatest strength lies in wood carving. His work in wood comprises narrative pillars carved out of single tree-trunks. These pillars make reference to the Bastar tradition of memorial pillars, which are erected to commemorate the life of significant persons after their death. It is remarkable that Raj Kumar's pillars, though they derive their form from a funerary tradition, are autobiographical. They memorialize his own lived experience in a distinct departure from tradition.

Since 1998 his involvement in the India Foundation for the Arts project in Bastar has been vital to his career as an artist, and his work has featured in group exhibitions in Mumbai, New Delhi, Kolkata, and Ahmedabad.

[In the work of Raj Kumar] the work of a sculpture [figures] as a place for making a wish, a postcard to God.

He has been a loner since childhood, having lost his parents, and was brought up by his maternal uncle . . . carving is more than a means of earning a livelihood with him. Having discovered his talent accidentally, he joined the Handicraft Board training program at Kondagaon, extended over a period of a year and a half.

His choice of the narrative form, carved in deep relief, is highly suited to his carving skills. He uses expressive gestures, pleasing weighty forms, compressing various moments in "multiple exposure," as in cinema. Deep shadows emphasise these forms.

[Raj Kumar] is symptomatic of a new generation of craftspersons in Bastar for whom carving is a career choice, as he is not part of any traditional artisanal community.

(Excerpts from Bhanumati, "Raj Kumar," in *Modes of Parallel Practice: Ways of World Making*, Bombay: Sakshi Gallery, 1998.)

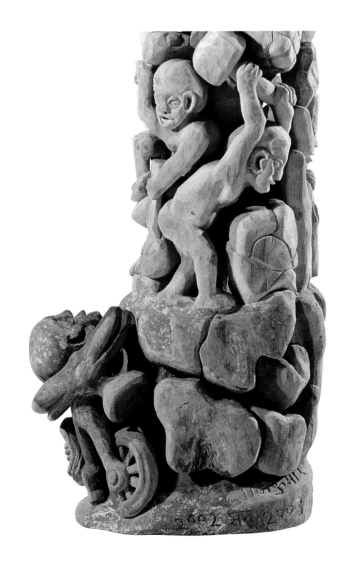

Cat. no. 10a (detail)

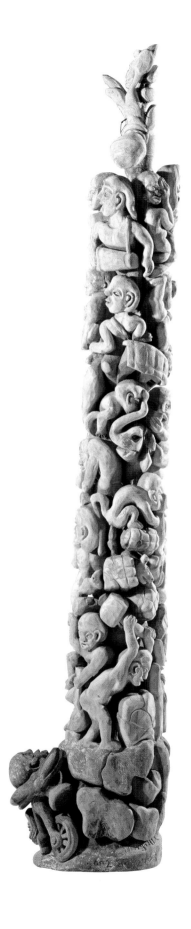

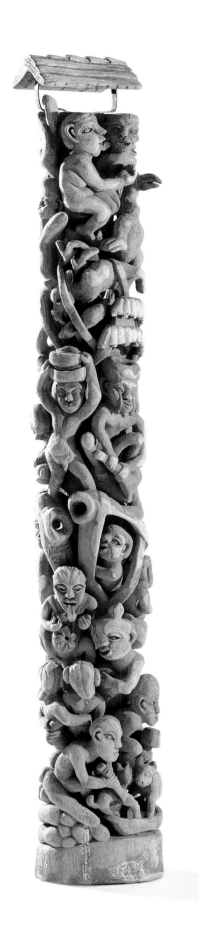

Left: Cat. no. 10a, Apne Zindagi Ka Khambha (The Pillar of My Life) I, *2002–03. Teak, iron wire, PVA, sawdust; 207 x 85 x 35 cm. Collection of the artist.*

Right: Cat. No. 10b, Apne Zindagi Ka Khambha (The Pillar of My Life) II, *2003 Teak, iron wire, PVA, sawdust; 200 x 90 x 25 cm. Collection of the artist.*

PUSHPAMALA N WITH CLARE ARNI

NATIVE WOMEN OF SOUTH INDIA~ MANNERS & CUSTOMS

"In nineteenth-century India there were "Zenana," or all women's studios, in cities like Hyderabad and Kolkata, entirely run by women photographers and technicians, where women in *purdah* could get themselves photographed. *Native Women of South India* is a performative work where we, Pushpamala, South Indian artist, and Clare Arni, British photographer who has lived most of her life in South India—one black, one white—play the protagonists in a project exploring the history of photography as a tool of ethnographic documentation. The series of photographs presents an eccentric array of "native types" by re-creating images from familiar or historical sources, ranging from the religious to the mythological to the fictional to the real. The project ironically comments on the colonial obsession with classification as well as the Indian nationalist ideal of "Unity in Diversity"—the notion of looking at ourselves as diverse peoples making up the nation—using performance and masquerade borrowed from the popular forms we see all around us, in the "costumes of India" pageants, Republic Day floats, festival tableaux, and dioramas and in the dream projections of popular studio photography.

The artifice of the posed studio photograph, with its elaborately created sets and costumes, becomes a site for fantasy to look at representations of South Indian women in the Indian imagination. The earliest image is from a sixteenth-century Deccani miniature painting of a "Yogini," a mythical sorceress who traps unwary travelers with her spirit medium, the pond heron, and the most recent one is from a 2002 newspaper photograph of two arrested chain-snatchers holding up police name slates. Playing with the notions of subject and object, the photographer and the photographed, white and black, real and fake, the baroque excess of the images subvert and overturn each other.

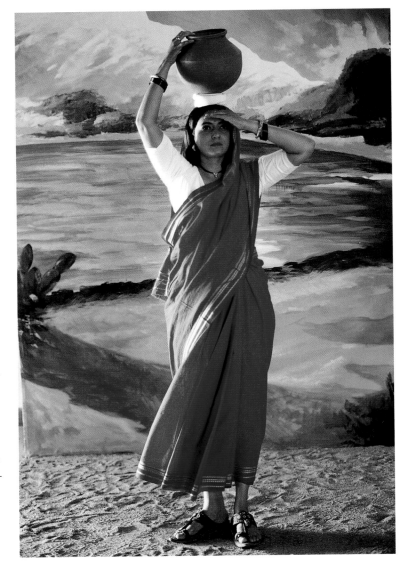

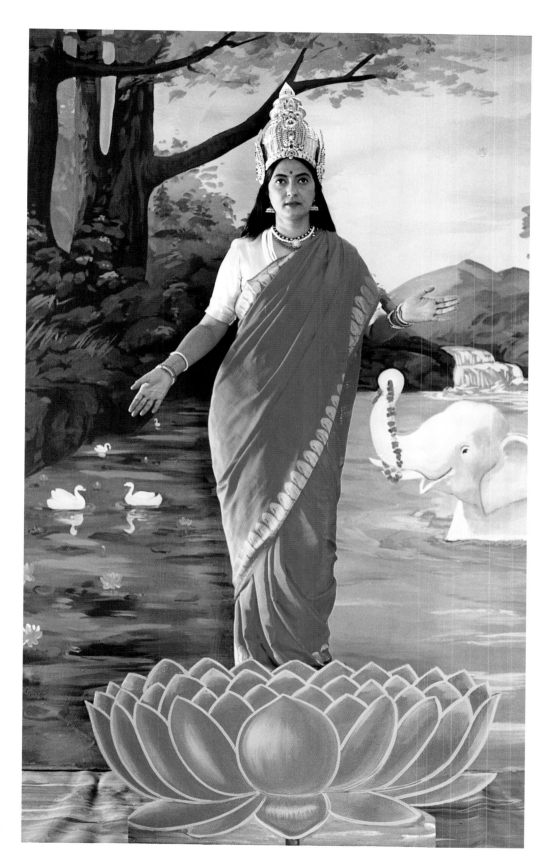

Opposite page; Cat. no. 11b, Native Women of South India: Manners and Customs: Returning from the Tank (Raja Ravi Varma), *2002–03. Manual photographic print on metallic paper (edition of 20); 70 x 57.5 cm (framed). Collection of the artists.*

This page: Cat. no. 11d, Native Women of South India: Manners and Customs: Lakshmi, *2002–03. Manual photographic print on metallic paper (edition of 20); 70 x 57.5 cm (framed). Collection of the artists.*

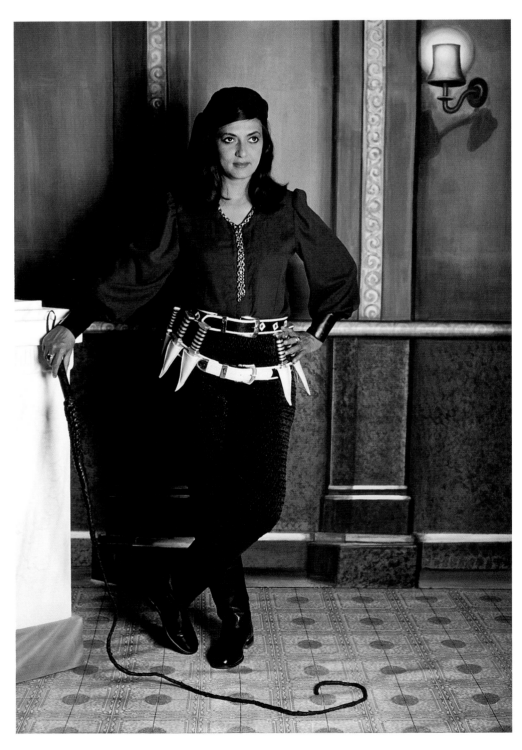

This page: Cat. no. 11a, Native Women of South India: Manners and Customs: Jayalithaa, *2002–03. Manual photographic print on metallic paper (edition of 20); 70 x 57.5cm (framed). Collection of the artists*

Opposite page: Cat. no. 11e, Native Women of South India: Manners and Customs: Toda, *2002–03. Manual photographic print on metallic paper (edition of 20); 70 x 57.5 cm (framed). Collection of the artists.*

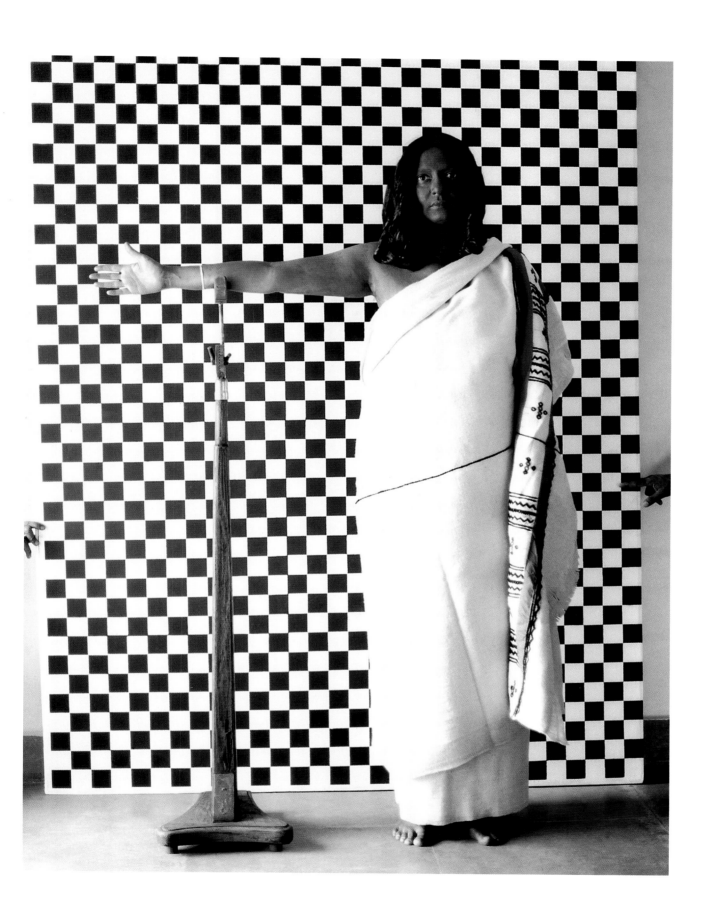

Cat. no 11i, Native Women of South India: Manners and Customs: Circus, 2002–03. *Manual photographic print on metallic paper (edition of 20); 70 x 57.5 cm (framed). Collection of the artists*

Opposite page: Cat. no. 11h, Native Women of South India: Manners and Customs: Lady in Moonlight (Raja Ravi Varma), 2002–03. *Manual photographic print on metallic paper (edition of 20); 70 x 57.5 cm (framed). Collection of the artists.*

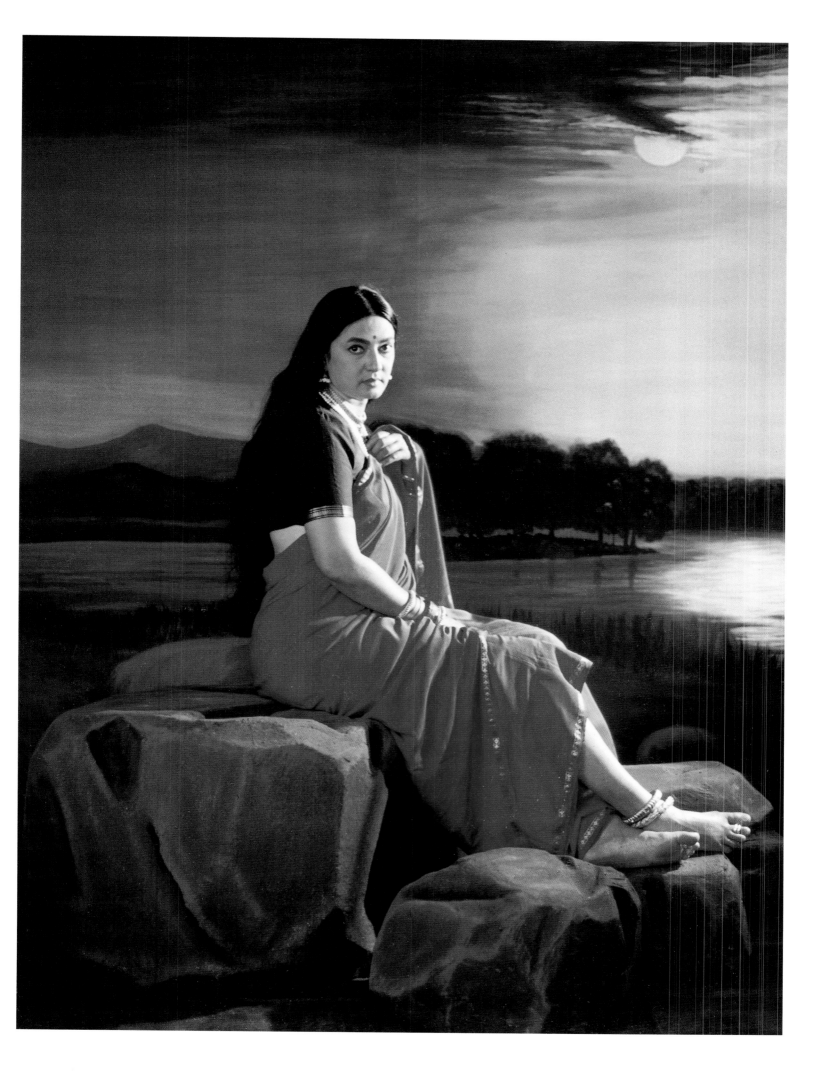

CONTESTED TERRAINS

SWARNA AND MANU CHITRAKAR

Swarna Chitrakar and her brother Manu Chitrakar belong to the community of *patuas* from the Midnapur district of West Bengal. Chitrakar, meaning maker of pictures, is a common surname used by the entire community. However, not all members of the community practice the art of scroll painting. The community was originally nomadic, each artist moving from village to village with a bundle of scrolls and offering renditions of various kinds of religious and secular narratives to patrons. In the process, the artists would also function as primary sources of news and information from different parts of the region.

Although they have not received formal training, they have learned the techniques of *pat* painting from elder artists in their community and have been making new paintings and songs based on their experience and understanding of the contemporary world. Though their work is frequently understood as "traditional," it comes across as a highly fluid and mobile practice that is able to respond to present issues with the same facility as that of other contemporary artists.

Several of their narrative scrolls have been executed for public education campaigns on behalf of local governments. This represents a continuation of the customary didactic nature of their practice, where every story offers a message along with entertainment. Other scrolls are made for the marketplace, for the purposes of generating an income. A third category of paintings is made by the artists for their own satisfaction, where they are able to give full rein to their beliefs and opinions.

Current issues in local and world politics form a major part of their oeuvre. The recent acquisition of a television set by a on the Hollywood blockbuster *Titanic*, and Manu's narrative on the war in Afghanistan, are cases in point. Ironically, television has also supplanted the artists as the primary conduit of news. It is interesting that world affairs and national politics have now started playing a larger role in their work, whereas previously, the emphasis lay on local issues like witchcraft, local politics, dowry, and crime.

Swarna and Manu continue to see themselves as reporters and seek to maintain a degree of neutrality when addressing issues like the attacks of September 11, 2001, the Iraq war, or the demolition of the Babri Mosque. For instance, rather than condemn violence, their scrolls seek to emphasize universal values such as peace and tolerance.

I would like to acknowledge Archana Hande's assistance in writing this note.

From left:

Cat. no. 12, Manu Chitrakar, Afghanistan War, 2003 Poster paint on paper; 240 x 75 cm. Collection of the artist.

Cat. no. 13a, Swarna Chitrakar, Shishu Kamya (Girl Child), 2004. Poster paint on paper; 240 x 75 cm. Collection of the artist.

Cat. no. 13b, Swarna Chitrakar, Titanic, 2003. Poster paint on paper; 240 x 75cm. Collection of the artist.

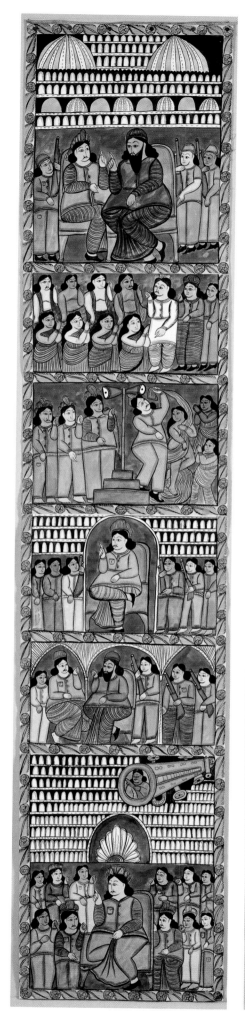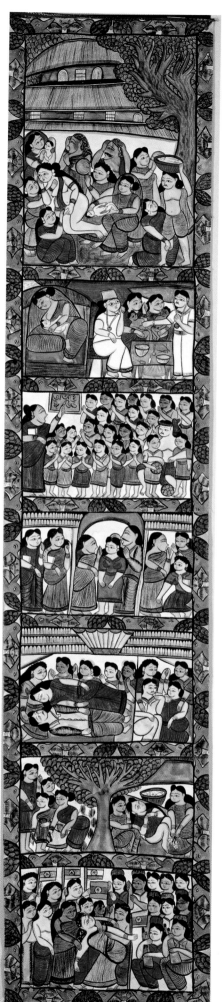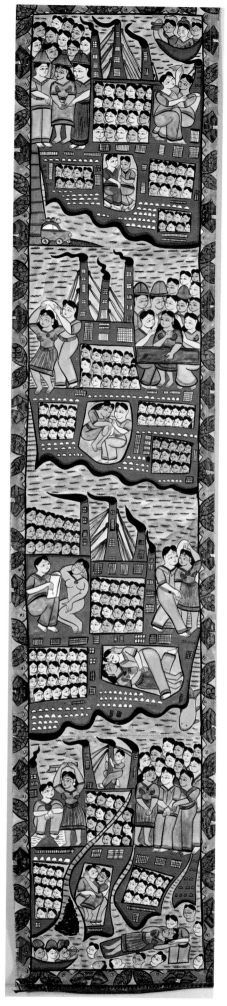

SANTOSH KUMAR DAS

This series of paintings on the Gujarat massacres of February and March 2002 came as an emotional outburst for me as I was deeply shocked by what I read in the newspapers and magazines about what was happening there. It was particularly remarkable and distressing that the riots continued for so long without the political system bothering to save the people from such a nightmare.

I followed the events as closely as I could and they triggered me to paint the images that lodged in my memory and fired my creative capacities. I was immediately struck by how it all started and then went on to assume unimaginable and awesome proportions. That is, it began with an alleged brawl with a tea-vendor at the small Godhra town railway station, to the train with Hindu activists being set on fire and consumed in flames, to a retaliatory backlash against Muslims in the form of massacres enveloping the entire state. I followed closely all the information about the events I could find in newspapers and magazines. Deeply moved and disturbed, I was inspired to paint the various episodes beginning with the burning train and the following events, but also the personal feelings and insights they precipitated in me. Although drawing on information and images from the media, the paintings are very much a personal expression of what the riots conveyed to me. The key elements that I have tried to show are:

The polarization of Hindus and Muslims that the riots and the massacres tragically consolidated.

The burning train and victims of riots and fire devouring the Gujaratis.

The rioter falsely acclaimed as a practitioner and protector of Hinduism while brandishing weapons, not to provide safety to the people, but to terrorize Muslims and demean them as inhuman.

With the Hindu Gods (Durga, Shiva, Rama) in tears, and Gandhism murdered and eliminated, Gujarat Chief Minister Narendra Modi becomes the star of a show of political shrewdness and communal violence.

Modi attacked and repudiated by the rest of India.

Yet voices in support of Modi grow in number and intensity even as peace and order in Gujarat is destroyed.

Modi becomes a local and Bharatiya Janata Party (BJP) icon despite being subject to deep criticism, curses, accusations, and attacks from numerous sources.

The tragic corruption of the sacred images of the lotus and trident, the central symbols of the Hindu gods and goddesses.

As a result of these insane and unreligious enterprises, the BJP ravages its own agenda, Hindutva, which I represent by the lotus catching fire and the trident turning fatal.

Riot victims seeking shelter and the scene at relief camps like Shah-e-Alam where enormous numbers of people still could not find safe haven from the devastation.

These are just some of the aspects that I have tried to represent through the series of paintings on Gujarat. They are spread over a set of twenty-three paintings.

Cat. no. 14a, Muslim Men Seeking Shelter from Rioters, 2003. Ink on paper; 38.1 x 55.9 cm. Ethnic Arts Foundation.

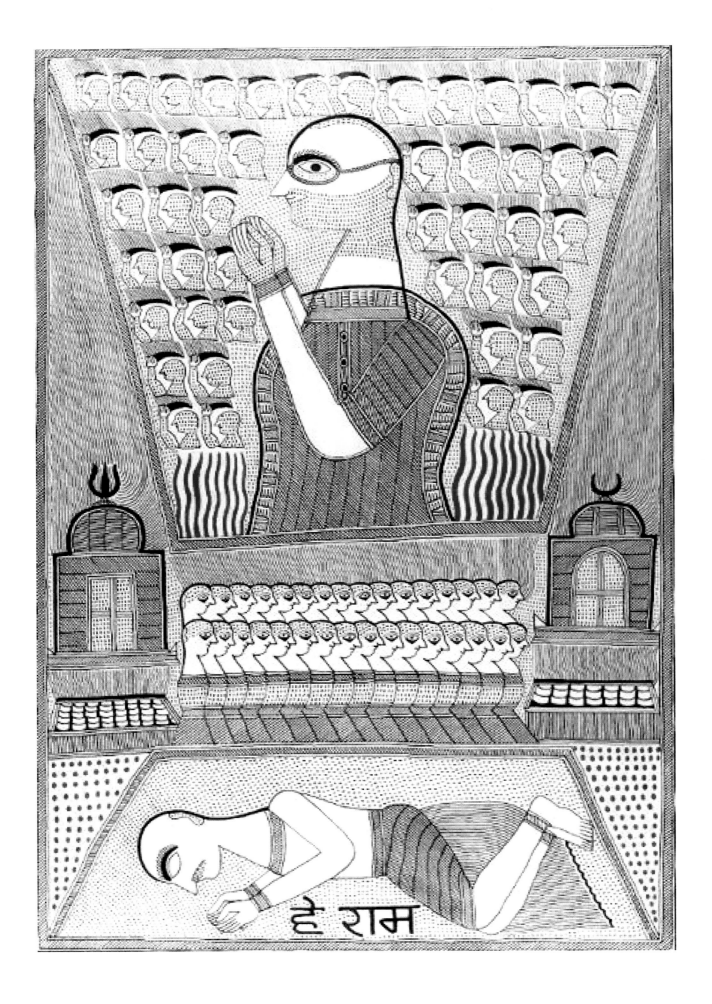

हे राम

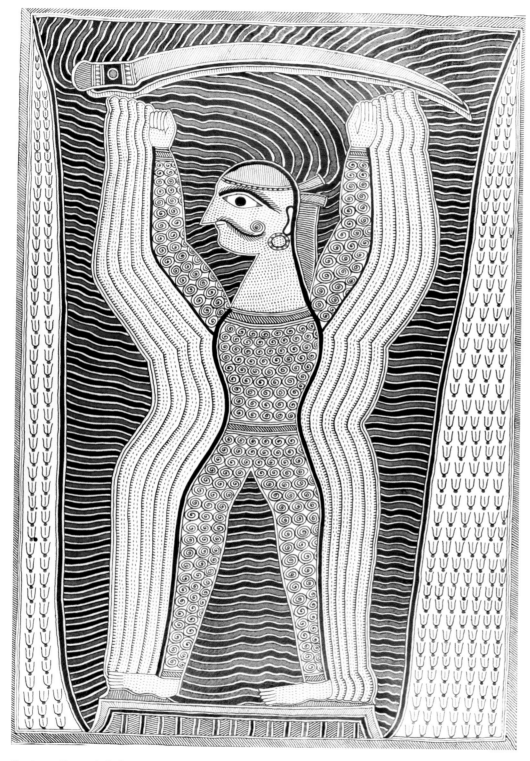

Opposite page: Cat. no. 14b, Chief Minister Narendra Modhi Inciting Religious Intolerance While Gujarat Burns and Gandhi's Death is Forgotten, *2003. Ink on paper; 38.1 x 55.9 cm.Ethnic Arts Foundation.*

This page: Cat. no. 14c, Rioter Becoming an Icon, Brandishing a Sword, *2003. Ink on paper; 38.1 x 55.9 cm. Ethnic Arts Foundation.*

SHILPA GUPTA

Shilpa Gupta's concerns as an artist have developed squarely within India's rapidly transforming economy over the last decade. Her understanding of contemporary culture and politics is filtered through the life experience of an urbanite coming to adulthood simultaneously with the beginning of the consumer and media revolution in the early 1990s.

The commodification of emotions, bodies, and relationships formed the focus of her early works executed during the late 1990s. One took the form of a glass cabinet in an art gallery, stocked with objects that denote sentimental attachments: a lock of hair, pressed flowers, declarations of syrupy sweet devotion. Viewers were exhorted to purchase one of these "memory packs" for a loved one, to save precious time. Gupta's concern with the commodification of all kinds of emotional and organic attachments has manifested in subsequent projects, including those executed in video or web-based media. Her work foregrounds the programmed and simulated nature of emotions and desires by creating new and manifestly spurious ones—which viewers are encouraged to partake of, thereby implicating them in a web of murky deals.

A major concern that runs parallel in Gupta's work is to do with the nature of bodies, subaltern, laboring, marginalized bodies, including those of women and the disabled. Her recent works have taken on overt politics, anchored in a critique of the compulsive consumption that characterizes contemporary urbanized societies. Gupta suggests to us that these acts of consumption, which we take as our sovereign right, are in effect acts of violence—such as diamonds from war-torn Angola or organs from impoverished Third World citizens desperate enough to maim themselves or others. Works such as the web-based *Diamonds and You* (2000) or the gallery-based *Your Kidney Supermarket* (2002) explicitly implicate viewers or visitors by making them participate in interactive charades of acquisition and consumption.

Gupta's recent oeuvre with her meteoric rise in an international art circuit is symptomatic not only of transformations within India but a growing interest in these transformations in First World economies. Gupta frequently poses as an insurgent in such contexts, offering provocations that challenge assumptions about public morality and civilizational ethics in economies accustomed to high levels of comfort, reminding them that their riches are born of continuing injustice.

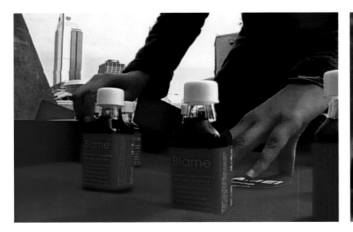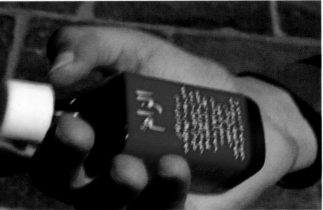

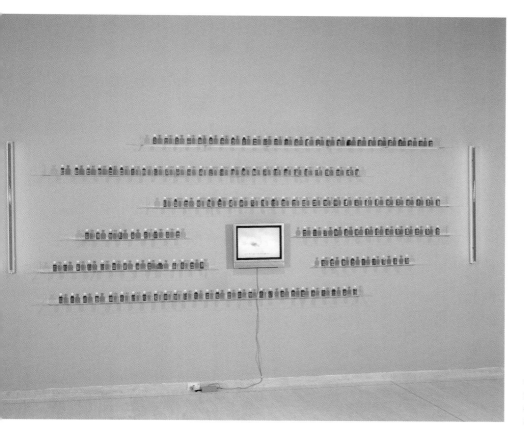

Cat. no. 15, Blame, 2003. Plastic bottles, stickers, liquid (water, sugar, food coloring, vinegar), DVD, Plexiglas shelves, fluorescent red tubes, flat screen monitor; 240 x 470 cm. Collection of the artist.

ARCHANA HANDE

I have been interested in the operations of the gaze and issues of veiling and unveiling since 1993, when I graduated from art school. Being trained as a printmaker, my initial works were mostly intaglio prints. Later I used the metal plates for my work instead of the prints, which led me to work on three-dimensional media like ceramic and wood. My current work has moved on to involve digital and inkjet prints, video, drawings, painted photographs, and textiles.

I have been traveling from one Indian city to another over the last seventeen years. The experience of different cultures, heritages, people, and reactions to India's conservative society have been major influences in my works.

As a woman in India, I have found that somebody, somewhere is always looking at you. Always being looked at is the most uncomfortable feeling, which makes you insecure and raises the question of your identity. Being a traveler, you are always conscious of your gender, and when you look around you get a sense of being stared at constantly, as though there is something on your face that needs to be wiped off. You can always feel the intrusive gaze of strangers trying to touch you and this makes your body jump with a shiver.

Having an ambiguous identity in terms of religion, language, and region, I find myself dealing with the seen and unseen, the obvious and the subtle, in my lived environment. Conservative societies wear an obvious veil around themselves. I find myself wearing the same veil but a semitransparent one, one that I seek to question. This unconscious veil has been there for centuries, hence it is never realized or questioned. Why it is there? How did it come about? How was it converted into a cultural practice? My work is an investigation of such issues.

(on screen) Cat. no. 16c, A Tale, 2003–04 Mini DVD, 40 minutes. Collection of the artist.

(on table and above) Cat. no. 16b, Story Books, 2003–04. Digital print on Arches watercolor paper, and rice paper (4 books); 14 x 31.5 cm (unfolds to 196 x 31.5 cm), 31 x 29 cm, 31.5 x 21 cm, 35 x 30 cm. Collection of the artist.

Left: Cat. no. 16a, An Epic, 2000–04 Mini DV (digital video), 27 minutes. Collection of the artist.

RUMMANA HUSSAIN

Reacting to the political climate of the country, Rummana Hussain gave up painting her earlier allegorical canvasses . . . for a more challenging conceptual approach to art.

As someone with a sense of her own epic cultural history . . . she along with many others felt traumatically violated and alienated [following the destruction of the Babri Mosque in Ayodhya on 6 December 1992]. This was a loss of innocence and a betrayal that was historical, national and deeply and individually personal. That it was akin to an orchestrated media event, anticipated and witnessed by the country on television, destroyed distancing and disbelief forever; everyone was implicated and somehow tainted.

Rummana's photographic creations, that at first seem to live somewhere between romantic shots of elegantly crumbling Moghul edifices, that are still integral parts of living cities, and her feminist…concerns featuring lower middle-class Indian women eking out their quotidian existence, nudge us to reconsider the woman-monument, internal-external, home-nation nexus. Some of these vignettes are interspersed with black and white pictures of a halved papaya and of mouths stretched in a rictus of terror. In most cases she has located a commonly shared symbolism and an easily recognised imagery; the women in the door-ways, the papaya halves and the open mouths are all images that provide a point of entry' they . . . guide us into a reading of power, sexuality, impotence, estrangement and rupture. The strength of these pictures lies in the impact of their juxtapositions: for example, the contrast between the graceful, generous arc of an Islamic archway and our knowledge of what actually happened there and can continue to happen.

We see an array of transparent office files and glass jars containing an assortment of memorabilia, odds and ends, and found material . . . a lock of hair, a needle and thread, trashy costume jewellery, a plastic comb, fifteen- year-old photographs of the artist and her baby daughter . . . all backed with printed textual matter pertaining to atrocities, rape, subversion—stock items scanned from daily newspapers.

Excerpts from Kamala Kapoor, from *Rummana Hussain: Home Nation*, exhibition catalogue, Mumbai: Gallery Chemould, 1996, p. 3.

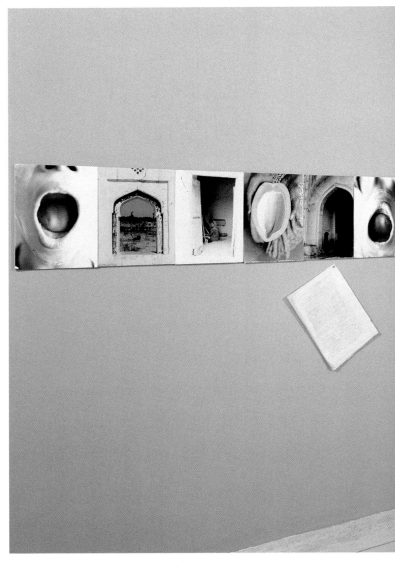

Cat. no. 17, Home Nation, *1996. Multipart installation (including wooden planks, plastic folders, photographs, glass bottles, cloth); 5.6 x 4 m. Courtesy of the Estate of Rummana Hussain.*

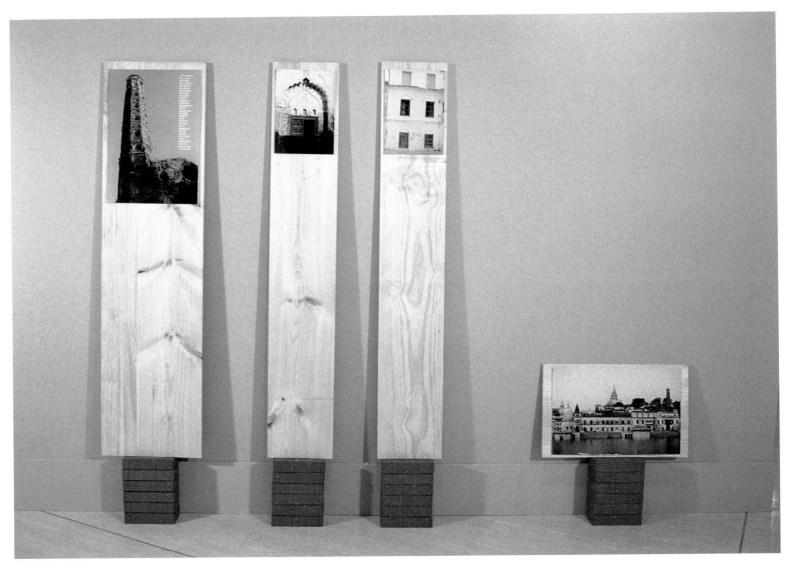

Cat. no. 17

NALINI MALANI

(From Chaitanya Sambrani, "Nalini Malani," in *Another Landscape: Life/History/Language,* Tokyo: Gallery Lunami, 1998, pp. 36–37)

There are two important preoccupations that need to be taken into account in order to understand Nalini Malani's recent work. Within the discourse of art practice, her perspective on the history of art and her consciousness of what this history has meant for the contemporary woman artist make it important for her to engage in a task of recasting tradition on her own terms. At another level, her work constantly confronts structures of material power that in our time determine the nature of the world.

Malani feels compelled to enter this circle of death, then let it impinge on her work, from there to move out and work out approaches to figuration that engage with a task of recuperation, an articulation of resistance. In this her work can be seen to constantly shift gear, to alternate between a position of being on object that receives imprints from the world and from art history, to a position of empowerment, where these imprints are interrogated, reworked, assimilated into a new structure of form that

carries within it an implicit critique of power.

Malani's work, which can be seen as an interrogation of contemporary reality, is accompanied by a devising of a visual language that would be sufficient unto the task of critical examination. This has played a fundamental role in Malani's work, resulting in a practice that operates in built-up layers of interlinked references—both within itself and with the processes of history. She, along with several of her contemporaries, has chosen to confront the possibility that the world may not after all be composed of finite and resolved entities that come together in determinate relations with definite ends. This pursuit of a post-utopian discourse of "otherness" has a special value in India, where the post-Independence foundations of contemporary art were laid along lines of a "classicised" modernism, which was intended to go along with a seamless discourse of the nation-state.

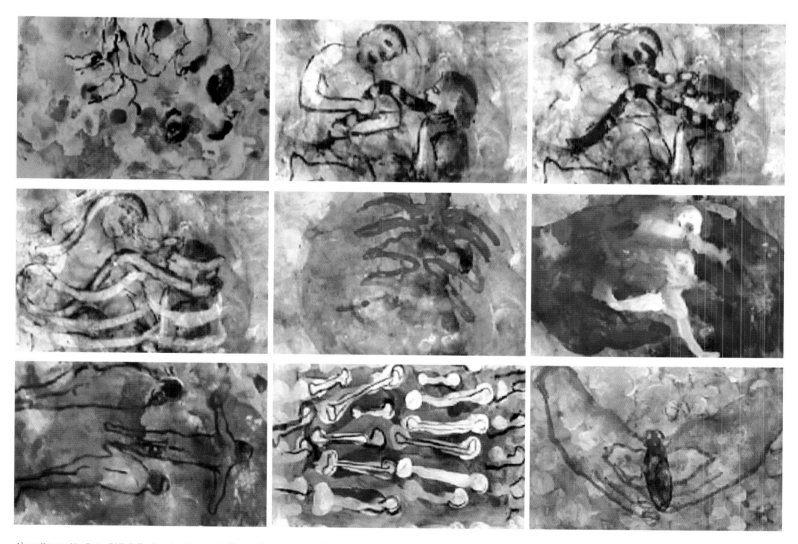

Above: Cat. no. 18c, Stains DVD Stills. Opposite: Cat. no. 18a, Unity in Diversity, 2003. Video – DVD (pal); 7 minutes, 30 seconds (with audio). Collection of the artist.

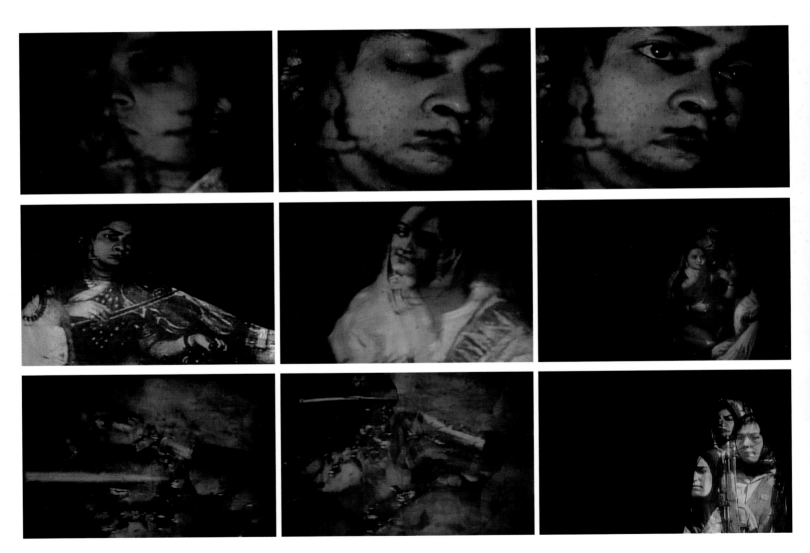

Above: Cat. no. 18b, Unity in Diversity DVD Stills.

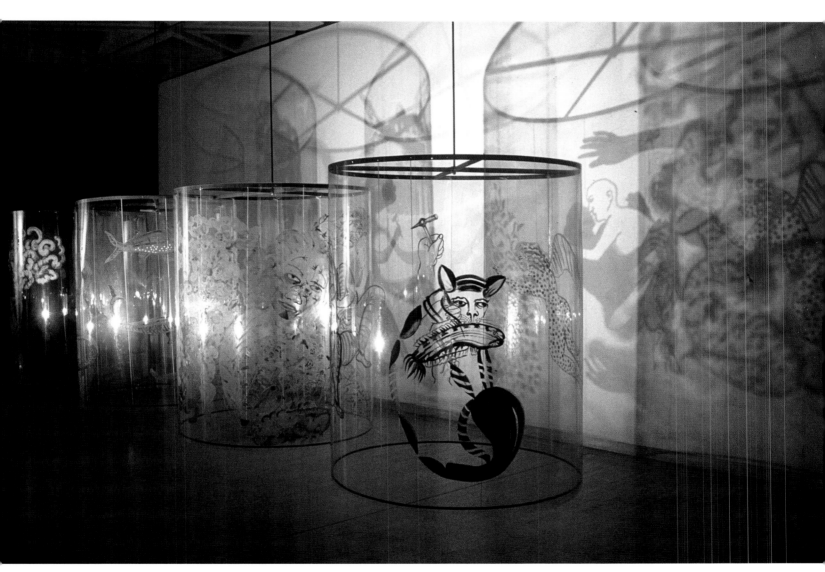

Above: Cat. no. 18a, The Sacred and the Profane, *1998. Synthetic polymer paint on Mylar, steel, nylon cord, electric motors, lights, and hardware; 3 x 5 x 11m. Collection of the Art Gallery of Western Australia.*

OPEN CIRCLE

At its inception in 1999, we of Open Circle aimed at creating a platform in Mumbai for interaction between artists at local as well as global levels, a space to share ideas of theory and praxis. We wanted to create a forum that was distinct from others entrenched in institutional discourses, or otherwise caught up in corporate and socialite compulsions.

Our first activity in October 2000 was an international workshop, seminar, and exhibition. We hoped it had distinct politics premised on identity and difference, with an exacting selection of participants and an emphasis on theoretical debate informing the art practice. The relevance of art practice in contemporary society, its connections to real life and issues made us look at other ways of engaging with art. Rather than just exchanges within art circles, we thought it was necessary to work toward broader interactions with society.

The second year saw us taking a stand that was more assertively interventionist. We worked in tandem with other organizations, carrying out public actions, protests against mammoth development projects that are dispossessing the tribal/indigenous people from their lands, their democratic rights, and their share in the so-called development. We also organized study circles that were open to the public. These were aimed at understanding economic policy and the impact it had on our markets, the closures of the textile mills, retrenchment, etc. We invited activists and professionals from various fields to present lectures, performances, and film screenings on these issues.

In recent years, odious displays of aggression, the chest thumping claims of fascist purity, and fundamentalist acts of ethnic cleansing have reduced the secular voice integral to the very definition of Indian culture to a muted whisper. In order to restore voice and visibility to the secular we launched a public campaign. We designed T-shirts and a series of stickers that were pasted on cars and in local trains, organized play readings, and film screenings. In August 2002, we conducted Reclaim Our Freedom, a hectic week of public events. The choice of venues and the genre of the works attempted to address people from all walks and strata. The events spread from galleries, to cafes, to pavements, and on to major transport hubs.

The *India Sabka* Youth Festival in December 2002, targeting college students, was conducted in collaboration with Majlis, an NGO that is active in the legal and cultural fields. Organized as a commemorative event to denounce the demolition of the Babri Mosque, it attempted to reclaim secular space and celebrate our syncretic traditions.

In 2003 Open Circle made props and objects during the antiwar rally in Mumbai, and organized open-air screenings of videos on communal harmony by artists at the Bandra Promenade in April.

Open Circle is made up orf Sharmila Samant, Archana Hande, and Tushar Joag. http://www.opencirclearts.org

Cat. no. 19, Bottle Neck Jammed,
2004.Six CDs. Collection of the artists.

N. N. RIMZON

Rimzon belongs to a generation of artists trained in the strong figurative tradition of Baroda's Faculty of Fine Arts during the early to mid-1980s, whose take on postcolonial politics was deflected into aphoristic statements generated through reference to their immediate locales. Rather than an openly confrontational Marxist-Leninist critique formulated through the language of Expressionism, which some of his colleagues gravitated toward, Rimzon continued to work in a mythical, allegorical mode.

His skill in fiberglass casting, together with a strong concern for the poetic and allusive, led to the creation of several works that made clear references to classical sculptural traditions in India. The figures in Rimzon's work often evoke the idealization and fluid grace of images of Jain Tirthankaras, of Vishnu, or the Buddha. Taking up iconographical elements from India's religious art and using them for secular purposes has been a major concern for Rimzon, making him part of a distinguished community of contemporaries.

Another major strand in Rimzon's work has to do with an existential alienation caused by (voluntary) exile. Born and initially educated in Kerala in India's south, Rimzon moved to Baroda as a student and then worked in New Delhi. The shift has not always been easy, involving linguistic and cultural displacement. This displacement was expressed in his sculptural installations and drawings in the form of a search for an inaccessible home, for security and belonging. The pared-down forms of the house, cave, or egg serve in his work as metaphors for home, with weapons such as swords providing reminders of omnipresent violence and denial. Rimzon is also one of the few contemporary academy-trained artists to have tackled the issue of caste in his work. One of his public installations made use of earthen pots, rope, and brooms, making reference to the practice that forced *dalit* untouchables to wear earthen pots around their necks to spit in and brooms behind their backs so that their footprints would be erased immediately. Such devices served to dehumanize *dalits*, to make sure that their presence did not defile the earth.

Even when his work speaks of a universal revulsion of violence—as in the work featured here—there remains the sense of alienation, of being cut off—from home, from full participation in the public sphere, from the secular values on which the nation was founded, evoking a sense of being cut adrift by a history of violence.

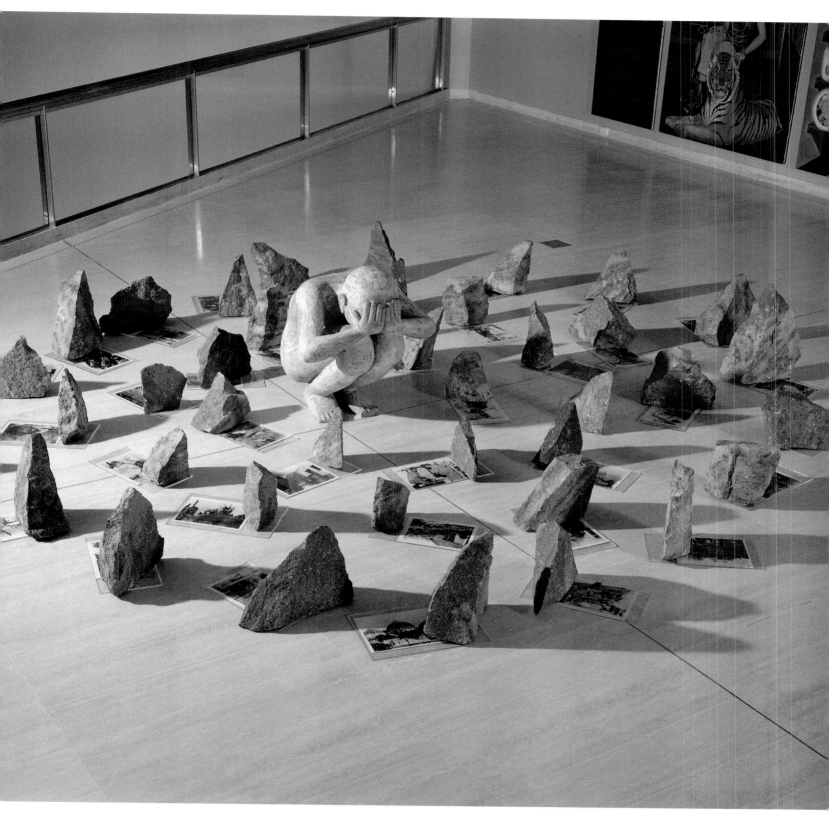

Cat. no. 20, Speaking Stones, *1998. Photographs (laminated), stones, resin fiberglass, marble dust (on figure); 90 x 500 cm (diameter). Collection of the artist.*

VIVAN SUNDARAM

Vivan Sundaram is part of the second generation of post-Independence artists, who in the 1960s and 1970s started questioning . . . the prevailing norms of art, including the abstract tendencies of the Progressives and the transcendental ones of the neo-TantricsBy the 1980s these artists had begun to freely mingle ideas, techniques, styles and periods from all over India and the world in heterogeneous cross-pollinations—largely figural and narrative—that found their focus in intense socio-political concerns even as they affirmed a strong sense of their Indian contexts and identity

Sundaram's work can be broadly divided into two phases: the painterly/narrative, from the late 1960s…to the early 1990s—and then the sculpture-installation based, for which he is now best known. [The shift in his work was] a conscious transition that had to be worked through, his choices pre-supposed a certain freedom, a flexibility, such as the shift and flow between representational image and conceptual idea, which situates his work in the open spaces of imagination.

[The] twin strands of his commitments to socio-political radicalism and artistic innovation remain intertwined in his work and in his living. This assumes particular significance in the face of the country's uncertain political climate in which the administration from time to time courts the rallying points of religion, fanning the fires of communalism (sectarianism), casteism and fundamentalism…Whether it was Memorial (1993), an installation with photograhs and sculpture, that simultaneously honoured, mourned, and informed…or his active association with SAHMAT (Safdar Hashmi Memorial Trust)—an organization that works towards maintaining secularism and unity in the country through a cultural manifesto—the integration of these twin strands…remain his life's blood.

Sundaram is not only active as an artist and as a political-cultural activist, but also as a curator, writer, and an organizer of numerous artist's (and multi-disciplinary) workshops and camps over several decades.

Excerpt from Kamala Kapoor, "Vivan Sundaram," in *Private Mythology: Contemporary Art from India*, Tokyo: Japan Foundation, 1998, pp. 102–03.

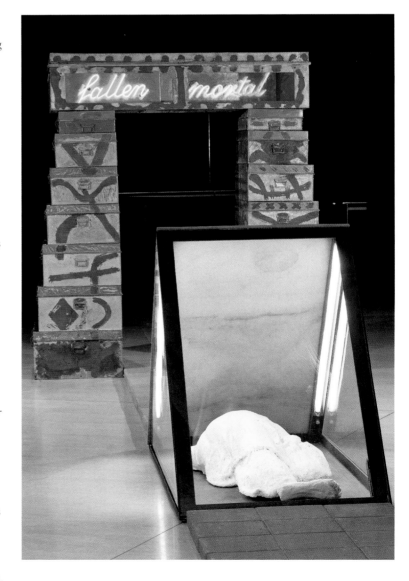

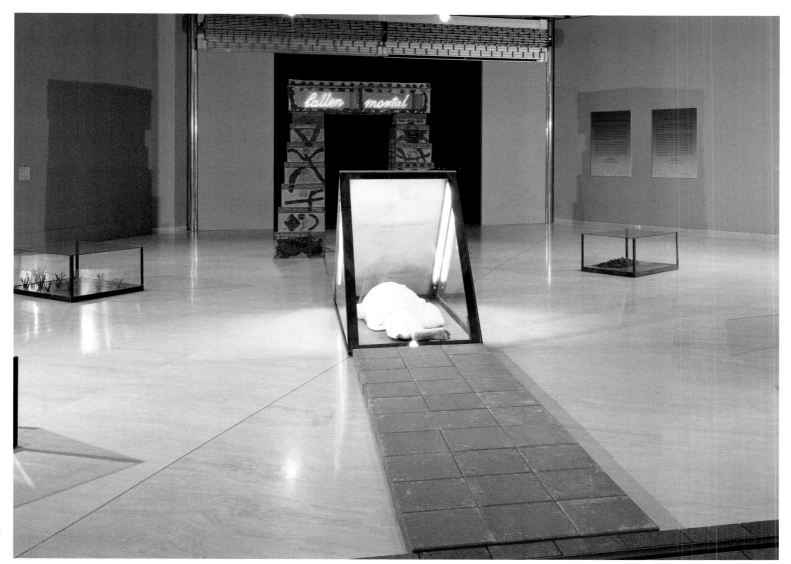

Cat. no. 21, Memorial, 1993/200. Mixed media; 18 x 10 m. Collection of the artist.

SONADHAR VISWAKARMA

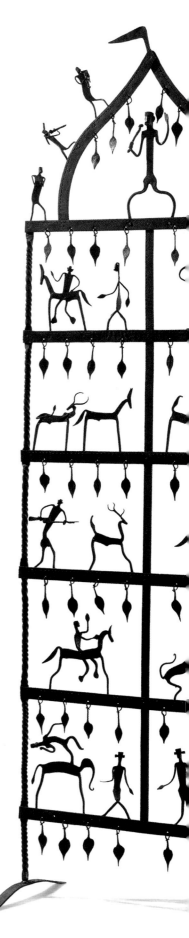

Sonadhar Viswakarma was born into a traditional *lohar* family in Bastar.
His father was a well-known iron craftsman, and Sonadhar received his
basic training within the family trade, working as an apprentice since
childhood.

Sonadhar Viswakarma is now one of the elders of his village and has
served as Sarpanch (one of a group of village elders who look after every-
day legal and social affairs), as well as having been instrumental in setting
up the Paramparik Bastar Shilpi Parivar (Bastar traditional crafts commu-
nity). He runs an open-air workshop staffed by his sons, relatives, and
apprentices, producing a large number of functional and decorative
objects for supply to urban markets.

Viswakarma's work has been shown in more than sixty group exhibi-
tions across India since 1981, mostly organized by state institutions
concerned with the development and promotion of folk and tribal crafts.
He is the recipient of a number of awards and honors bestowed by
government agencies.

The *lohars* of central India are generally classified as "traditional" or
"folk" artists, and their work is assumed to lie within the frame of a local
practice of antique vintage. It is often not recognized that by virtue of the
material and techniques they use (steel strips produced in factories,
which are heated, twisted, cut, and riveted together), their work is
peculiarly modern and has no immediate precursors in premodern
practices.

The bulk of work produced by Viswakarma's workshop consists of
"ethnic chic" objects such as metal figurines, lampstands, bed-frames,
extending sometimes to monumental open-air structures such as the
ornate six-meter-high gateway to the village he was commissioned to
make on the occasion of a politician's visit to the village. However, he
has occasionally produced work, which, while sharing in the formal
characteristics of such objects, seeks to address larger questions in
contemporary society.

Cat. no. 22, Babri Masjid – Ramjanmabhoomi, 2003–04.
Iron; 175 x 200 cm. Collection of the artist.

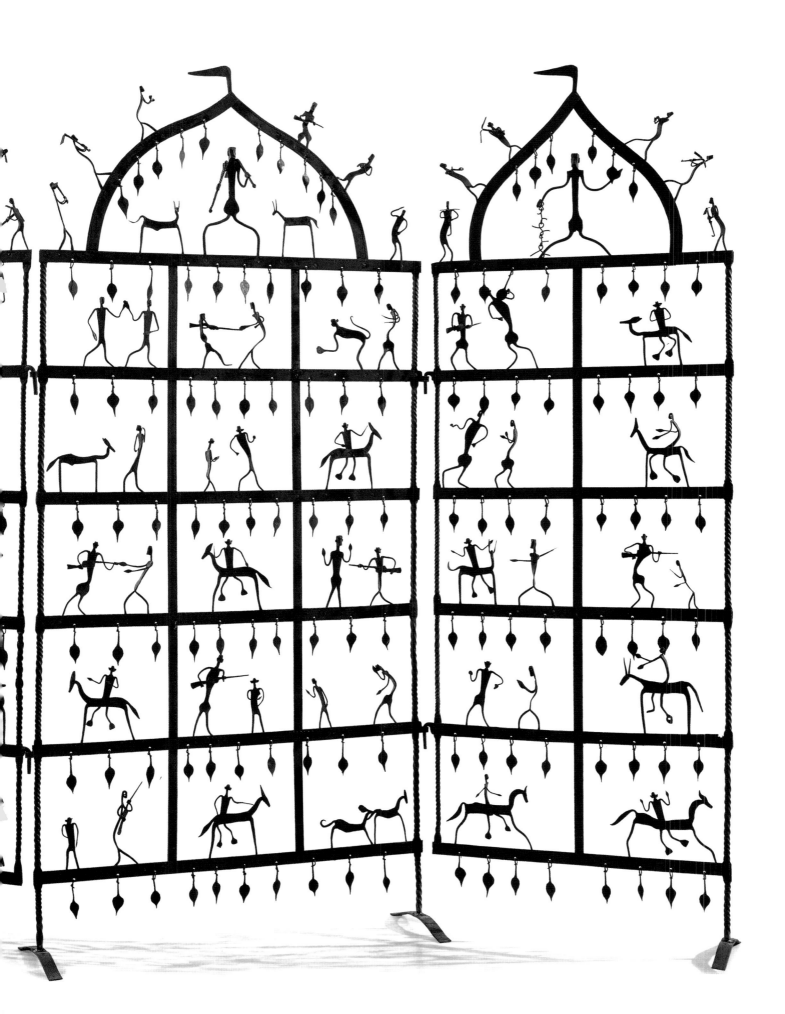

RECYCLED FUTURES

KAUSIK MUKHOPADHYAY

The city of Bombay/Mumbai plays a major role in my work—whether it is images of the larger-than-life stars of the silver screen, or the miniscule living cubicles in the tenement colonies in the suburb of Charkop. My earlier works played with the viewer's gaze—I used boxes with peepholes, mirrors, and fragments of ready-made objects inside. More recently, the objects have come out of the boxes and have become complex assemblages that the viewer can pick up and handle. My recent works are mostly made from functional objects such as toys, utensils, machines, and furniture, which have become obsolete household junk.

The city of Mumbai is also full of small workshops. The mechanics here can repair anything and recycle everything including plastic with a bare minimum of technical means. The repairing and recycling industry also transforms the objects—bicycle wheels become machine parts—there is a strange kind of creativity here. This forms another connection between the city and my work.

All my objects make sense only when peeped into, sat on, worn, toyed with, taken in hand. There is a need for some sort of participation. This reduces the distance and the burden that "seriousness" of "art" creates. It is important for me that at least it is possible to laugh at the objects, if not to love them. Once the objects lose the aura of art, it is easier to encounter them and find out what they are. Then each encounter between the objects and the viewer is a discovery. It is at that moment of discovery that the objects become meaningful to the viewer in a new and sometimes unexpected way.

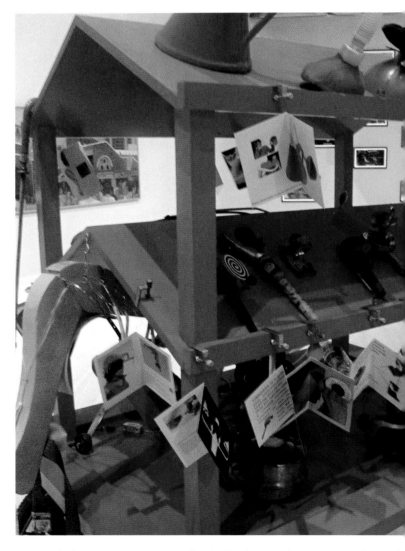

Cat. no. 23 (detail). Opposite page: Cat.no. 23, Assisted Readymades: Alternative Solutions, 2003–04. Handcart, tricycle, assemblages of discarded household objects with manuals; 180 x 306 x 92 cm. Collection of the artist.

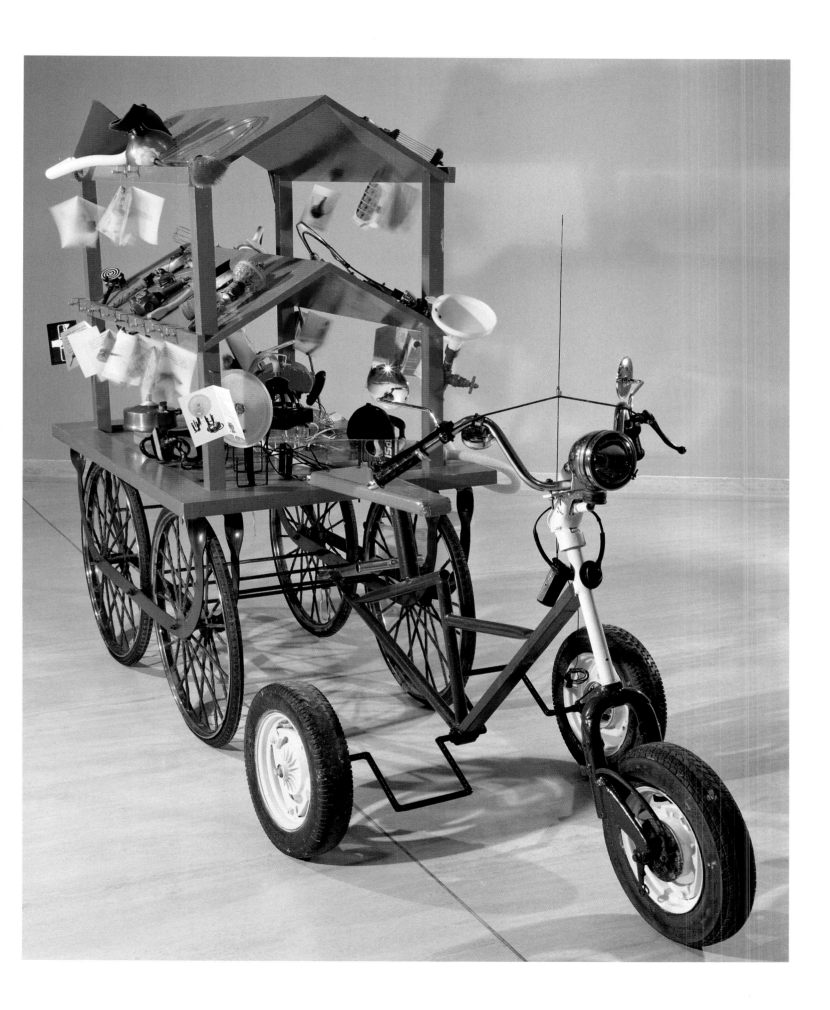

RAQS MEDIA COLLECTIVE

Raqs Media Collective and Mrityunjay Chatterjee

The Global Village Health Manual v.1 wants you to suspend conventional notions of authorship while you interact with it. Just as the artisans of the popular prints of the last two centuries often used images and motifs from the visual universe around them, so too this work gathers materials from the World Wide Web to constitute different layers and points of entry.

This is as much to bring to attention the inherent extensibility and reproducible nature of artwork in the digital domain, as it is to reclaim the knowledge-sharing imperative of early popular printmaking. This is why the frontal interface of the work evokes the form of a popular primer of public health from the nineteenth century.

In the late nineteenth century, printmaking entered the public imagination as a cheap, accessible and popular means of producing and circulating pictures, stories, information, and rumor. This was a culture that eluded censors and skirted copyright. Today, a hundred years later, a cluster of technologies centered on the computer and the Internet has made possible the birth of a new folklore of images and ideas, which, like its print ancestor, is also busy eluding censors and skirting copyright.

Pictures, stories, news, and rumor, speculations and skirmishes in info-wars, databases and image banks, hard facts and harder fictions are all streaming onto our desktops, just as cheap paper prints once piled up in our great-grandparents' closets, or crowded the walls of the cities they walked in.

The artists, coders, and writers who generated the materials that we (Raqs Media Collective and Mrityunjay Chatterjee) have used here are our co-workers in this work. In this sense, and through its bringing together of disparate materials, information and reflections on the laboring body (either enmeshed into electronic contexts, or articulated as online labor), this body of work is a work about work, especially in the new global economy of today.

Cat. no. 24, Global Village Health Manual, Version 1.0, 2000. HTML based CD. Collection of the artists.

SHARMILA SAMANT

My work is a deliberation of my immediate circumstances and surroundings.

My experiences of the corporate take over of the urban imagination, prevalent in the megalopolis of Mumbai (for one), manifest through the works I create. The projects I undertake involve collecting, documenting, and recycling of banal urban debris, looking at the mundane and the profane. I use photographs as fragments of memory (collective/personal), objects like coke bottles or crowns, export reject garments, which I manipulate to create a sense of ersatz.

My work critiques the market forces that define the cultural and art practices of peripheral nations and question how our identities, within the global set up, are sustained via a hybridization of our culture.

During work periods in Europe, where being from India I cannot escape the expectation and characterization of exoticism, I try to play interrogator of the processes of appearance. Consequently, I attempt to turn the difficulties of cultural exchange into negotiations entrenched in the specificity of an experience, by juxtaposing disparate objects in order to question readings. This creates layers of meanings reflecting my position.

Several of my projects are made for and viewed within the sterile and predictable cultural spaces of galleries and museums. However my practice itself is becoming more and more extroverted with an emphasis on co-operation/collaboration from acquaintances, friends, or even strangers.

In the past five years much of my praxis has been executed in residencies outside my geographical context, and thus deals with transition. Working within the frameworks of artist residencies, I am faced with the dichotomy of being the outsider/inside. I like to describe this as I am here now, but I am going home.

Working outside my context compels me to look for the familiar in an unfamiliar surrounding—such as multinational consumer products because of their worldwide proliferation—while simultaneously considering my own socio-cultural background in relation to local conditions of the place I am in. A connection between the artistic work and general social, economic, political, historical, geographical, or religious questions becomes an inevitable part of praxis.

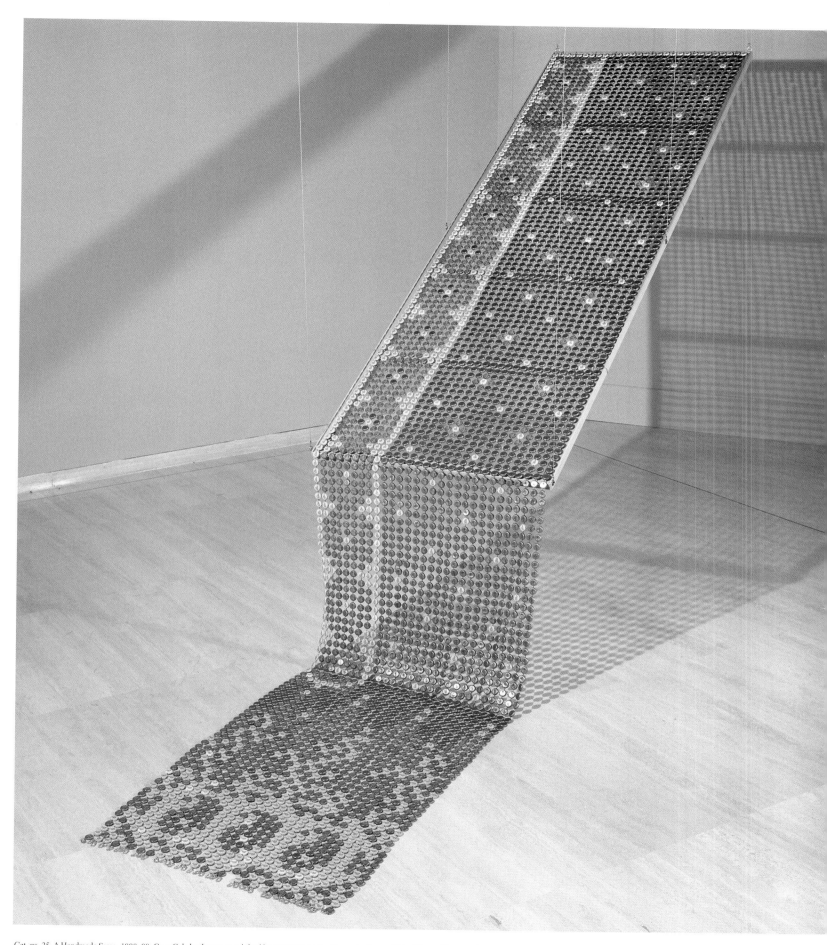

Cat. no. 25, A Handmade Saree, 1998–99. Coca-Cola bottle caps, metal shackles, computer prints with wooden frames; 550 x 120 cm, 15 x 15 cm (3 units, computer prints). Collection of the artist.

NATARAJ SHARMA

Freedom Bus started in 2000, when I was invited to the *Khoj* artists'
workshop. It was a twenty-one-day stay, and it was based in Modinagar,
which is a decayed, once-great industrial and engineering center. All us
artists, a motley group from all over the world, were picked up in a bus
from the hotel in Delhi and taken on a two-hour journey through the
north of Delhi and beyond. That bus journey was great; we all made
friends and there was such a feeling of possibilities. At *Khoj* we had the
services of good craftsmen in various mediums. One such was
Habibbhai, a crafty patrician of the old school, a master welder. One of
the thousands who had spent their working lives in the services of the
now dead industries. We got on well and the logical impulse was to make
a bus structure with welded iron. Who would the passengers be?
Obviously the same bunch of crazy artists I had just traveled with. I took
profile photographs of the artists (and of course, Habibbhai), printed
them life size, made them into cut-outs and fitted then into the bus. So
that was the first version of the bus.

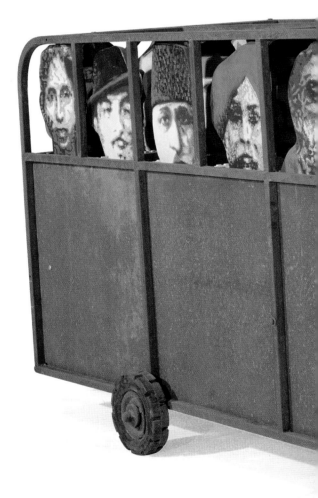

 In an insular workshop context, maybe a busload of artists (a ship of
fools) made sense. But outside it couldn't sustain its meaning. Much
later I was looking through my daughter's sixth-grade textbooks (always
fascinating for me, the way things are broken up, simplified, distorted so
that these strange seeds can be easily sown in young receptive minds). I
came across a chapter on the nationalist movement. I was fascinated at
how that whole cosmically heaving succession of events had been
condensed into two pages. It struck me immediately that these were the
new passengers of the bus and also the title of the work came jumping up
effortlessly from that textbook page—Freedom Bus (or a view from the
sixth standard). I made note of all the names of our freedom fighters
mentioned in the chapter, found that the bus could still hold two more so
added A. K. Gopalan from the Left and Sarvarkar from the Right (to
maintain the balance of the bus). I went to the Internet and downloaded
all their portraits and then painted them as cut-outs. I tried to paint them
as popular calendar painters would but found that it wasn't convincing
enough. I then realized that in the original downloaded images the pixila-
tion created an abstraction and distancing that was good. The best of
humor, the best of satire contains a core of truth.

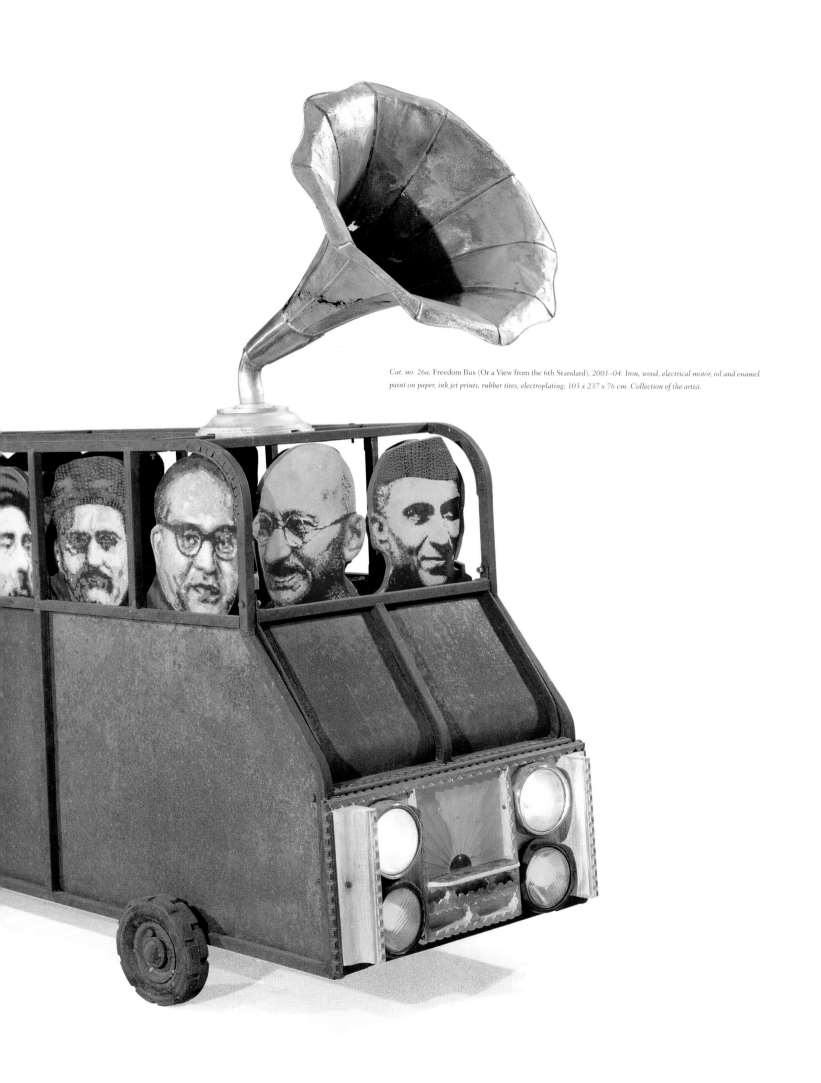

Cat. no. 26a, Freedom Bus (Or a View from the 6th Standard), 2001–04. Iron, wood, electrical motor, oil and enamel paint on paper, ink jet prints, rubber tires, electroplating; 103 x 237 x 76 cm. Collection of the artist.

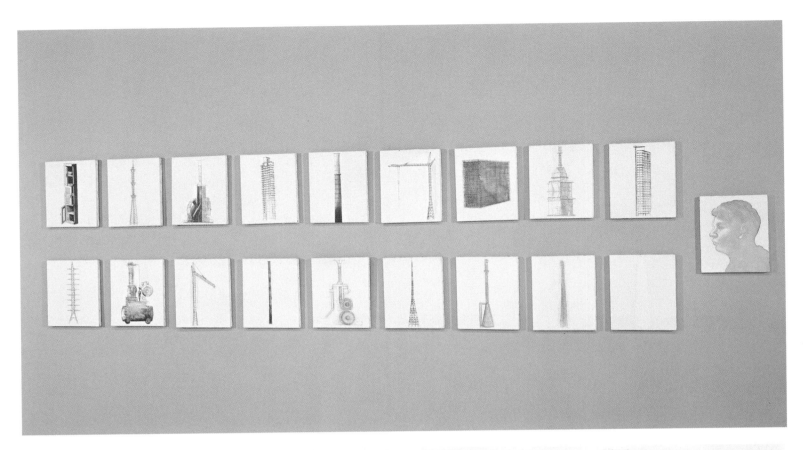

Top: Cat. no. 26b, Mumbai Structures, 2000–04. Gouache, pencil and "texture white" on canvas; 32.2 x 27.3 x 3 cm
(19 units). Collection of the artist. Bottom and opposite page: Cat. no. 26b (details).

K. G. SUBRAMANYAN

K. G. Subramanyan's paintings, so magnificently visceral and sensuously visual, celebrate both life and art. They combine the gravity of creation with the pleasure of play. He is a painter, muralist, sculptor, printmaker, writer and illustrator of books for children; a seminal thinker and influential writer on art. He has designed toys and textiles, done sets and costumes for plays, woven tapestries and made soft fibre sculptures. He has done paintings on paper, canvas, board, glass, acrylic and iron sheets; used watercolours, gouache, oil, acrylic and enamel; done painted, printed and relief murals on panels, fabrics and walls, using dyes, paint, terracotta and sand-cast cement, porcelain and metal. Long before painting was declared passé and multi-media began to be courted universally, he felt compelled to work with different materials, to mix them belying reigning purist taboos, to reach out in many ways and at many levels, and to be a polyglot in the visual arts.

The position Subramanyan takes allows him to look at antecedents divided by space, time and hierarchy—Matisse, Persian and Indian miniatures, Japanese woodcut prints, Kalighat pats, and popular glass paintings—on an even dialogic plane defined by his location rather than by a perspective view taken from somewhere else on the globe. Taking a personal locational perspective also allows him to draw upon the classical, folk and popular traditions of different kinds and lineage, without carrying imprints of their influence onto his work. He uses them as points of departure rather than as models. Each new contact with some fact of culture outside his orbit, each new centrifugal movement in turn leads to a centripetal one that adds to the core and extends it, making each rupture a new source of growth and greater resourcefulness. This makes him a remarkable exemplar of what he calls a living tradition by which he does not mean the persistence of old art forms in a changed present by engagement with a larger art language, its change and continuities.

From R. Siva Kumar, *K. G. Subramanyan: A Retrospective,* New Delhi: National Gallery of Modern Art, 2003, pp. 10–11.

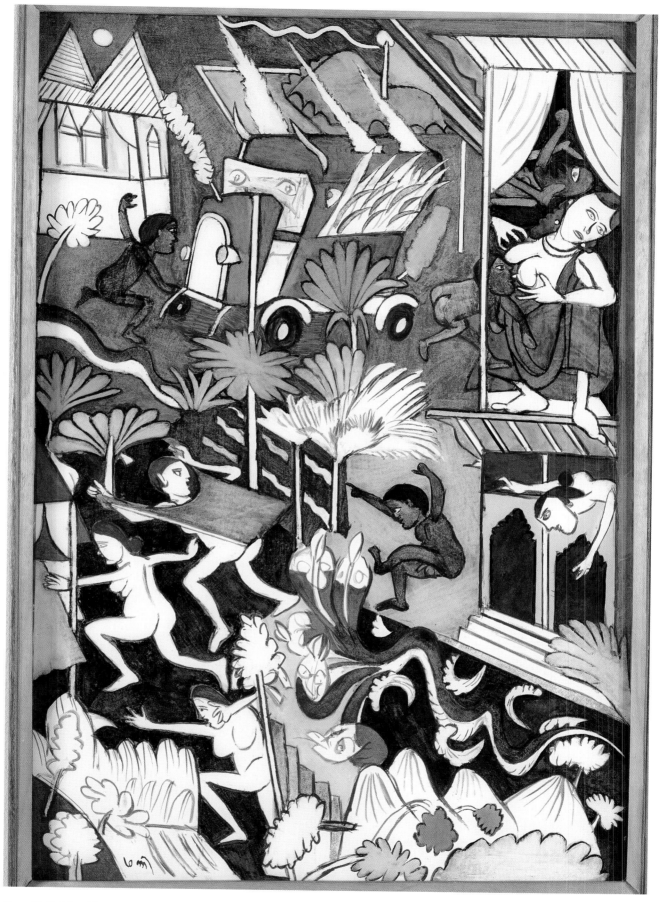

Cat. no. 27a, Black Boys Fight Demons. *94 x 63.5 cm. Collection of the National Gallery of Modern Art, Delhi.*

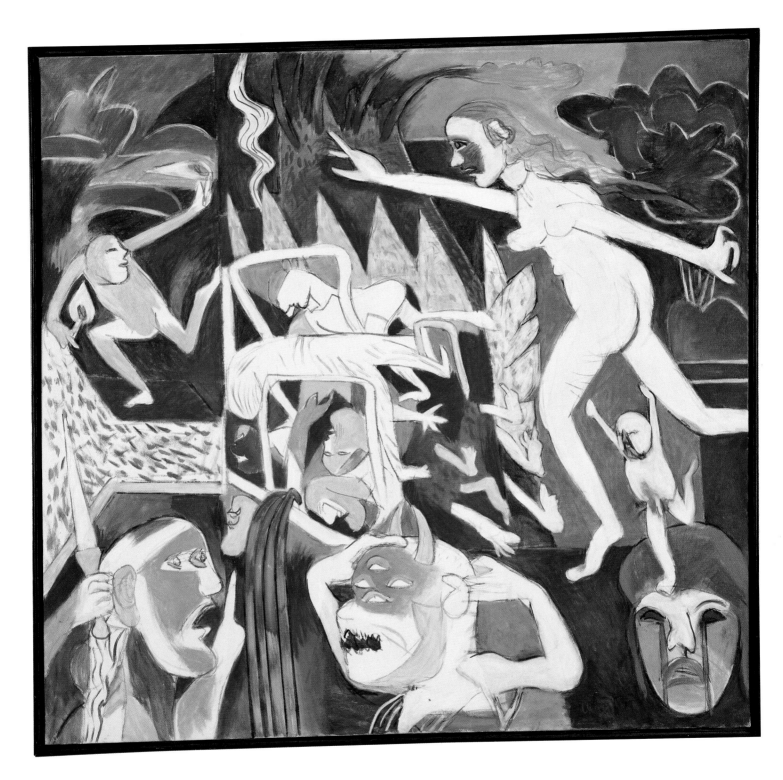

Cat. no. 27b, The City Is Not for Burning, *1993. Oil on canvas; 121.5 x 121.5 cm. Collection of the artist. Opposite page: Cat. no. 27c,* Ageless Combat 1, *1999. Acrylic reverse painting on acrylic sheet; 194 x 136 cm. Collection of the Seagull. Foundation of the Arts.*

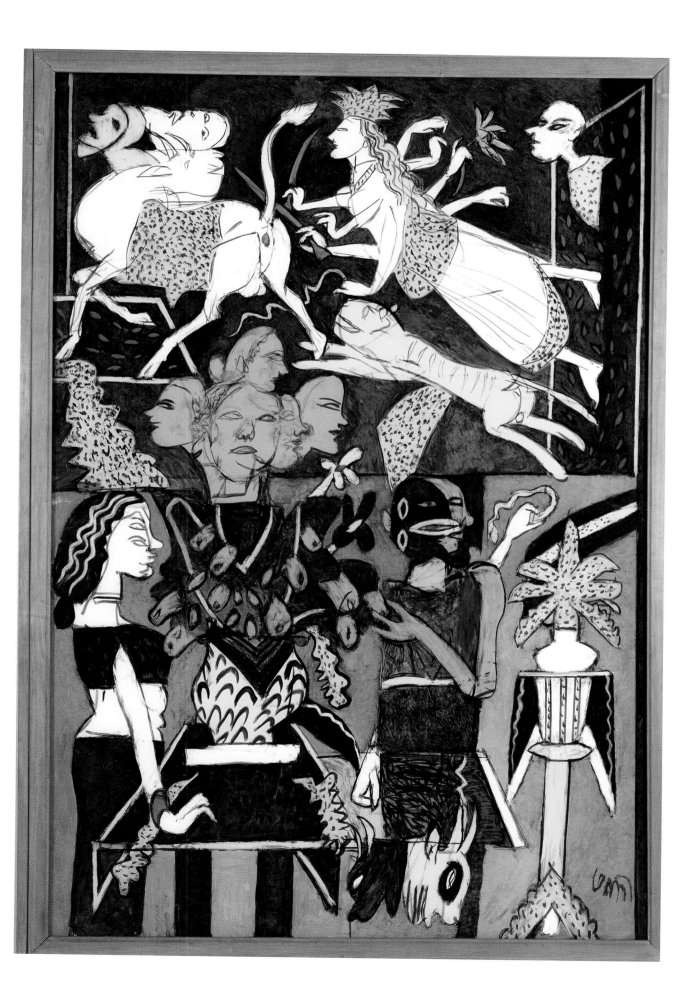

SUBHASH SINGH VYAM

Subhash Singh Vyam is a self-taught artist who lives and works in Bhopal. Born into a Gond Adivasi family in the village of Sunpuri, Vyam is related by marriage to the late Jangarh Singh Shyam, perhaps the most prominent Adivasi artist of his generation. Vyam migrated to Bhopal, which emerged as the most important center for Adivasi artists following the establishment in 1981 of the Roopankar Museum at the Bharat Bhavan arts center, under the leadership of J. Swaminathan.

Vyam's work has been seen in more than forty group exhibitions of folk and tribal art across India since 1991. Though considered a "traditional" artist, Vyam, along with his contemporaries, works in manifestly nontraditional modes such as pen and ink on paper and acrylic on canvas. Drawing on a rich vein of fabulation where animal, plant, and mechanical elements feature in brightly patterned plenitude, Vyam's work presents an important example of the inherent mobility of tradition. It is significant to his practice that the same kind of biomorphic rendering is applied to all kinds of objects and entities, human and nonhuman, organic and mechanical, sentient and insensate—as though at base, they were all made of the same kind of stuff.

Just as Vyam's practice has responded to the influence of market forces and urban materials for making art, so too have the subjects he deals with. The work featured here was executed specifically for this exhibition from a series of drawings the artist had made in response to the troubled history of technology in our times. The work, which features an organically rendered aircraft tangled among the branches of a tree, also has overtones of aircraft plunging into buildings on September 11, 2001, which Vyam recalls having seen on television.

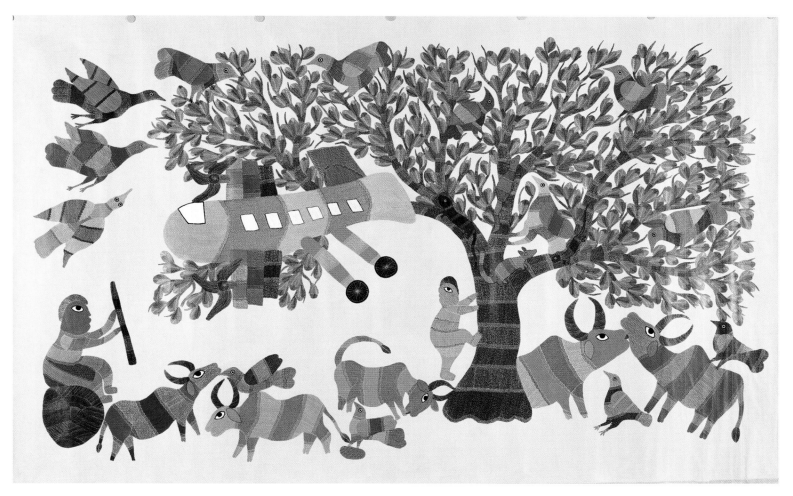

Cat. no. 28, Untitled [Plane Stuck in a Tree], 2003. Acrylic on canvas; 153 x 243 cm. Collection of the artist.

UNRULY
VISIONS

ATUL DODIYA

In recent years I have allowed all of the world to enter the loneliness of my studio. I have painted, as if, at the crossroads—where East meets West, the popular and naïve meet the high classical or the very personal, autobiographical image overlaps the universal icon.

From these apparently anarchic hybrids I hope to understand the nature of creativity.

Creativity earlier meant that I was a link in a long chain of art-makers from the ancient to the postmodern. The inclinations and obsessions have moved. Almost dramatically the earth has shifted beneath my feet. As my notions of security and beauty have changed, a deluge of images has hit me. Living in a nation seeped in poverty maybe it is unavoidable. Death, decay, corruption, compromise, struggle are not distant metaphors of the fall of man. These are real, right here, lived with. Metallic omnipresence. Metal as a roller-shutter-guard to a shop. Opening/closing it is a symbol of the daily grind. Time passing by, the cruel industrial sounds, the lonely laborer, the glamour and glitz of the city.

The city for me is the chief inspiration. The overlapping contradictory images, which I paint, are born here. Constant contradiction is truth. Image of the earth shifting beneath one's feet perpetually.

Gandhi's absence manifests itself in the different mounds of ruin—the political mess, the hypocrisy, and deceit of the individual. In the national playground we are all sliding down. As an armless, helpless individual I have made an archive of our citizens' sleeves. Crafting wings from chopped arms is the prerogative of a despairing artist-citizen. Rogier van der Weyden and Picasso could paint tears. I can only go about circumambulating ladders, sliding down, looking up, knocking against skulls and bellies. In the final countdown it is all skulls and bellies.

Cat. no. 29, Tomb's Day, 2001. Enamel paint, varnish on laminate; 191 x 129 cm (framed, each panel). Collection of the National Gallery of Modern Art, Mumbai.

RANBIR KALEKA

When I use video I do not set out to do something that could be described as "video art." I have been interested in cinema. That's the medium that I have been familiar with. I know that meaning can be created through cinematic forms. And then I find video accessible. So while I use the tools that are available to me, my interests remain the same.

I am interested in using light to create an image and in watching what the aura of an image created through light is. It is quite different from the aura of a painted image. Even a photographed image, which is created by using light, has a different presence. Using something like holograms for a greater presence of an object, or a different kind of presence of an object, that would interest me. Not so much that it's a development in scientific terms. That's also fascinating. I would always like to follow it up. But only because it will allow me to reach areas of meaning which for me do not seem to be accessible through the painted image, or the photographed image, or the video image.

I don't think that using a new medium or using technology in my work has greatly shifted what I have always been interested in. Most of my earlier paintings consisted of interiors. It took me a long time to venture out of that interior, where I introduced the landscape. But that landscape also in many ways is like a large and closed space. That space does interest me. Again as a space of an event, and that's a psychological event. And the actual happening of the event, when art happens, that happens outside of the frame. …There are indications, there are gestures, there is a trajectory from the eye traveling from one point to the other. But if we need to experience what is happening, then we have to close our eyes and let the event happen.

[Edited excerpts from a conversation between the artist and the curators Michael Wörgötter and Angelika Fitz. From *Capital and Karma: Recent Positions in Indian Art,* Hatje Cantz Verlag, 2002, pp. 151–56.]

Cat. no. 30, Windows (Stills).

RAVI KUMAR KASHI

As an artist I see myself as a witness to my times. I am as much a witness to my times as to the ways it is being "re-presented" in the media, and to the visual culture around me.

I often collect interesting photos, image clippings, discarded objects, headlines, quotations, and the like. I suppose one can think of me as a visual scavenger. This becomes a bank/source of imagery when I start working. I also have a diary, where I keep jotting down ideas with visuals and text, which becomes a starting point and triggers my work. From that stage it takes off and grows organically.

In my work, not a single image has been either drawn or painted directly, as if to say I refuse to see first hand. Everything comes filtered through a secondary source, resulting in the construction of a secondary reality. Something curious happens in this filtration process. The mass-media projects objects, people, and experiences with a certain "tinge." This "tinge" is carried over to my work because of my scavenging.

The format/experience of my work is akin to watching TV. Think of a wall of televisions in a store, each tuned to a different channel. Hundreds of images are all talking at the same time, in a hyper-textual visual narrative.

While scanning through the channels we come across various images, incidents, but by habit we watch each channel in isolation: the advertisement for a tooth gel as separate from the image of terrorist killings, which one saw a moment ago on a news/documentary channel. When this flow is seen as a continuous stream of images, the associations and the contradictions that arise are mind-blowing. Fiction, news, documentary, and reality all get mixed up. The violence, blood, and gore one saw a moment ago in a Hollywood action movie start shifting over to the news channel as you watch the daily news. Many of the villains in movies are so well dressed that they could be modeling clothes. Meanwhile, you are enticed to spend, consume, and be happy; there is nothing wrong with this world, after all!

Cat. no. 31 (detail). Opposite: Cat. No. 31, Everything Happens Twice, *200–04. 100% cotton rag acid-free paper, gauze cloth, photocopy transfer and acrylic lettering, stamps, polyvinyl acetate glue; 158 x 220 x 2.5 cm (overall, 9 units, each unit 40 x 60 cm). Collection of Peter Mueller.*

MALLIKARJUN KATAKOL

I grew up seeing paintings on auto-rickshaws and horse carts (*tonga*) in Mysore. Later, at art school, it was interesting to see how these reflected our present time when modern Indian art was struggling for an identity. In the 1980s Mysore had painted *tongas* and bullock carts. Reflecting the princely state's charm, these paintings were very similar to landscapes rendered in miniature styles. These quickly disappeared as technology changed.

Though I cannot say it directly affected my work as a professional photographer, this kind of art and craft certainly exists around us and surely influences popular image-making in India. Seeing the *tonga* paintings disappearing in Mysore, I wondered how much urban pressure they could take. These paintings were somehow an integral part of that city. But seeing them on auto-rickshaws in Bangalore in a more urban, technological scenario was much more striking; they spoke of how we carry these values in popular visual culture. And at the same time I felt that there was a common thread between these paintings, Company

School paintings (hybrid colonial imagery from the nineteenth century), Indian cinema posters, hoardings, and backdrops and sets from itinerant theater companies.

One of the reasons I photographed this art is that it captures a particular time in history that I feel I am part of. I also felt these mobile paintings needed preservation and wider exposure. At the time I started taking photographs of rickshaw paintings in 1995, I saw my photographs purely as documentation. I did not realize that they could play a role in projecting a socio-cultural aspect of contemporary India. For me, it was a great insight to speak to rickshaw drivers and painters and to find how they would use their painted vehicles to project their ideas and dreams. As I asked for their permission to photograph their vehicles, most drivers and painters were more than happy to exhibit their work. The work often resulted from a collaboration between the driver and painter, the painter lending his skills to realize the driver's ideas.

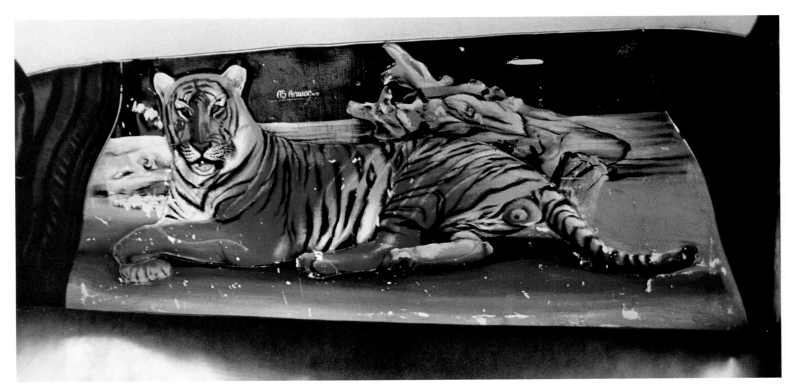

Cat. no. 32, Auto Art Series (1-16), 1995–96 (printed 2003). C-type photographic prints; 30 x 50 cm, 50 x 30 cm,
40 x 60 cm, 50 x 60 cm. Collection of the artist. Opposite and following pages: Cat. no. 32 (details).

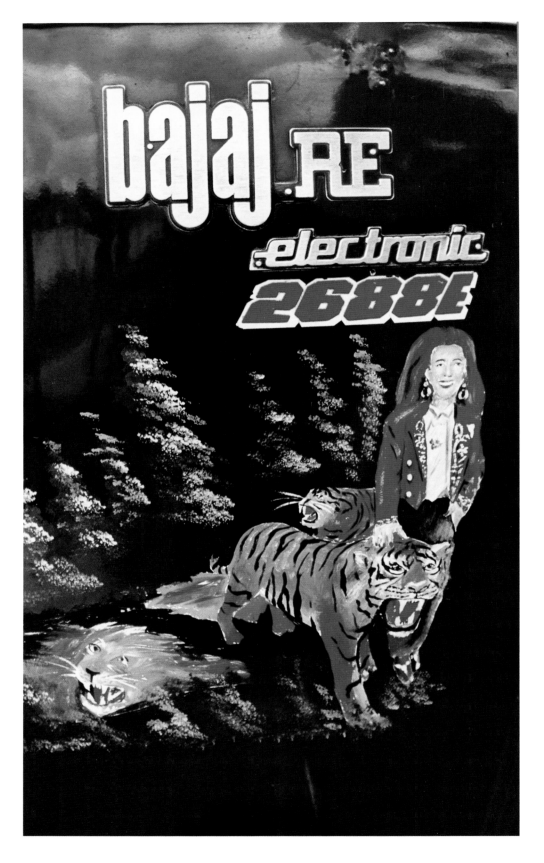

SURENDRAN NAIR

Surendran Nair belongs to a generation of artists who as they started working in the early 1980s, found themselves engaged with a politically hinged representation of their environment, an interpretation of the world that was simultaneously an interrogation. Like many Indians, Nair in his childhood imbibed a rich storehouse of mythical and magical narratives. This storehouse came into interaction with a political understanding of the world in his years at art school at Trivandrum and Baroda. The imagery of religion has assumed overtones of disquiet due to its appropriation within the rhetoric of fundamentalism. Rather than choose a state of disaffection with this imagery in the pursuit of a secular ideal, it becomes relevant for Nair to focus on the discomfort that the religious image occasions. For him, to focus on this discomfort is also to reappropriate the religious image into the ambit of the creative imagination. Pushing at the limits of iconography, he seeks to resist the ossification of this imagery into a restricted regime of True Icons. …

This however is not to imply that Nair is working on an expressly formulated program of reclaiming the icon. Rather, it is significant that the motivations to his practice come from the tremendous attraction that the exquisitely modelled image has to his eyes; an attraction that goes together with an awareness of the way these images have become disputed locations. Not motivated by belief, but by an almost hedonistic engagement with the sensual and poetic potentials of iconic images, he shares an ambivalent relationship with his material, its aesthetic seduction matched by the unease occasioned by its use. His effort to strike up a relation with this imagery takes place in the arena of 'play', in the sense that it hinges on the latent lack of fixity that the image as a signifying unit has.

From Chaitanya Sambrani, "Surendran Nair: Of Iconicity and Truth," *Beyond the Future: The Third Asia-Pacific Triennial of Contemporary Art,* Brisbane: Queensland Art Gallery, 1999, p. 54.

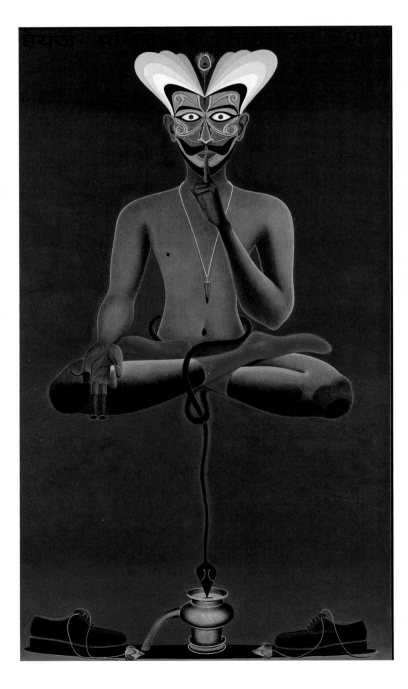

Opposite page: Cat. no. 33a, Mephistopheles....Otherwise, the Quaquaversal Prolix (Cuckoonebulopolis), *2003. Oil on canvas; 210 x 120cm. Collection of Usha Mirchandani, The Fine Art Resource, Bombay. Above and following pages:*
Cat. no. 33b, Precision Theatre of the Heavenly Shepherds, *2002–03. Watercolor on paper; 65 x 50.5 cm. Collection of Nitin Bhayana.*

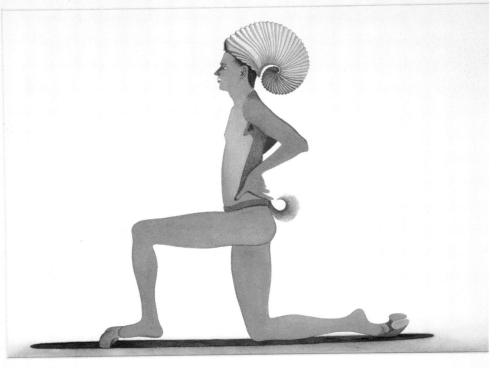

Top: Scorpio; above left: Aquarius; above right: Aries

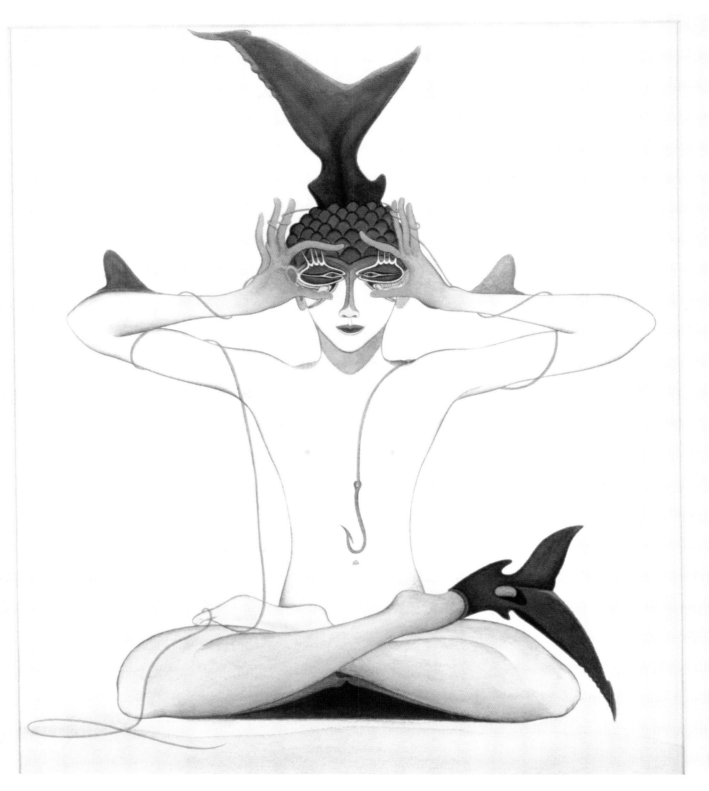

Pisces

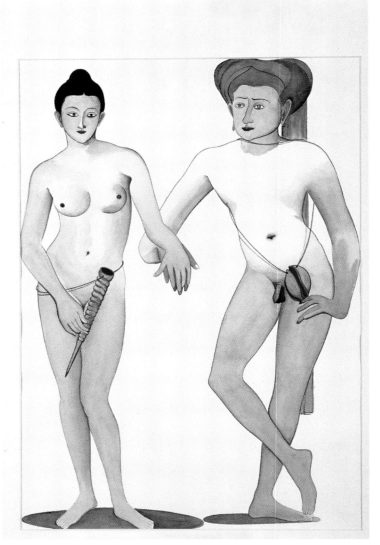

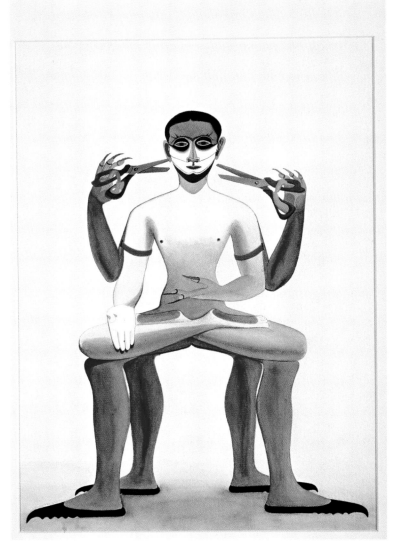

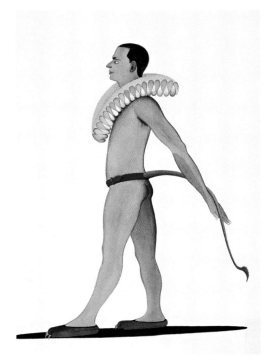

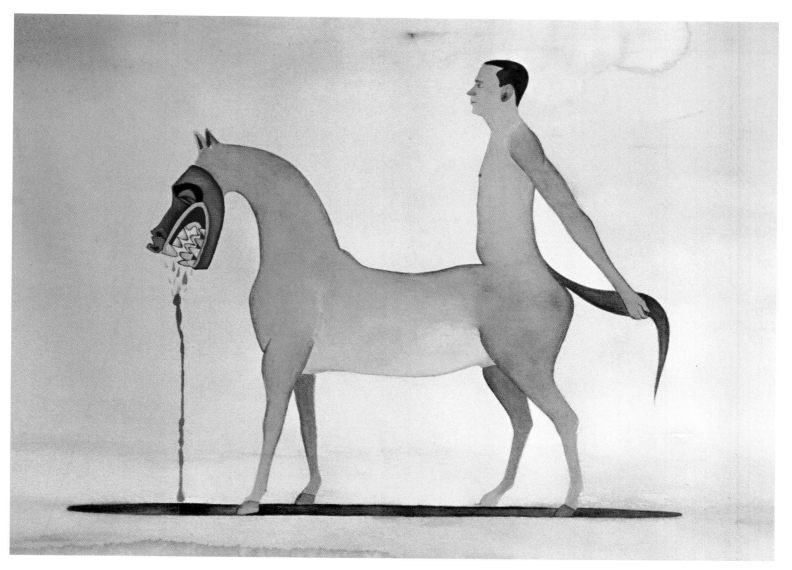

Sagittarius

OPPOSITE PAGE

Top right: Gemini; *top left:* Cancer; *below left:* Leo;
below middle: Virgo: *below right:* Libra

Scorpio

CYRUS OSHIDAR

Cyrus Oshidar is vice president, creative and content, at MTV India, where he has worked since 1997. Together with his team, Oshidar is responsible for the image of this free-to-air television channel, which has played a significant role in the reinvention of urban youth culture in globalizing India. The team's work is marked by wacky humor, irreverent commentary on contemporary life, and an anarchic fusion of the cosmopolitan and the vernacular. The local and the international, the crude and the sophisticated, Bollywood and Hollywood, street culture and religious imagery, all figure in their programming strategy.

"MTV is many things to many people and it is many things to me. It's transcended a brand, when you think of music television you think of MTV. It's gone beyond that. It has become an adjective for strange humor. It's become another word for wacky. It's become a category, a descriptive for a kind of communication, and a description of a generation. In a sense it's a compliment, tremendous burden, and responsibility.

A lot of our work is exported…the VJ hunt was created here and is being exported. About ten of our promos are being exported globally. The *Lift Man* is running in Germany, Russia, France, the [United] States, and Latin America…*The Chai boy, Malishwala, Gaseous Clay* [were] running in Germany for a while with subtitles.

We are much more than a music channel. MTV means music television but our demographic is young people. We do whatever it takes to reach young people…MTV…is the spirit of young people, it is the opportunity to speak up…and sometimes [to] shout. It has the ability to impact people with…pro-social stuff like [our] AIDS [campaigns]."

Edited excerpts from an interview with Trupti Ghag, indiatelevision.com, September 2003.

Above and following pages: Cat. no. 34 (DVD stills).

Cat. no. 34, Video-Filler Compilation. DVD, cigarette/small goods stall roadside shop (complete), wooden bench, television monitors; duration 30 minutes (approx) ; installation: 240 x 126 x 187 cm. Collection of MTV India.

GULAMMOHAMMED SHEIKH

(Statement by the artist, catalogue, *Place for People*, Bombay and New Delhi, 1981.) Among Several Cultures and Times

"Living in India means living simultaneously in several cultures and times. One often walks into "medieval situations," and runs into "primitive" people. The past exists as a living entity alongside the present, each illuminating and sustaining the other.

As times and cultures converge, the citadels of purism explode. Traditional and modern, private and public, the inside and outside continually telescope and reunite. The kaleidoscopic flux of images engages me to construe structures in the process of being created. Like the many-eyed and many-armed archetype of an Indian child, soiled with multiple visions, I draw my energy from the source."

(From Chaitanya Sambrani, "Gulammohammed Sheikh: Tree of Life," in *Tree of Life: a mural by Gulammohammed Sheikh,* Baroda: published by the artist, 1998)

Gulammohammed Sheikh has sought to reach an involvement with the present while retaining a relationship with tradition. And this perspective on tradition is one that seeks to be inclusive and synthetic, moving "among several cultures and times"[1] to take in exemplars from across space and time. In doing this, Sheikh opens out a way of addressing the present without turning away from the baggage that history inevitably dumps at the doorstep of the speaking subject, even if the subject were to pretend it doesn't exist.

Sheikh's art takes on the task of narrating, and therefore, recreating the world. The act of telling stories, of narrating experience, is perhaps the primary binding that constitutes the fabric of civilisation. There is a close tie-in between this narrative and an act of mapping the world, which gives to the speaking subject the possibility of addressing the world as his/her own. Every time a story is re-told, it is realized anew, the world within it is born afresh. Narration is a re-creation, and in the act of

reinvention, it invests the known with a dimension of the awe and wonder that derives from the realm of the unknown. Sheikh's art can be seen to embark on a survey and narration, and what passes through the field of vision and speech is transformed in the very act of seeing and speaking. Sheikh's work also points out that in no case is the act of surveying a disinterested act. There is nothing pure about the seeing eye, and it is this element of intention, this "impurity" in the gaze that contributes to a political reading of the world.

[1] Title of a lecture delivered by Sheikh at the Smithsonian Institution, New York, 1985. Published under the same title in Carla Borden (ed.) *Contemporary Indian Tradition,* The Smithsonian Institution, New York 1989.

Cat. no. 35a, Traveling Shrine 1: Journeys, 2002–04. Wooden box, multiple doors, gouache, casein, acrylic, egg tempera and watercolor; 48 x 106 x 40 cm. Collection of the artist.

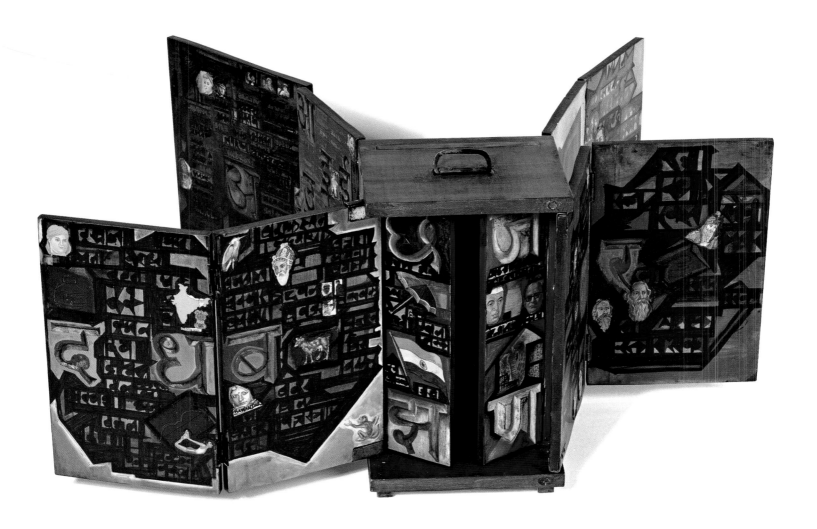

Cat. No. 35b. Traveling Shrine 2: Alphabet Stories, 2002–04. Wooden box, multiple doors, gouache, casein, acrylic, egg tempera and watercolor; 39 x 110 x 30 cm. Collection of the artist.

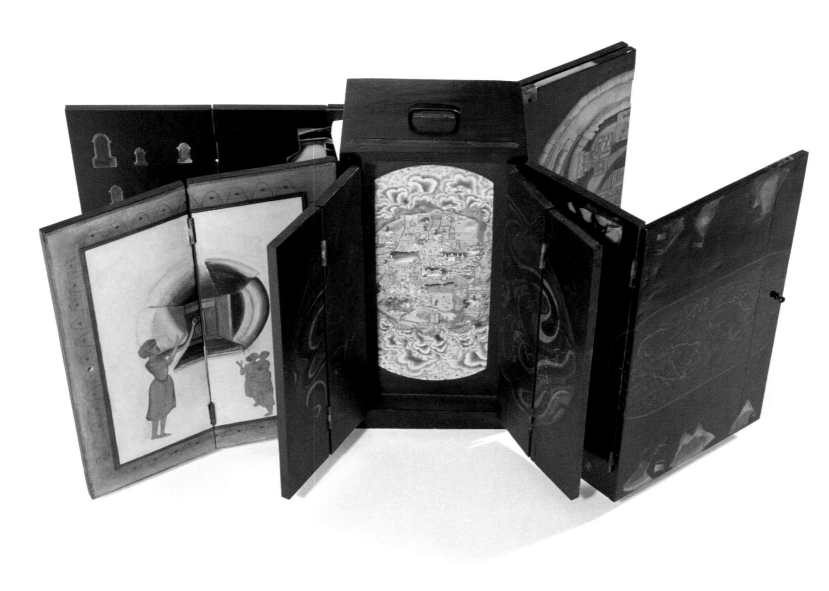

Cat. no. 35a, Traveling Shrine 1: Journeys.

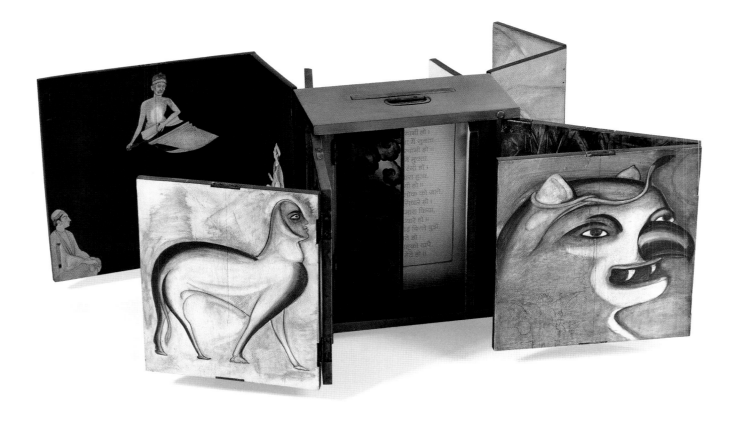

Cat. no. 35c, Traveling Shrine 4: Musings and Miscellanies, *2002–04. Wooden box, multiple doors, gouache, casein, acrylic, egg tempera and watercolor; 36 x 32 x 136 cm. Collection of the artist.*

DAYANITA SINGH

A Photographer's Daughter

As the oldest of [four] sisters, I was the most photographed child in my family. My mother was the family photographer. She would often photograph me just to validate an experience in her own life. When she was taken to stay in a five-star hotel in Kashmir, as a present for bringing me into the world, she placed me on a chaise lounge and took a picture in order to prove to her friends that she had actually lived in the presidential suite. I was a mere speck in the photograph, whereas the chandelier was most prominent. She also photographed the light fixtures, the bed, the desk, each one a separate portrait. When she dressed me as a Romanian gypsy for a fancy-dress party at school, the photograph documented how well she had sown the dress, even more so when she dressed up my sister as Queen Victoria with crown and all. The gypsy photo, she says, turned out to be quite prophetic. I am quite glad that I did not settle into the role of the Mother Mary portrait.

At a certain time in my life, I was living at a friend's house in a small village in Goa. While he was writing and reading, I had to occupy myself, so I started to visit the local church, meeting families and going to their homes to make portraits, since this was my only way of engaging with a new place. While making these portraits, I would sometimes photograph a detail of a door or a crockery cabinet as little records for my friend who could not be with me in all these wonder-filled spaces. I did not think of these as photographs, just little notes for him. It was the same time when I photographed the house museums he was researching in. Just little notes…

One day, when Mrs. Braganza, one of the Goa residents I was photographing, left the room to answer the phone, I suddenly realized that the room was not empty. I could sense the many generations that had used this chair, and I realized that I could make a portrait without a person in it. I started to make photographs of spaces without human beings, yet peopled by the unseen generations that had lived there before. Very soon

I was consumed by this seeming emptiness: beds of those who had passed away, but that were still made every day, beds turned into shrines, with photos and sandals on them…Chairs, too, in particular those that had been in the same place for decades, but whose sitters had moved onto other worlds in the meantime, but their presence was embedded in the chairs, or so it seemed to me."

Excerpts from Dayanita Singh, "A Photographer's Daughter," in *Dayanita Singh: Privacy,* Göttingen: Steidl, 2003.

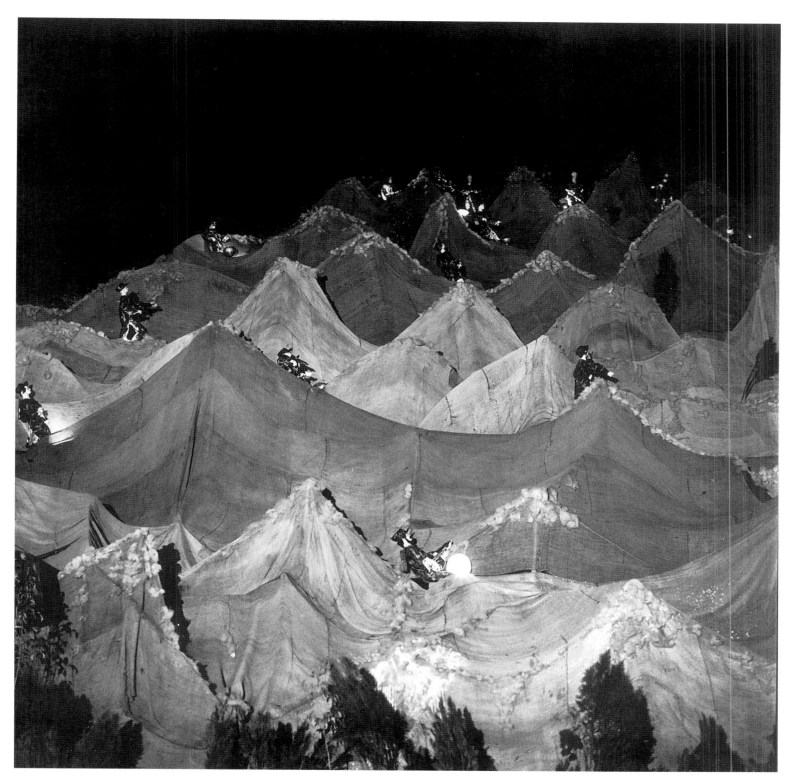

Cat. no. 36a. Kargil Wedding Tent, 2000, printed 2003 Silver gelatin print; 100 x 100 cm. Collection of the artist.

Clockwise from top left: Cat. nos. 36 b, c, e, d

Clockwise from top left: Cat. nos. 36 f, g, i, h

L. N. TALLUR

Tallur was initially trained as a museologist. He had actually hoped to gain admission to the painting program at art school, but when that didn't work, he accepted entry into the museology department on the same campus.

His training as a museum professional, which included issues of history, display, taxonomy, and taxidermy, has carried over into his practice as a visual artist. Over the last decade, he has devised wickedly humorous contraptions that for all the world appear like display cabinets or pristine objects of sculpture. Often though, these cabinets contain sprung or pop-up objects, images and texts that surprise the viewer as they are opened. What looks like a piece of shiny metal sculpture turns out to be a mechanical contraption that goes into frenzied and extremely noisy motion at the touch of a button.

The following are excerpts from an artist's statement by Tallur, the title being a reference to the autobiography of M. K. Gandhi:

MY EXPERIMENTS WITH TRUTH
Watching television at the dinner table is a great experience. A lion enjoying its prey somewhere deep in an African jungle...or President Bush screaming war on terrorism . . . Bon apetit!

We have the privilege of having approximately 150 television channels to surf on. What a great freedom! This is the ultimate organised freedom one can think of. We are so organised and institutionalised that even our diversity is standardised.

As part of the cultural exchange, I am planning to design a RIGHT BODY TO RIGHT HEAD, quiz programme for museum visitors in Britain. My inspiration is the broken heads of Indian sculptures in British museums. The bodies that belong to these heads are in India!

As an exotic Indian, as usual, I have designed a temple in The United Kingdom. It is for the Indian market, designed with a thorough knowledge of modern Indian requirements. It is mobile, inflatable, handy and bright in colour, looks like contemporary art too.

Cat. no. 37, Made in England – A Temple Designed for India, *2001/2002.*
Polyvinyl acetate coated fabric, blowers; 600 x 300 x 300 cm Collection of the artist.

ASHISH RAJADHYAKSHA

Visuality and Visual Art

When we, the people of India, solemnly decided to constitute a country – not on behalf of god or at the behest of any external agency, but because we came together, in our collective wisdom, to set up a sovereign, socialist, secular, democratic republic that would name all of us as its citizens, privileged by membership with the promise of equality of status, of opportunity and fraternity – we put together a *vision* of the nation. The direct realisation of the preamble of the Constitution of India into spaces *visually* organised so as to incarnate the rights of the new citizen – spaces physically reflecting the fact that you had the right to enter, and to do certain things, determined by the sole overriding fact that you were an Indian, a member of the public – is one of the more palpable, everyday, presences defining the abstract conditions of citizenship.

Bazaargate, Bombay. Streets with public transport, pavements, shops, hotels, and restaurants and places of entertainment made this among the earliest, and most visible, instances of the graphic laying out of the of new public sphere including the rights of those who could enter this new space. (From Sharda Dwivedi and Rahul Mehrotra, Bombay: The Cities Within *(Mumbai: Eminence Designs, 2001).*

The Constitution itself names a number of such spaces: Article 15, which also outlines the all-important right that prohibits "discrimination on grounds of religion, race, caste, sex, or place of birth," also then says that no citizen shall on these grounds be "subject to any disability, liability, restriction or condition" with regard to access to "*shops, public restaurants, hotels* and *places of public entertainment*; or the use of *wells, tanks, bathing ghats, roads* and *places of public resort* . . . dedicated to the use of the general public." (Part III, Fundamental Rights: The Right to Equality, 15/2, emphasis mine). These then were to be among the new spaces that incarnated among the most precious rights of the modern citizen: where your rights could be tested, on the ground, every step of the way. It is also astonishing to see how much *visual* work has been done both *in* these spaces – in laying them out as a perceptual-sensory experience enhancing or forbidding entry – as well as *on* them, in painting, photography, and film, exploring in their depiction of such sites what we can recognize as the limits of Constitutional rights in relation to public access.

If there is an experience of visuality basic to the modern Indian experience, this is surely it. Constitutional rights are predominantly verbal: rendered visible to the state only when they are shored up by reasoned arguments stating claims using a language of rights. The *visual* that in such

Speculating on a Link

Clockwise: Sudhir Patwardhan: Lower Parel painting (Cat. no. 3; detail).
Acrylic on canvas; 122 x 244 cm. Collection of Jamshyd R. Sethna.
Women on Bathing Ghats: to check and add?

Meeting of Cloth Merchants in Madhav Bagh, Bombay, after the declaration of
Swadeshi (1905). (From Sharda Dwivedi and Rahul Mehrotra, Bombay: The
Cities Within (Mumbai: Eminence Designs, 2001).

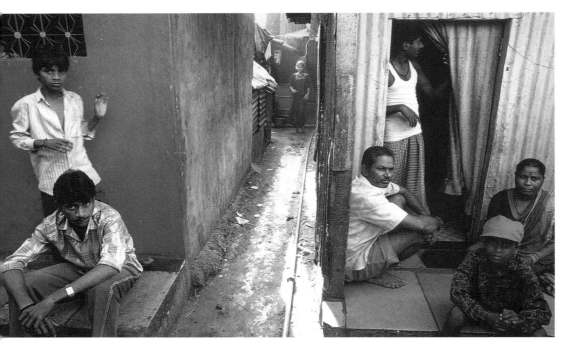

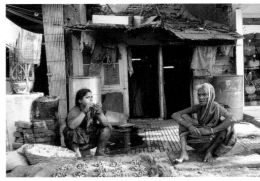

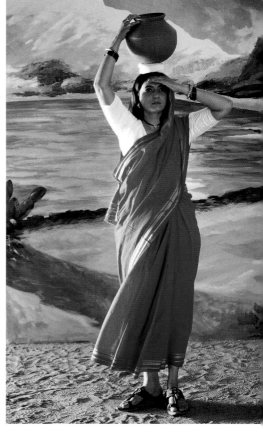

cases emerges as resolutely *extra*-verbal, also becomes elusive to words and thereby to representation, and then enables transgressions designed precisely to *bypass* the regime of legal-literal order, translated into occupation, squatting, or assembling constructions "invisible" to the law. Visuality here develops a double register: where a denotative dimension representing legitimacy, asserting that "this is so"— this person is a certain type of person, this place is a certain type of place, because the state has so recognized —then gets superseded by a far more transgressive *connotative* representational overlay designed precisely to use extra-verbality to escape, to bypass: where this place isn't doing what you imagine it doing and this person is not who you believe he is.

There are, it increasingly appears, direct consequences to viewing art as a participant presence in the charged, disputed, contexted terrain of a visuality that enters and refigures public space. While some artists have sought to literally enter these spaces and make art in them (see the Open Circle project in the *Edge of Desire* show), I would like to cast my net somewhat wider as I seek to chronicle artists' engagement with visuality. I shall focus on the double-edged access of visual representation – visual assertion of *publicness* on the one hand, and the bypassing of the public gaze through a *political* deployment of the liminality of the extra-verbal on the other – to explore two locations, one the production of the national citizen-subject, and two, the production of national public space. This essay will propose that bringing the concerns of the visual public sphere to art has often unexpected consequences to understanding both.

Top left: Raghubir Singh, In the Bylanes: Dharavi.

Top center: Raghubir Singh, Woman Vendor: Dharavi.

Above: Pushpamala N. and Clare Arni, Native Women of South India: Manners and Customs; Returning from the Tank *(Raja Ravi Varma)*, *2002–03 (Cat. no. 11b). Manual photographic print on metallic paper (edition of 20); 70 x 57.5 cm (framed). Collection of the artists.*

RECONSIDERING THE NARRATIVE SUBJECT: PUBLIC AND PRIVATE

"The citizen subject then, is at the same time the social subject-agent (legal, psychological, ethical, imaginary), the obedient subject of the law (including conscience) and the elementary term or the constitutive element of the liberal-democratic polity"—Susie Tharu[1]

Bhupen Khakhar's work— and his celebrated fascination with the banal, with kitsch, reflected in famous statements like "A bouquet of plastic roses is an eternal joy to the eyes"[2] – has become something of a figurehead for a generation of artists, in its use of kitsch, the spurious and the

make-believe, to evoke contrasting ways by which the obedient subject of the law exists in the way s/he is 'supposed to be' seen, read, represented. In one real sense, his gallery of rogues are his men eating *jalebis*, and on their own, presented as either friends, relatives, ancestors, famous men, or those wanted by the police, deploy in full measure the apparatus of producing the (citizen-) subject of India's national-socialist realism.

In much of his work from the 1970s and early '80s, made before he "came out" with his homosexual orientation, Khakhar used to devastating effect the strategy of a double-register reading, in which an actually existing viewer could potentially recognize multiple registers from where to look at, "get," the work from the standpoint of how a fictional exemplary viewer is 'supposed to be' reading it. Like the protagonist of the *Bouquet of Plastic Flowers* painting, a well meaning-good family-heterosexual-citizen figure, Khakhar in much of this enormously influential work couched a direct address within the languages of rationality and realism, invoking in this address the authority of a state-authorised exemplariness, only to follow it with a second, more connotative, register as his de-narrativised realism is literally encircled by *eruptions* of subterranean vernacular meanings, economies, and languages that become incompatible with, even elusive to, the supposedly benign zone of the public citizen.

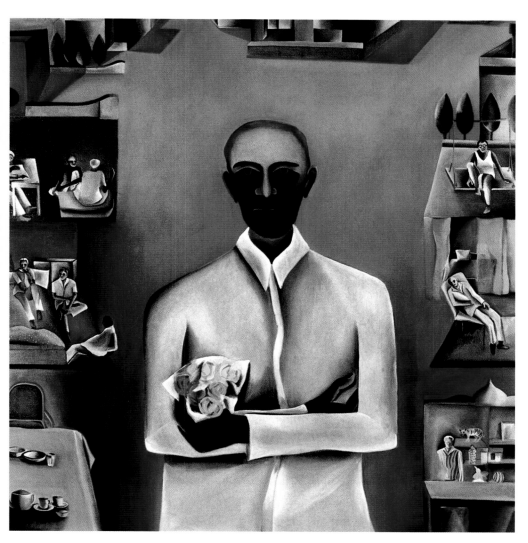

Left: Bhupen Khakhar, Man With a Bouquet of Plastic Flowers, 1976. Oil on canvas.

Below: Subodh Gupta, Bihari, 1998 (Cat. no. 7c; detail). Handmade paper, acrylic, cow dung in polyvinyl acetate solution, LED lights with timer and transformer; 127 x 96 x 8 cm. Private collection.

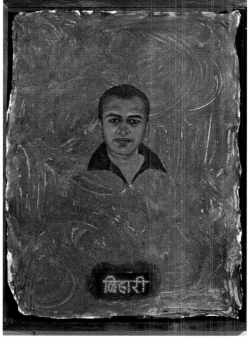

There is art historical significance to this double register. On one somewhat superficial level – recalling here Brecht's classic injunction to all artists to define an 'external viewpoint' that might enable 'external action'[3] —Khakhar's work has been held as enabling a middle-class realism, an easy interaction with the street view[4] or the middle-class home where it might be placed alongside all the other visual paraphernalia including, famously, calendar paintings, blue walls and plastic roses. In enabling such activity within and around the painting, Khakhar—like others of his generation exploring the visual gap between denotation and connotation—can also be seen to perform a narrative displacement that has evident implications for a larger conception of visuality. Khakhar's contemporary, Gulammohammed Sheikh, recently summed up the gamut of the visual universe of publicness as traversing between "Home-Street-Shrine-Bazaar-Museum."[5] Negotiating the visual here is a *traversal*, "corresponding to the successive opening of spatial units," where a physical viewer, standing in front of the work, physically did things as s/he engaged with the work. Sheikh, of course, famously went on to use this device as a vantage point from where to identify a large tradition from pre-Renaissance Europe to folk and popular painting in India [6].

As we deepen that level here, and see what this art-historical intervention may do to our *political* location of visuality, a second connotation arises that takes us far from middle-class realism. Khakhar's work now suggests, radically, that the descriptive superficial aspect incorporates a critical "surface" meaning, which functions as public-democratic representation on a level of easy and widespread recognisability, so that narrative becomes not a process of unfolding, or indeed even a "successive opening out," but an *inside-outside* move. Outside: you perform as a citizen, you recognize what you are supposed to recognise, know what you are told. Inside, a second universe of perception emerges: we might now dub this "informed spectatorial activity," or a kind of indexical manual on "how to read this work." "How to read" is now a matter of contrasting 'how you actually read' with a second 'how you are supposed to read' what is before you: the inside depends on an outside for its charge. Exploring what we might momentarily see as a 'how to' of the 'instruction manual' that accompanies all public space: a do's and don'ts that accompanies the protocols of how to become an obedient citizen subject—and further recognizing the function of *narrative* in this, political theorist Sudipta Kaviraj draws on what he calls an "agenda of historical semantics" by which to explore the hectic activity encompassing narratives of publicness.[7] Suggesting that we may be better able to understand the processes of political and social organisation as primarily a narrative practice, Kaviraj here unambiguously defines narrative as charged with the *predominant* purpose of initiating its audience into the rites of membership of a culturally determinate collective. "In some ways," he proposes, "it is better not to treat democracy as a governmental form . . . A better strategy . . . is to treat it, more problematically, as a "language," as a way of conceiving, and in more propitious circumstances of making, the world.' This language in turn, underpins something perhaps more appropriately seen as *not* universal but as something local and particular: as something—and here we are introducing the demands made by group-differentiated cultural formations for self-definitions that can achieve them legal visibility—that Kaviraj elsewhere calls a *narrative contract*.[8].

For Kaviraj, the telling of a story "brings into immediate play some strong conventions invoking a narrative community" "societies, particular groups, sometimes movements aspiring to give themselves a more demarcated and stabler social form." Given that all such communities from the stable to the emergent 'use narrative as a technique of staying together, redrawing their boundaries or reinforcing them,' it becomes necessary to view narrative as an act of "participating in a movement" and "involves accepting something like contractual obligations." He then states, startlingly, that:

Narrative therefore *does not aspire to be a universal form of discourse*. It draws lines, it distributes people, unlike rational theoretical discourse which attempts to unite them in an abstract universe of ideal consensus. Narratives are not for all to hear, for all to participate in to an equal degree. A

narrative has a self in which it originates, a self which tells the story. But that self obviously is not soliloquizing or telling the story to itself. It implies an audience, a larger self to which it is directed, and we can extend that idea to say that the transaction of a narrative creates a kind of narrative contract. (emphasis mine)

What is the purpose of such a definition of narrative? What is it supposed to do? If it is a contract, what is its legal status? Kaviraj's definition of narrative is in some ways the opposite of what the term usually means in literary theory. While this definition would follow Barthes' famous earlier use of the phrase to accept the transactional nature of narrative, as a *"medium of exchange, an agent, a currency, a gold standard,"*[9] in Khakhar's instance it departs significantly from that conception in its emphasis, contrary to the way narrative aspirations are usually understood, on a subaltern *non*-universality, privileging its capacity to create divides between those who are "in the narrative"—inside the space—and those who are outside, looking in.

INSIDE-OUTSIDE: URBAN PUBLIC SPACE

Putting Khakhar's work in this kind of contractual arrangement makes for a distinct departure, a further elaboration of what we have earlier identified as his 'inside-outside' structuring of narrative: a move that allocates certain 'insider' privileges to spectator-participants, themselves performers in the story, while disenfranchising those who don't possess the required reading competence, but who too are audiences of a kind. The purpose of the entire performance is to incarnate symbolically, for the benefit of those outside, the rights bestowed upon those who are invited by the work to *belong to* the narrative universe.

The 'inside-outside' paradigm as it relates to the public sphere is of course associated with Partha Chatterjee's definition of anticolonial nationalism, which he has argued "creates its own domain of sovereignty within colonial society . . . by dividing the world of social institutions and practices into two domains. [T]he material is the domain of the 'outside,' of the economy and of statehood, of science and technology, a domain where the West has proved its superiority and the East has succumbed. The spiritual, on the other hand, is an 'inner' domain, bearing the 'essential' marks of cultural identity."[10]

In other formulations that explore inside-outside delineations, in contrast to the more standard storytelling device of *unravelling*—and also bringing us back to the space of public activity—Richard Sennett shows how the graphic laying out in modern cities of "empty" public space contrasts with the paradoxical rise of "uncivilized" community space, with barricades and crowd control systems physically incarnating the externalised/internalised nature of different registers of publicness: a narrative further underscored by the element of role-playing in public life, with "how to arouse belief in one's appearance among a milieu of strangers," which from the viewpoint of audiences is resolved through the production of a "public geography" in which "social *expression* will be conceived of as *presentation* to other people of feelings which signify in and of themselves, rather than as representation to other people of feeling present and real to each self."[11]

The possibility of associating *realism* with a public presentation of selfhood opens up the possibility of viewing surface—seemingly transparent surface meaning—as something that obscures subterranean, even therefore sub-conscious, representations simmering below the façade of realism, which in turn potentially always threaten to *erupt* to new symbolic visibility. In fact the necessity of public space accounting for, and indeed *managing*, such eruptions has increasingly become characteristic of the architecture of metropolitan fortresses as well as of a new "massclusive" culture of spatial consumption.

Subodh Gupta, The Way Home, 1998–99. Stainless steel, fibreglass, plastic.

Slum Images in the city: Images courtesy the Kamala Raheja Vidyanidhi Institute of Architecture, Mumbai.

Left: Samar Singh Jodha, Farmer's Home – 4.

Center: Jewelry Shop.

Right: Coal Depot Owner's home. Jodha's work documents the physical and visual-auditory location of the box streaming film images alongside other paraphernalia of its consumers. From the exhibition Heat: Moving Picture Visions, Phantasms & Nightmares, *Bose Pacia Modern, New York, 2003.*

THE INTERSTICES AND THE ERUPTION

"After all, it is true that in the slums of our cities, as in the films made there, to protect one's sister is to rape someone else's"—Kumar Shahani [12]

While narratives become here an 'inside,' 'not for all to hear, for all to participate in to an equal degree,' their exclusivity has to only be contrasted with an outside to this representation, of an experience of cultural production that is ubiquitous, literally everywhere and has to be seen to be everywhere depending on how you see.

I turn here to a key, and famous, location for the playing out of a visuality politics. The popular Indian cinema has been, it is well known, one of the most pervasive examples of a visual experience of publicness, often literally functioning beyond the zone of state regulation (the film industry in India receives little support from the Indian state and, despite draconian censorship laws and usurious taxation policies, sees little evidence of control, especially in its B and C exhibition sectors). This cinema has in recent years seen a massive makeover through the infusion of new kinds of capital and new industries that have grouped together under the now-well known word "Bollywood." Bollywood, I believe, can be validly seen as an industry that is not so much *about* the cinema as an evocation of cinema for the purposes of creating a slew of new culture industries including fashion, music, consumption, tourism, advertising, television and the internet – industries that, as it were, reproduce the cinema outside the movie theatre. Going by this instance of reproduction, I think we will find direct evidence of two critical characteristics of the visual public sphere that have been intensely significant to numerous artists in Khakharite India: the capacity for *reproduction/re-enactment*: where ubiquitous publicness is reproduced under controlled narrative conditions for determinate, non-universal counter-publics, and of *eruption* (and the social management of that eruption), as meanings slice through the representational frontage, the veneer.

The role of the cinema in producing a culture of extra-cinematic visuality—a widespread social tendency of reprocessing the cinema in order to make it available for varied uses outside the movie theatre—appears to enable a range of practitioners of a visuality politics to generate a pure, evocative, de-narrativised *charge* of some sort. Such a reproduction of cinema includes pervasive images like Raj Kapoor-Nargis, *Sholay* or Govinda on MTV, an Amitabh hair style in a barber's shop; these may extend into a more anonymous evoking of nostalgic black-and-white effects or an even more generalized fetish for indeterminate pasts, for example in heritage tourism. In evoking such a

charge, we can note a process of signification with an avant-garde ancestry. Thick evocations embed, make covert tangential reference to, other texts or histories, an elusive 'idiolect' which requires knowing spectators to "get it." In all probability the ancestor of such a device is the state itself, and to its assemby of an 'authenticity' effect, producing culturally authentic objects, artefacts and processes and administratively overseeing the 'authenti*cation*' of cultural production.

Many years ago, Ashis Nandy had made a somewhat startling link between the Indian cinema and the urban slum. Just as the slum, as urban sprawl, entered the very interstices of the city – occupying, notably in Mumbai, every single square foot of available space, over gutters and canal fronts, pavements, unoccupied and half-built land, marsh and park – so the cinema, and the art drawn from this definition of culture, signals a kind of production that visually, and aurally, seeps into every crevice of the entire zone of the public experience. Amazingly, in Mumbai both slum and cinema are illegitimate and, more, invisible to the state. "The language of the slum in India includes the lower middle class view of the culture of the ultra-elite . . . in fantasy, memories of a peasant or rural past serving as a pastoral 'paradise' from which it has been banished, fears about the urban-industrial jungle into which it feels it has already strayed; and anxieties about the 'amorality' of modern life into which it fears it might any day slip," writes Nandy. "This discarded, obsolete population is a constant embarrassment to their urbane brethren – the way popular cinema is an embarrassment to . . . high culture. These discards show the same cussed unwilling-ness to bow out of history and the same obstinate ability to 'illegitimately' occupy a large space in the public domain, geographically and psychologically."[12]

Along with illegitimacy and invisibility then, *ubiquitousness, connotation, familiarity*: knowing in a covert way, the special knowledge of the urban denizen who knows the byways; the representation of publicness in ways that tell you something else about it; multiple registers of meaning produc-tion. These would be the among the issues an urban experience of the visual in Mumbai throw up, for the artist to consider. Entering this very space of ubiquity with its own graphic presentation of an 'inside' is a modern Bollywoodized vernacular architecture that brings "surface meaning" into physical significance. I am referring to an urban tendency of built-up space to externalise: to aggressively announce how the named space is "meant to be" seen, to overtly *declaim* the purpose it is 'supposed' to serve and how you are expected to understand this purpose: an "announcement"

Above: Artist Shilpa Gupta's work with a fictitious film and song advertising an improved design of a wheelchair tricycle (2002)

Anjolie Ela Menon's chairs, at the Kitsch Kitsch Hota Hai *show, Gallery Espace, Delhi, 2001, curated by cultural journalist Madhu Jain, an important instance exploring the possibilities of Bollywood.*

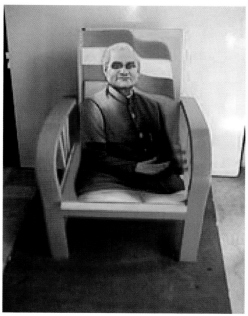

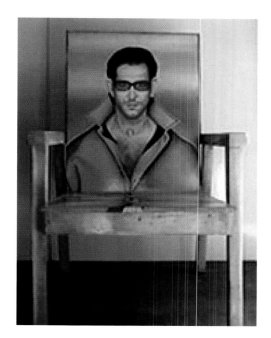

Hiranandani Gardens featuring in Ghulam *(1998). Siddharth (Aamir Khan) drops rich girl Ayesha (Rani Mukherjee) home, having defeated her motorcycle gang.*

that often smothers the actually more modest spaces within which the announced functions are often performed.

Postcolonial Indian architecture, like the middle-class realism that went with it, developed a characteristic look described by one historian as "reinforced concrete structures and flat concrete roofs"[14] most prominently associated with large housing schemes produced by entities such as the Housing and Urban Development Corporation (HUDCO), the Delhi Development Authority (DDA) or the Public Works Departments across India. Years ago, architect Romi Khosla had bewailed the the urban and semi-urban landscape after 1950 as "faceless built form (that) has somehow got lumped together as 'Modern Architecture'" denoucing the buildings that "make no references outside their own technical achievements" and were no more than an amalgam of independent and individually expressed functionalities where the "suppression of complexity (goes with) the belief in unmodulated plain surfaces, the removal of roofs, edges, cornices and surface texture, the detachment from any form of iconography and a belief that building volumes must be defined with straight lines or free form."[15] Arguably such modular construction would perhaps, even today, come closest to signaling a "realism" of space: a space with no worthwhile outside to it, performing the modest welfarist function of enclosing the *actually occupied* space of the "citizen."

In sharp rebellion to that tradition, the 1990s has shown the rise of a more flamboyant, figurative Bollywoodized style that Lang calls the "Modern Indian Vernacular," an architecture of "popular middle class taste," "of display" often drawing from a Hindu, Islamic or colonial past past as well as a modern "mixture . . . of glass and other shiny materials—marble, polished granite and metals," sometimes even combining all this to create what he names a "Las Vegas modern" style, commonly in evidence in Delhi's Greater Kailash, Kolkata's Salt Lake City or Bangalore's Jayanagar. Its purpose is to declaim its imagined internal purposes to those outside, and its central feature has been the growing prominence of, precisely, surface: in the frontal façade—a direct announcement which a construction uses to declare at a street level something about itself. The declaration constitutes a distilled, de-narrativised, *performative* charge, a statement that replicates the paradigms of the visible and recognizable "surface production," to whose political purpose Khakhar's work has, as I think of it, already alerted us. Among its most famous instances in modern consumption would be the new enclaves and malls associated with the signature style of architect-designer Hafeez Contractor, known for his ability to translate complex building laws along with consumer prejudices into an architectural aesthetic, ubiquitous settings for a number of 1990s suburban Bombay's high-life movies.

While a number of late 1990s elite constructions, including shop frontages, malls, glass-fronted offices and residential complexes, would attempt such a distilling of a building's functionality into its façade-statement, directly intervening into the visual definition of a public sphere with their non-verbal "do not enter" signs and their ubiquitous private guards—we need to note a different, low-end consumer context for such a production as well. One of the numerous locations where a critical Bollywood economy functions, the Pakeeza Photo Studio on Grant Road, has a board and photographs displaying its wares through encroaching on wall space on both sides, but also adopts the gigantic movie hoarding sitting atop its awning to further its announcements of what it does and the cultural arena within which it offers its wares. Its enormous frontage, encroaching on all sides as well as on the pavement, makes for a visual encroachment that far exceeds, indeed dwarfs, the miniscule cabin it has available for its business: a cabin which the photo studio further shares with an STD booth and a travel agency. The Pakeeza strategy has astonishing resemblances, on the visuality plane, to a building very much the other end of the spectrum: the astonishingly colored *Times of India*'s Bahadur Shah Zafar Marg building in New Delhi. That building shows a Lichtensteinian Krishna play Holi with two very contemporary teenagers, and was painted to announce the launch of the full-color edition of the newspaper.

Hiranandani Gardens, Powai. Architect: Hafeez Contractor. Pictures: Design Cell, Kamala Raheja Vidyanidhi Institute of Architecture, Mumbai.

Pakeeza Photo Studio, M.S. Ali Road, Mumbai. One of many "Bollywood" photo studios in the Grant Road area, offering images with cut-outs of Hindi stars taken before painted backdrops. Located adjacent to Mumbai's famous Falkland Road "red light" district, it photographs (and displays pictures of) domestic tourists, travelers and often single men, in front of cutouts of the Taj Mahal, swans and peacocks in palaces, or through computer-aided conditions of intimacy with their favorite movie stars.

As we take the façade, and its de-narrativised symbolic announcement further, we shall rapidly encounter a situation where the façade functions increasingly like a *performance*, with no functional relationship to any real space to which any "citizen" has access: a collapsible, flattened *trompe l'oeil*. The performative quality of the façade is directly foregrounded by Dayanita Singh's gigantic marriage pandals literally staged as a bridal setting before admiring audiences.

RECONSIDERING THE COSMOPOLITAN VERNACULAR

The fascination of the Indian artist with subterranean cultural forms, insider speech and vernacular representations, as Indian art moved outside of its colonial-modernist confines, is well documented. Many art works made in Mumbai, Delhi, Kolkata and other places (such as Baroda) and including music, poetry, literature and visual art, have sought to vernacularize the canons of "high-art" modernism—precisely as a process of investigating the properties of "official" publicness. A number of artists evoking celebratory, fraudulent, countercultural excess have sought to use kitsch, impermanence, or uselessness to investigate a complex political legacy for statist authenticity-production.

THE TIMES OF INDIA

Above: The Times of India building, Bahadur Shah Zafar Marg, New Delhi. Artist: Naved Akhtar. The color was intended to announce the launch of the all-color edition of the Times. The 'pichak' sound evokes a well known musical beat associated with the singer Kishore Kumar, and in early 2002 with the song "Dhoom Pichak" by Palash Sen and the band Euphoria. The Shalimar theater and the Hotel Shalimar Palace, decorated with giant vertical strips of 35 mm celluloid. Grant Road, Mumbai.

Left: Designers Abu Jani-Sandeep Khosla make fashion statements. Their Mata Hari images are superimposed upon found film stills. From Sharada Dwivedi, Abu Jani Sandeep Khosla: A Celebration of Style, Mumbai: AJSK Publications, 2000.

WE TRADE IN:

DAIRY EQUIPMENT
IMITATION JEWELLERY
LAUNDRY SERVICES
STEAM, SAUNA, JACUZZI B
OTHER HEALTH CLUB EQUIPMENT
TOBACCO PRODUCTS
CHANTILLY LACE
CRANES - RENTAL & SERVICES
SOAP & DETERGENTS
HIGH PRESSURE HOSES
CONSULTANTS - EDUCATION
(FOREIGN & INDIAN)
ROLLING SHUTTERS
POLYTHENE BAGS
HOSIERY
CLEARING - FORWARDING SERVICES
ENERGY CONSERVATION PRODUCTS
PATIENT CARE EQUIPMENT
PLUMBING, SANITARY, FIRE FIGHTING CONTRACTS
WATER COOLERS & WATER PROOFING
HAIR-COMB, RULERS, HANGERS &
SALES PROMOTION ITEMS
STENCIL DUPLICATOR
SPL. UMBRELLA HANDLES

(WE ALSO SELL SILICA GEL)

Atul Dodiya, "A Poem for Friends," 1998. *Enamel Paint on Laminate. Starting with the two dancers to the top right, the work could be playfully read as a list of the many components of the recently established Bollywood industry.*

If an argument bringing such access into the line of popular productions, urban space and the element of *performance* inevitably recalled by any presentation of cultural belonging has any relevance to the overt en*visioning* of public space, it is likely that we could have a radically different context within which to comprehend contemporary urban art. This context would distinguish a double axis, of the actually existing overlaid with the normative "supposed to"—so how actual spaces function is crucially dependent on how they are supposed to be defined—and thus to a *transactional* element of narrative to as part of the process of defining a democratic polity: a survival strategy for the citizen and the artist.

NOTES

[1] Susie Tharu, "Citizenship and its Discontents" in Mary E. John and Janaki Nair (ed.) *A Question of Silence? The Sexual Economies of Modern India*, New Delhi: Kali for Women, 1998, pp. 216–42.

[2] Quoted in Timothy Hyman, *Bhupen Khakhar*, Bombay/Ahmedabad: Chemould Publications and Arts/Mapin Publishing, 1998, p. 48.

[3] Bertolt Brecht, "The Film, The Novel and Epic Theatre" (1932), in *Brecht on Theatre*, London: Eyre Methuen, 1978, pp. 47–51.

[4] See 'A View From The Teashop,' Geeta Kapur, *Contemporary Indian Artists*, New Delhi: Vikas, 1978, pp. 147–77.

[5] The reference is to an exibition curated by Sheikh (with curatorial associate Jyotindra Jain) in 2002: *New Indian Art: Home-Street-Shrine-Bazaar-Museum* was shown at the Manchester Art Gallery, UK from 13 July to 1 September 2002. See *Art South Asia* (exhibition catalogue), Manchester: Shisha, 2002, pp. 20–35.

[6] Gulammohammed Sheikh, "Viewer's View: Looking at Pictures," *Journal of Arts & Ideas* n 3, April – June 1983, pp. 5–20.

[7] Sudipta Kaviraj, "Democracy and Development in India," in Amiya Bagchi ed. *Democracy and Development: States, Markets and Societies in their Context*, New York: St. Martin's Press, 1995.

[8] Sudipta Kaviraj, "The Imaginary Institution of India," in Partha Chatterjee and /Gyanendra Pandey (ed.) *Subaltern Studies VII: Writings on South Asian History and Society*, Delhi: OUP, 1992, p. 33.

[9] A famous earlier use of the "narrative contract" is Roland Barthes (*S/Z*). His emphasis too is on the transactional element of a narrative: "A desires B, who desires something A has; and A and B will exchange this desire and this thing, this body and this narrative: a night of love for a good story. Narrative: legal tender, subject to contract, economic stakes, in short, *merchandise*, barter which, as here, can turn into haggling, no longer restricted to the publisher's office but represented, *in abyme*, in the narrative" (Roland Barthes, *S/Z: An Essay*, trans. Richard Miller, New York: Hill and Wang, 1974.:89).
Barthes' contention, that "narrative is determined not by a desire to narrate but by a desire to exchange,' is fully echoed in the argument being presented here. However, Barthes' emphasis on narrative as a form of capitalist tender —his claim that 'it is a *medium of exchange*, an agent, a currency, a gold standard"—may be lost in Kaviraj's selective and non-universal narratives with a system of entry that may precede the purely commercial transaction.

[10] Partha Chatterjee, *The Nation and its Fragments: Colonial and Postcolonial Histories*, New Delhi: OUP, 1994.

[11] Richard Sennett, *The Fall of Public Man*, New York/London: W.W. Norton & Company, 1974, pp. 39, 298–300

[12] Kumar Shahani, 'Politics And Ideology: The Foundation Of Bazaar Realism', in Aruna Vasudev and Philippe Lenglet ed., *Indian Cinema Superbazaar*, New Delhi: Vikas, 1983)

[13] Ashis Nandy, 'Popular Cinema: A Slum's Eye View Of Indian Politics,' *The Times of India*, 9 January, 1995.

[14] Jon Lang, *A Concise History of Modern Architecture in India*, Delhi: Permanent Black, 2002, p. 98

[15] Romi Khosla, 'Including Iconography and Images in Architecture,' *Journal of Arts & Ideas* 7, April – June 1984, p. 7.

KAJRI JAIN

India's Modern Vernacular

Not long ago, an otherwise marvelously erudite European scholar of art asked me whether there were any modernist artists in India. This was not, I'm fairly certain, a subtle question about the vexed status of modernism in a postcolonial context, informed by a sense of the paradoxes convoluting the struggle for authentic national forms from within an international (read "metropolitan") modernist artistic paradigm. On the contrary, the question was itself an index of that vexed status: of the marginality of postcolonial modernisms to the civilizational narratives of art history, according to which India's more than fifteen centuries of fame—or (perhaps more to the point) of putative authenticity—began to wane with the colonial messiness of the eighteenth century, and petered out entirely by the early twentieth. Admittedly, this exchange with the European scholar (was an extreme instance), but the fact remains that art audiences outside India are far more likely to be familiar with Chola bronzes and Rajput miniatures than with Amrita Sher-Gil or Gulam Sheikh. The primary representatives of India's modernity in recent years have tended to emanate from the culture industries: the so-called "Bollywood" cinema, or the mass-produced bazaar prints so enthusiastically appropriated by metropolitan youth culture.

The works in *Edge of Desire* reassert the existence of contemporary art practice in India, while simultaneously responding to the burgeoning interest—both at home and abroad—in the idioms of a broader visual culture. Located as it is within the institutional ambit of the international art circuit, the show deals primarily with a modernist processing of the visual culture it seeks to represent, rather than offering that visual culture up in the raw. In doing this, it raises questions about the nature of the relationships between the art world, the culture industries, and the craft traditions in India following the initiation of deregulation and economic liberalization in 1991. At first glance, it might seem as though the use of visual elements and formal idioms from mass and folk culture simply iterates a local version of postmodern irony, nostalgia, appropriation, and pastiche, consistent with India's entry into the global late-capitalist marketplace and its emergence as a full-fledged

On the Edge

consumer society.[1] Given, however, that India's modernity has had a trajectory distinct from Europe's—or rather, distinct from Europe's universalizing narratives about (its) modernity—it stands to reason that these works should also elicit other possible readings that speak to the distinctly postcolonial character of this putative postmodernism and the capitalism it inhabits. Here I want to outline one such alternative entry point to reading these images, informed by the specific histories of commercial culture and art institutions in India—specifically, their negotiation of the parallel strands of vernacular and cosmopolitan, Anglophone or "English-educated" culture.[2] Like many other aspects of postcolonial modernity, the modern vernaculars that many of the works in this show draw on are subject to a kind of spatiotemporal warp, so that even as they form an integral part of contemporary experience, they are also cast in the modern(ist) historical imagination as marginal, anachronistic, teleologically prior, or at the very least about to disappear in the face of globalization. This unsettled status of the vernaculars, I want to suggest, has the effect of ambivalently situating the works that draw on them between engagement and distance—between memory, nostalgia, and critical historicity.

What do I mean by "modern vernaculars"? In part, I am using this term to connote the visual idioms of mass-cultural products aimed at a non-Anglophone audience—or, more accurately, at that aspect of audiences or subjects that does not participate in Anglophone culture. These products include printed posters and calendars, the cinema, books, and magazines, as well as product packaging and advertising in the vernacular Indian languages. Here, colonially introduced or imported technologies—both artistic techniques and modes of mass reproduction—have been selectively appropriated and molded to local themes and formal idioms. In particular, what has tended to distinguish these forms from their counterparts in the world of the Euro-American "Protestant ethic" is the presence of religious or iconic imagery, and the deployment of such imagery as a basis for nationalism and other kinds of identity formation based on religion, caste,

community, region, and so on. Thus, for instance, the printed images produced from the mid-nineteenth century onward that have come to be known as "calendar art" or "bazaar art" have dealt predominantly (but by no means exclusively) with mythological and religious themes (Fig. 1), as did many early Indian films and, more recently, the serially televised mythological epics that have dominated viewer ratings since the *Ramayana* was first aired in 1987 (Fig. 2).

Similarly, ever since consumer goods aimed at the Indian market began to be packaged and publicized in the second half of the nineteenth century—indigenous medicaments and cosmetics such as kohl and hair oil, soap, *beedi*s (hand-rolled cigarettes), incense, matches, textiles, flour, kerosene—many of them have been branded or advertised with images of deities and mythic figures (Fig. 3). This was also the case with certain products circulating in Western markets, particularly before the mid-twentieth century: the trademark for Woodward's Gripe Water, for example, is a picture of the infant Hercules based on a painting by Joshua Reynolds. However, there is a qualitative difference between the "post-sacred" allegorical use of gods and heroes from a classical past as exemplars for present human conduct (as in European neoclassical painting) and a contemporaneous religiosity that seeks to maintain the sacred as ever-present, integrally inhabiting everyday life.[3] In India even mass-produced depictions of mythic figures, whether sold as religious souvenirs, given away on advertising calendars, or even purchased as part of the packaging of a product, have commonly been incorporated for personal or familial worship in domestic and work-place shrines (Fig. 4), suggesting that such iconic images are not simply representations of divine beings, but are also deployed in an indexical register to embody something of the sacred essence that they depict. In other words, the image itself, as an object, takes on a certain power, its very presence bringing good fortune; correspondingly, the viewer's, or consumer's, ritual engagement with it far exceeds distanced visual appreciation to include various kinds of embodied performance, such as offering incense, feeding, anointing, garlanding, worship, and even religious ecstasy.

Attendant on this indexical mode of signification and the embodiment of sacred value is the formal imperative of frontality. Frontality, as elaborated by Geeta Kapur, is central to what she terms "the aesthetics of popular art in India," which includes both images and, more explicitly, performative cultural forms: for example, *patua*s (storytellers) such as Swarna Chitrakar (*Titanic*, 2001; Cat. no. 13) who tell stories using painted scrolls, have traditionally combined image-making and performance. Frontality encompasses features such as "flat, diagrammatic and simply contoured figures . . . a figure-ground with notational perspective . . . the repetition of motifs within ritual 'play' . . . a space deliberately evacuated to foreground actor-image-performance . . . [and] stylized audience address."[4] Even as popular forms have adopted certain aspects of Western-style naturalism in order to imbue figures with *bhava* (emotional appeal) and *sajivta* (the Hindi word used by several calendar artists to denote "livingness"), naturalist devices such as perspective and rendering have tended to remain subservient to those qualities that foster ritual engagements with images. Thus iconic figures face directly frontward, their timeless gazes uninterrupted as they bestow benevolence on the viewer and enhance the auspiciousness of their presence via the image as object (Fig. 5). In *Edge of Desire*, we see this characteristic forced into a confrontation with history, for instance as it undergoes ironic reversal in Nataraj Sharma's *Freedom Bus* (2002–03; Cat. no. 26), in which calendar art's once-powerful iconic representations of nationalist "leaders" (the industry's term for such figures (Fig. 6) are consigned to a juddering rattletrap on the verge of collapse. Similarly, in Surendran Nair's *Mephistopheles* (2002; Cat. no. 33) the diabolical metamorphosis of a first-century C.E. Mathura-style Buddha statue echoes the concealments and dissimulations of recent attempts to construct a selectively defined travesty of Indian civilization.

However, while the frontal imperative obtains both in popular idioms and in classical, textually prescribed iconographic codes, it would be a mistake to read the use of religious and frontal

Fig. 1. Shree Lakshmi, *artist unknown, poster published by SS Brijbasi and Sons, Mathura, ca. 1950s.*

Fig. 2. Postcard featuring a scene from the Mahabharat *mythological television series that aired in India from 1988 onward.*

imagery in India's colonial and postcolonial visual print capitalism as signaling the persistence of some kind of primordial Indian religiosity.[5] On the contrary, the presence of such imagery in the realm of commodity aesthetics has to be recognized as a product of colonial relations, indexing processes of national identity formation—and, concomitantly, the commodification of cultural difference—engaged in by colonizer and colonized alike. Mythic material provided a readily recognizable cipher of Indianness, both for foreign firms seeking to penetrate the Indian market and for India's own entrepreneurs and cultural producers, who were asserting a national identity through indigenous products as the independence movement gathered momentum.

In fact, in all likelihood it was foreign rather than Indian firms that first introduced mythic imagery on products aimed at Indian consumers. Thus, in one of colonialism's more delicious ironies, God-fearing British Protestant mill owners produced bales of cloth labeled by intermediary managing agencies with chromolithographed images of Hindu deities and illustrations of mythic tales; these labels (known as "tickets") were carefully collected and preserved, if not worshiped, by Indian consumers (Fig. 7). Austrian, Swedish, and Japanese matchboxes carried prints with similar themes, including versions of images by the celebrated Indian painter and print entrepreneur Raja Ravi Varma (1848–1906; Fig. 8). While large foreign firms could afford to replicate Indian images

in luscious color, smaller indigenous capitalists used single-color woodblock illustrations such as those produced in the Battala district of Kolkata (formerly Calcutta), inserting them in almanacs or pamphlets and, to a lesser extent, in the vernacular press. These nineteenth-century images reappear in the high-tech environment of Raqs Media Collective's *Global Village Health Manual* (2001) on CD-Rom (Cat. no. 24), generating affinities between the informal technological appropriations of early vernacular capitalism and the twenty-first century's proliferating electronic commons.

The colonial context affected not just the form and content of images in the commodity realm, but also their modes of production and distribution. In particular, it was central to the parallel formation of an informal arena of vernacular trade and entrepreneurship alongside the formal or official colonial economy—a coexistence that continued to characterize post-independence culture as India's technocratic elite took over the Anglophone, Western-style corporate sphere.[6] Colonial officials called the vernacular arena the "bazaar," casting it as the indigenous arena in a dual economy. Here again, however, it must be recognized that while it displayed many features of precolonial social organization and commercial and moral economy, the bazaar was an integral part of the colonial system: its traditional trading communities and their complex, far-reaching credit networks formed a crucial interface between the mostly foreign-owned managing agencies (trading agents) linked to the colonial administration, on the one hand, and the agrarian economy of peasants, artisans, and petty moneylenders, on the other.[7] Colonial trade depended on the persistence of these extensive and intensive informal networks of the bazaar—and therefore on its social structures and moral economies—much as contemporary global capitalism depends on exploiting modes of organization, work practices, and moral economies that do not receive official sanction in the metropolitan centers.

It was from this arena of the bazaar, distinct from yet integral to the colonial economy, that the first Indian entrepreneurs emerged, channeling their gains from trade into the production of textiles, jute, sugar, paper, or the kinds of indigenous petty commodities listed earlier, as well as into the vernacular culture industries, where modes of production and distribution reflected this context—as did their themes, ideology, and formal characteristics, such as frontality. Bazaar-style production and distribution, both before and after independence, have revolved around mobile agents or traders working on commission, decentralized ancillary providers, and family businesses that typically have not separated ownership from control. In these respects, it has greater similarity to the mixed formal and informal arrangements and disaggregation of disorganized or late capitalism than to the classic model of centralized Ford-style mass manufacture or the managerial ethos of the monopoly phase of capitalism, which accompanied the growth of the Euro-American culture industries. The informality of the bazaar—that is, the relative non-reliance of its credit networks on legal instruments to secure transactions—has meant that its ethos has emphasized personalized, reciprocal relationships of trust (including those of kinship and marriage), reputation, and social performance. These features, in turn, link the ethos of the bazaar back to the maintenance of explicitly religious or communitarian affiliations, and to a gift economy with which the commodity realm is inevitably enmeshed; it is hardly surprising, then, that the key constituency of Hindu nationalism in India (dating back to the pre-independence Hindu Mahasabha or the later Jan Sangh) has been not the rural and urban working classes but the trading and manufacturing communities of the bazaar.

Much contemporary art practice in India is engaged in a critique of Hindu nationalism: N. N. Rimzon's elegiac *Speaking Stones* (1998; Cat. no. 20) and L. N. Tallur's tongue-in-cheek *Made in England: a Temple Design for India* (2000; Cat. no. 37) represent something of the range here. At the same time—and this is where we begin to sense the mixture of antipathy and affinity in the relationship of this art practice to the bazaar—other elements of the bazaar formation also increasingly figure in artistic genealogies of the present that no longer privilege a romanticized

Fig. 3. Contemporary label for "Laxmi Brand" spices.

Fig. 4. Brahmin family shrine, Sivakasi, Tamil Nadu.

Indian village as the repository of authentic national experience, as was the case in public discourse, the arts, and the academy for several decades after independence.

Sudhir Patwardhan's *Ulhasnagar* triptych (2001; Fig. 9) provides a crystallizing figure for the thriving manufacturing formation emanating from the bazaar's trading communities and inhabiting interstitial spaces that do not sit comfortably within simple polarities between rural and metropolitan or subordinate and elite. Ulhasnagar began as a post-partition camp on the outskirts of Bombay; Sindhi refugees soon transformed it into a bustling center for a host of industries of varying scales, including textile and biscuit-making machinery, furniture, soap, fountain pens, spare parts, and small electrical devices. For those of us growing up in pre-liberalization India, Ulhasnagar was a symbol of the marginal, informal, semi-pirate status of India's indigenous manufactures: the common joke was that on goods circulating in India that were labeled "Made in USA," the familiar acronym actually stood for "Ulhasnagar Sindhi Association."

The arena of post-independence image production has replicated this coexistence of separate yet intersecting worlds. However, this has not been simply a matter of a division between the three main areas of image production: an official domain of art schools, exhibitions, and critical writing; a traditional realm of arts and crafts either integrated into rural economies (as with the narrative *pat* illustrated scrolls) or patronized by courts, merchants, and priests—or, more recently by tourists and the cosmopolitan Indian elite; and the mass culture industries. Here again, a largely unacknowledged vernacular shadow has closely accompanied the official or formal cosmopolitan art world, anchoring it to the ground as it were, in much the same way as the bazaar undertook its work of translating and mediating but also underpinning the formal economy. While the colonially instituted art schools in India produced their share of artists who participated in the world of fine art, they also trained others whose career trajectories crisscrossed all three of the image-producing domains just listed. For instance, it comes as a surprise to most people to discover that many artists employed in the calendar art industry actually attended art schools in Mumbai (formerly Bombay), Chennai (formerly Madras), or Kolkata; several of these artists also came from traditional image-making lineages, such as those associated with Nathdwara and Tanjore painting.

The art schools have not just been the domain of an Anglophone elite: on the contrary, they were first set up in the second half of the nineteenth century as schools of industrial art intended to attract students from artisanal communities, in keeping with the industrial-arts revival in Britain and also with the colonial characterization of Indians as not possessing a fine art but excelling in

Above: Fig. 5. Ram Rajya Tilak, published by Bharat Picture Publishers, artist and date unknown.

Left: Fig. 8. Matchbox labels from Austria and Sweden depicting Indian mythological characters. The one on the right is based on Raja Ravi Varma's chromolithograph Arjun and Subhadra.

the decorative arts. Caught between an agenda of "refining native tastes" and the administration's need for skilled technicians, colonial art education soon came to include elements of fine-art practice, and to attract students from the gentry.[8] Art schools have therefore had a mix of students from varyingly vernacular and Anglophone, artisanal and elite, and provincial and metropolitan backgrounds; similarly, the careers of many early artists from varying backgrounds bridged both the commercial and fine-art arenas. If the non-art-school-trained Raja Ravi Varma is one instance here, so is M. V. Dhurandhar (1867–1944), a commercial illustrator (Fig. 10) and first Indian principal of the Jamsetji Jeejeebhoy ("JJ") School of Art in Mumbai.

The success of artists like Dhurandhar rode on the conjuncture between the art establishment's support of an Indian naturalism (in western India, that is: elsewhere, particularly in Kolkata, this was hotly contested), the taste of elite patrons for Western-style portraiture and history painting, and the market's demand for naturalist commercial illustration. However, the advent of modernism onto the Indian scene, starting around 1935, instituted a much starker distinction between fine and commercial art, forcing artists to choose between commercially sponsored naturalism and the modernism sponsored by the nationalist elite and the post-independence state. On one side of this divide were people like the self-taught modernist M. F. Husain (b. 1915), now one of the wealthiest and best-known living artists in India (despite—if not because of his vilification by Hindu nationalists), who famously survived as a cinema billboard artist in Mumbai until he started exhibiting as part of the Progressive Artists' Group. On the other side was a host of unknown or lesser-known artists, often trained at the same art schools as the modernists, working across a range of professional arenas: signboard painting, book and magazine illustration, technical drafting, photographic retouching, and sets and publicity for the popular theater or the cinema and its spin-offs (as revealed in Dayanita Singh's photographs of Mumbai film studio sets).

Thus, for instance, it is quite probable that the highly successful Sholapur-based artist Venkatesh Sapar (b. 1967), who studied fine art at the JJ School of Art and now produces a prolific variety of religious and secular images for the commercial print and calendar industry (Fig. 11, shared the same classrooms and corridors at JJ with Sharmila Samant (born in the same year), whose Coke-bottle-cap saree (1999; Cat. no. 25) is featured in this show, or Atul Dodiya (also represented here), well known for his use of popular or vernacular imagery and environmental elements. As a primary producer of vernacular imagery, Sapar has networks that radiate from his Sholapur studio-home to clients (mostly calendar and print publishers) in the major Indian cities as well as further afield: one of his commissions is a series of illustrations for an edition of the *Bhagavad Gita* published by the Self-Realization Center in Los Angeles. As critical processors of imagery like that produced by Sapar, the networks of the metropolis-based artists in this show also extend to cities like Los Angeles (or New York, Tokyo, or Amsterdam), but to the cosmopolitan circuit of art galleries and museums. So it is not necessarily their training or even their social backgrounds that separate the worlds of these artists, nor is it the elements in their imagery or their global reach. What separates them are the disjunct yet overlapping aesthetic and economic frames within which they circulate: on the one hand, those of the vernacular bazaar, which resists divisions between religion, commerce, kinship, aesthetics, and politics, and on the other those of a largely Anglophone global arena whose ongoing project is the assertion of a post-Enlightenment bourgeois ethos (most recently through global trade forums such as the World Trade Organization [WTO] and the General Agreement on Tariffs and Trade [GATT]).

The difference between these arenas is often literally a matter of framing, as in the case of the auto-rickshaw paintings photographed by Mallikarjun Katakol. Katakol's *Autorickshaw Paintings* (1997–98; cat. 32) are valued (both critically and in terms of their price) according to their circulation in a formal arena of signatures and intellectual property rights, where value attaches to the creator of the image. The auto-rickshaw painter partakes of that frame of value to the extent that he

Fig. 6. Nehru Jivani (*Nehru's Life*), artist Lakshmilal Nandlal, Nathdwara, published by Hem Chander Bhargava and Sons, Delhi.

Fig. 7. Putana Ticket, *artist and publisher unknown, textile label for Gilanders Arbuthnot and Co., managing agency, Calcutta. Courtesy Priya Paul.*

signs his work, but operates in a commercial arena where clients attach importance to the subject or theme of a painting rather than to its author. Even as Katakol's inclusion of the painter's signature in his photograph constitutes a reflection on the relationship between these economies, the image does no performative work to challenge the divisions between them. In other words, while the works in the show make visual references to the arena of vernacular image production, with the possible exception of the *Global Village Health Manual* they do not speak to that arena's alternative modes of production and distribution. Nor can they participate in its frames of value, messily imbricated with religion, commerce, and regressive politics, for that would eliminate their critical-modernist, secular, historicist edge.

In this sense, then, the modern vernacular refers to a parallel arena of incommensurable co-presence: incommensurable, that is, both with the avowed ethos of the post-Enlightenment marketplace and with its correlated frames of aesthetic value and forms of critique. But there is another sense of the modern vernacular that is intimately shared by many of the works in this show: one that refers not just to specific culture industries or contexts of production and distribution, but to

the broader sensorium of a distinctly Indian modernity. Much of this sensorium emanates from life on the street, and the shared spaces (mostly, though not exclusively, urban) where vernacular and cosmopolitan worlds commingle and slip past each other: the intense colors of clothing, commodities, posters, billboards, and roadside shrines; loudspeakers blaring *filmi* (movie) and devotional songs or political slogans (evoked in Natraj Sharma's *Freedom Bus;* Cat. no. 26); the sweaty crush of buses and trains; the frenetic chaos of traffic; "eve teasing" (the local euphemism for sexual harassment); dubious electrical connections; ambient smells of pollution and decay interrupted by incense, jasmine, hair oil, cow dung, and cooking. Like the fluorescent tube light that pervades Subodh Gupta's *Bihari* (1999; Cat. no. 7a), such elements of shared experience infuse the works in this show, instilling them with an empathy that both tempers and draws attention to their critical distance.

This relationship of affinity and distance is encapsulated in Vasudha Thozur's *Self-Portrait* (2000; Fig. 12), where the point of view is designed to cast her in the manner of street artists who make money from painting or drawing deities on footpaths, even as the very use of perspective pointedly alienates the painting from the vernacular tradition it invokes; similarly, the painting itself does not attempt to be anything but acrylic on canvas, hung vertically in a gallery. To this extent, there is a certain symmetry between the ways in which a vernacular sensorium informs these works and the ways in which, on the other side of the divide, artists like Sapar harness elements of modernism—expressive brushwork or knife work, semi-abstract forms, and, of course, the signature—to their otherwise incompatible commercial and religious practice.

How, then, does this double movement of identification and dis-identification with the modern vernacular place the works in this show with respect to narratives of postmodernity, late capitalism, and globalization? The invocation of vernacular commercial idioms in these works can often work effectively to instate indigenous culture industries and commodity culture as sites of local specificity—indeed, as sites of authenticity. This constitutes a resistant response to universalizing teleologies of capital and commodity culture, as well as to the threats of cultural imperialism and homogenization represented by certain processes of globalization. If Hindu nationalism's production of essentialized cultural traditions constitutes one response to the post-liberalization demise of economic nationalism, the positing of a vernacular modernity provides an alternative speaking position from which to appeal implicitly to a certain cultural nationalism.[9] This position

Above: Fig. 11. Venkatesh (VV) Sapar, detail from a 1995 Lakshmi calendar for the Bengali market. Courtesy Venkatesh Sapar.

Left: Fig. 10. MV Dhurandhar, print advertisement for Simla Hair Oil, date unknown. Courtesy Ambika Dhurandhar.

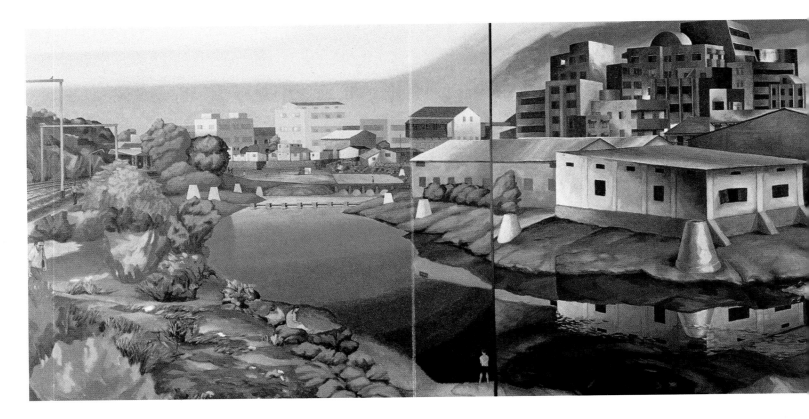

both departs from and shares a postmodern antifoundationalism, for even as it deals in nationalism, the basis of this nationalism is not pristine and primordial but impure and historical, a modern product of the colonial encounter.

And yet, at the same time, this very ability on the part of artworks to assert and articulate locality both indexes and further effects a lapse in the currency and localness of the vernacular forms being deployed to do so. Reminiscent of Walter Benjamin's oft-invoked characterization of the aura, but in a reversed context (that is, in the movement from mass culture to art rather than the other way around), the acknowledgement of these forms within the aesthetic realm of the art system signals a process of auraticization, which is primarily a movement of distancing.[10] This distancing is effected by the movement of particular elements from the unremarked yet intimate flux of presentness and eternity into the frame of historical thinking; from banality and everydayness to aesthetic spectacularization; and concomitantly from denigration, devaluation, and marginalization to an enhanced sense of aesthetic, historical, and cultural value.

By virtue of receiving scholarly attention and being processed through modernist artworks, certain vernacular forms attain historical significance and so pass into pastness within a teleologically driven economy, whether as antiques with heritage value or for their retro cachet. Attendant on this is the quick conversion of these forms of cultural value to market value: after all, the art system is itself a culture industry. Thus, for instance, early calendar art and cinema or advertising posters that were reviled as kitsch up until at least the 1980s had by the turn of the millennium become international collector's items, appearing in gallery shows and auctions in India and overseas.[11] Conversely, the auraticization of past mass cultural forms—or rather of forms now framed as past, as historical—is not confined to the art world, but also characterizes the culture industries themselves, as they increasingly trade on nostalgic self-reference. This is particularly true for the Hindi cinema and music channels on television, such as MTV and Zee's Channel V. The latter are

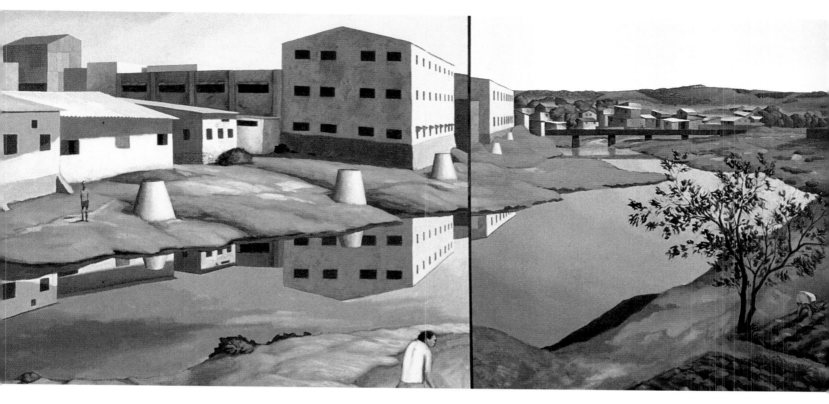

Opposite page: Fig. 12. Self-portait, 2000, Vasudha Thozur, from India: Visual Cultures.

Above: Fig. 9. Ulhasnagar, 2001, Sudhir Patwardhan, acrylic on canvas, 102 x 428 cm.

also characterized by their use of bazaar art–inspired graphics and their hip spoofing of vernacular characters and accents, a device whereby once again acknowledgement and engagement serve to establish both intimacy and distance (in this case from an Anglophone-identifying youth audience).[12]

So to the extent that those forms that make it to the gallery are always already no longer banal, the art of India's post-liberalization era heralds the reduced valence of these particular modes of vernacular culture. But this is not to say that vernacular cultural forms in general, or semi-formal bazaar-style networks, are disappearing in the face of globalization, for the culture industries are constantly taking on new avatars. As with the colonial bazaar, these new manifestations thrive on a dual interface: with informal modes of production and distribution on the one hand and global corporate capital on the other. Again, nowhere is this more evident than on Indian television, with its proliferation of Hindi and regional-language programming, much of it broadcast on global networks like Sony and Star even as it is engaged (like the highly successful "K" soaps on cable television) in relentless elaborations of the ideology of Hindu nationalism, where the patriarchal joint family works out its equation with liberal values and post-liberalization consumerism.[13] It is now the turn of these forms to be reviled as regressive kitsch by the intelligentsia, who can see little in them that is spectacular, that is worthy of framing or that lends itself to auraticization—or at any rate, not just yet. This is contemporary visual culture that will not make it to the gallery space, whether raw or processed, as long as its banality still has teeth.

NOTES

1 Fredric Jameson, *Postmodernism, or, The Cultural Logic of Late Capitalism*, London: Verso, 1991.

2 "English-educated" is the apt phrase used by Gauri Viswanathan in *Masks of Conquest: Literary Study and British Rule in India*, New York: Columbia University Press, 1989.

3 On the "post-sacred," see Peter Brooks, *The Melodramatic Imagination: Balzac, Henry James, Melodrama, and the Mode of Excess*, New York: Columbia University Press, 1975.

4 Geeta Kapur, "Revelation and Doubt: Sant Tukaram and Devi," in *Interrogating Modernity: Culture and Colonialism in India*, eds. Tejaswini Niranjana, P Sudhir, Vivek Dhareshwar, Calcutta: Seagull Books, 1993, p. 20.

5 On print capitalism see Benedict Anderson, *Imagined Communities*, London: Verso, 1991.

6 See Arvind Rajagopal's discussion of a "split public," a term he uses in the context of the Indian press; Arvind Rajagopal, *Politics after Television*, Cambridge: Cambridge University Press, 2001, pp. 151–211. While this is a useful heuristic, as with my own deployment of the term "vernacular" I would want to caution against mapping this split onto distinct constituencies of reception, as opposed to distinct arenas of production and distribution. At most, I would suggest that it might be used to describe the different registers of performance that are available to individual subjects, with varying degrees of access.

7 Rajat Kanta Ray, "Introduction," in Rajat K. Ray (ed), *Entrepreneurship and Industry in India 1800–1947*, Delhi: Oxford University Press, 1992, pp. 10–18.

8 For accounts of art education in colonial India, see Tapati Guha-Thakurta, *The Making of a New 'Indian' Art: Artists, Aesthetics and Nationalism in Bengal*, c. 1850–1920, Cambridge: Cambridge University Press, 1992, and Partha Mitter, *Art and Nationalism in Colonial India, 1850–1922: Occidental Orientations*, Cambridge: Cambridge University Press, 1994.

9 See Satish Deshpande, "Imagined Economies: Styles of Nation-Building in Twentieth Century India," *Journal of Arts and Ideas*, 25–26 December 1993, 5–35.

10 Walter Benjamin, "The Work of Art in the Age of Mechanical Reproduction," in *Illuminations*, ed. Hannah Arendt, trans. Harry Zohn, New York: Schocken Books, 1969. Auraticization here connotes valorization based on the object's indexical uniqueness and presence, its authenticity, which emanates not only from its sacral "cult value" or its authorial originality, as Benjamin describes it, but also, I would suggest, from its historicity.

11 Starting in October 2001, a private arts institution called Osian's mounted a series of auctions of film posters, calendar art, and paintings, accompanied by preview exhibitions, handsome catalogues, and lectures by curator (and founder and chairman of Osian's) Neville Tuli in New Delhi, Mumbai, London, New York, and Dubai. Variously entitled *India: A Historical Lila* (October 2001), *A Historical Mela: The ABC of India* (March 2002), and *A Historical Epic: India in the Making 1757–1950* (August 2002)—note the legitimizing emphasis on the word "historical"—these exhibition/auctions were held in collaboration with institutions such as the National Centre for Performing Arts and the National Gallery of Modern Art in Mumbai, and the British Council, the India Habitat Centre (an influential cultural complex and elite social club) and Art Today (a gallery associated with the newsmagazine *India Today*) in New Delhi. From 26 June–6 October 2002 the Victoria and Albert Museum in London held a show of hoardings, posters, and other elements of cinema's visual culture, called *Cinema India: the Art of Bollywood*; in October 2002 the London-based auctioneers Bowrings held an auction of Indian film memorabilia in New Delhi. Meanwhile, in March 2001, a New Delhi show called *Kitsch Kitsch Hota Hai* celebrated the influence of calendar art on contemporary Indian artists and designers.

[12] The pre-eminent instance here is Jaaved Jaafri on Channel V's mid-1990s music show *Timex Timepass*.

[13] The "K" serials, as they are known, are soaps produced for the cable television channels by the prolific Ekta Kapoor, for whom the letter "K" seems to have acted as a lucky charm. Three of these soaps, *Kasauti Zindagi Kay, Kahani Ghar Ghar Ki*, and *Kyunki Saas Bhi Kabhi Bahu Thi* have consistently topped the TV ratings charts in 2002–03. Others include *Kasamm, Kkusum, Kaliren, Kundali, Kavita, Karam, Kalash, Kahin Kisi Roz, Koshish Ek Asha, Kuch Khona Hai Kuch Pana Hai,* and *Kabhi Souten Kabhi Saheli, Kohi Apna Sa* (the peculiar spelling of some of these titles is attributed to numerological formulas).

Exhibition Checklist

LOCATION/LONGING

N. S. HARSHA
For You My Dear Earth, 2004
Acrylic on cotton duck, canvas
mounted on plywood with gold leaf
(in 3 parts); 137 x 563 cm, 137 x 563 cm,
137 x 46 cm, 137 x 1,172 cm (overall)
Private Collection, New York
Courtesy: The Artist and Talwar Gallery,
New York

UMESH MADDANAHALLI
Between Myth and History, 2001
DVD;12 minutes (with audio)
Collection of the artist

SUDHIR PATWARDHAN
Lower Parel, 2001
Acrylic on canvas; 122 x 244 cm
Collection of Jamshyd R. Sethna

NILIMA SHEIKH
Firdaus I: Valley, 2003–04
Casein tempera, stencil on canvas;
300 x 180 cm
Collection of the artist

NILIMA SHEIKH
*Firdaus II: Every night put Kashmir in
your dreams*, 2003–04
Casein tempera, stencil on canvas;
300 x 180 cm
Collection of the artist

NILIMA SHEIKH
Firdaus III: Gathering Threads,
2003-2004
Casein tempera, stencil on canvas;
300 x 180 cm
Collection of the artist

NILIMA SHEIKH
Firdaus IV: Farewell, 2003–04
Casein tempera, stencil on canvas;
300 x 180 cm
Collection of the artist

VASUDHA THOZUR
Untouchable, 2001
Oil on canvas; 242 x 192 cm
Collection of the artist

VASUDHA THOZUR
*Lost Years: a Reconstruction (or
Portrait of Vishnu)*, 2003
Oil on canvas (3 panels); 244 x 106 cm,
244 x 180 cm, 244 x 38.2 cm
Collection of the artist

VASUDHA THOZUR
Secret Life: Tiger, 2000
Oil on canvas (3 panels); 229 x 49 cm,
225 x 152 cm, 229 x 86 cm
Collection of Vikram Kiron Sardesai

TRANSIENT SELF

GANGA DEVI BHATT
Vyaktigat Itihaas (personal history),
2002
Pencil and acrylic paint on paper;
28 x 38 cm (16 units, 2 one sided, 14
double-sided), 34 x 44 cm (framed
each)
Collection of the artist

SUBODH GUPTA
Vilas, 2000/2003 (print)
C-type photograph; 165 x 120 cm
Collection of the artist

SUBODH GUPTA
3 Cows, 2003
Bronzed bicycles, aluminum plated
milk cans; life-size
Collection of Arani and Shumita Bose

SUBODH GUPTA
Bihari, 1998
Handmade paper, acrylic, cow dung in
polyvinyl acetate solution, LED lights
with timer and transformer;
127 x 96 x 8 cm
Private Collection

TUSHAR JOAG
Phantoms, 2002–04
Mini DV transferred to DVD; 3 minutes,
30 seconds (with sound)
Collection of the artist

SONIA KHURANA
Bird, 2000
DVD; 1 minute, 10 seconds
Collection of the artist

RAJ KUMAR KORAM
*Apne Zindagi Ka Khambha (The Pillar
of My Life) I*, 2002-2003
Teak, iron wire, PVA, saw dust;
207 x 85 x 35 cm
Collection of the artist

RAJ KUMAR KORAM
*Apne Zindagi Ka Khambha (The Pillar
of My Life) II*, 2003
Teak, iron wire, PVA, sawdust;
200 x 90 cm x 25
Collection of the artist

PUSHPAMALA N. AND CLARE ARNI
*Native Women of South India: Manners
and Customs: Returning from the Tank
(Raja Ravi Varma)*, 2002–03
Manual photographic print on metallic
paper (edition of 20); 70 x 57.5 cm
(framed)
Collection of the artists

PUSHPAMALA N. AND CLARE ARNI
*Native Women of South India: Manners
and Customs: Lakshmi*, 2002–03
Manual photographic print on metallic
paper (edition of 20); 70 x 57.5 cm
(framed)
Collection of the artists

PUSHPAMALA N. AND CLARE ARNI
*Native Women of South India: Manners
and Customs: Toda*, 2002–03
Manual photographic print on metallic
paper (edition of 20); 70 x 57.5 cm
(framed)
Collection of the artists

PUSHPAMALA N. AND CLARE ARNI
Native Women of South India: Manners and Customs: Lady in Moonlight (Raja Ravi Varma), 2002–03
Manual photographic print on metallic paper (edition of 20); 70 x 57.5 cm (framed)
Collection of the artists

PUSHPAMALA N. AND CLARE ARNI
Native Women of South India: Manners and Customs: Circus, 2002–03
Manual photographic print on metallic paper (edition of 20); 70 x 57.5 cm (framed)
Collection of the artists

PUSHPAMALA N. AND CLARE ARNI
Native Women of South India: Manners and Customs: Jayalithaa, 2002-2003
Manual photographic print on metallic paper (edition of 20); 70 x 57.5 cm (framed)
Collection of the artists

PUSHPAMALA N. AND CLARE ARNI
Native Women of South India: Manners and Customs: Flirting, 2002–03
Manual photographic print on metallic paper (edition of 20); 70 x 57.5 cm (framed)
Collection of the artists

PUSHPAMALA N. AND CLARE ARNI
Native Women of South India: Manners and Customs: Criminals, 2002–03
Manual photographic print on metallic paper (edition of 20); 70 x 57.5 cm (framed)
Collection of the artists

PUSHPAMALA N. AND CLARE ARNI
Native Women of South India: Manners and Customs: Yogini (Bijapur), 2002–03
Manual photographic print on metallic paper (edition of 20); 70 x 57.5 cm (framed)
Collection of the artists

PUSHPAMALA N. AND CLARE ARNI
Native Women of South India: Manners and Customs: Mary (Our Lady of Vailankanni), 2002–03
Manual photographic print on metallic paper (edition of 20); 70 x 57.5 cm (framed)
Collection of the artists

CONTESTED TERRAIN

MANU CHITRAKAR
Afghanistan War, 2003
Poster paint on paper; 240 x 75 cm
Collection of the artist

SWARNA CHITRAKAR
Shishu Kamya (Girl Child), 2004
Poster paint on paper; 240 x 75 cm
Collection of the artist

SWARNA CHITRAKAR
Titanic, 2003
Poster paint on paper; 240 x 75 cm
Collection of the artist

SANTOSH KUMAR DAS
Ram Being Worshipped by Laypeople and Sages, 2003
Ink on paper; 38.1 x 55.9 cm
Ethnic Arts Foundation

SANTOSH KUMAR DAS
Mother Goddess Weeping for the Victims of 2002 Gujarat Riots, with Durga and Shiva at Her Side, 2003
Ink on paper; 38.1 x 55.9 cm
Ethnic Arts Foundation

SANTOSH KUMAR DAS
February 27, 2002, Railway Station in Gudhrat, Gujarat, 59 Hindus Dying in Torched Train, 2003
Ink on paper; 38.1 x 55.9 cm
Ethnic Arts Foundation

SANTOSH KUMAR DAS
Burning Bodies in an Inferno of Smoke and Flames, 2003
Ink on paper; 38.1 x 55.9 cm
Ethnic Arts Foundation

SANTOSH KUMAR DAS
Muslim and Hindu in Warring Camps Separated by a Trident and a Burning Lotus, 2003
Ink on paper; 38.1 x 55.9 cm
Ethnic Arts Foundation

SANTOSH KUMAR DAS
Demonic Hindu Rioter Snatching Babies from the Train Platform, 2003
Ink on paper; 38.1 x 55.9 cm
Ethnic Arts Foundation

SANTOSH KUMAR DAS
Auto-Riksha in Flame: Rioters Gathering in Background, 2003
Ink on paper; 38.1 x 55.9 cm
Ethnic Arts Foundation

SANTOSH KUMAR DAS
Rioter Becoming an Icon, Brandishing a Sword, 2003
Ink on paper; 38.1 x 55.9 cm
Ethnic Arts Foundation

SANTOSH KUMAR DAS
Turbaned Gujarati with Flames Ascending His Body Like a Blossoming Lotus, 2003
Ink on paper; 38.1 x 55.9 cm
Ethnic Arts Foundation

SANTOSH KUMAR DAS
Chief Minister Narendra Modhi Inciting Religious Intolerance While Gujarat Burns and Gandhi's Death is Forgotten, 2003
Ink on paper; 38.1 x 55.9 cm
Ethnic Arts Foundation

SANTOSH KUMAR DAS
Muslim Men Seeking Shelter from Rioters, 2003
Ink on paper; 38.1 x 55.9 cm
Ethnic Arts Foundation

SANTOSH KUMAR DAS
Muslim Families Finding Shelter in the Shah-e-Alam Mosque, 2003
Ink on paper; 38.1 x 55.9 cm
Ethnic Arts Foundation

SANTOSH KUMAR DAS
Muslim Families Finding Shelter in the Shah-e-Alam Mosque, 2003
Ink on paper; 55.9 x 76.2 cm
Ethnic Arts Foundation

SANTOSH KUMAR DAS
Ram and Gandhi Mourn Trident's Piercing of the Earth and Train, 2003
Ink on paper; 38.1 x 55.9 cm
Ethnic Arts Foundation

SHILPA GUPTA
Blame, 2003
Plastic bottles, stickers, liquid (water, sugar, food coloring, vinegar), DVD, Plexiglas shelves, fluorescent red tubes, flat screen monitor; 240 x 470 cm
Collection of the artist

ARCHANA HANDE
Story Books, 2003–04 (detail)
Digital print on *Arches* watercolor paper, and rice paper (4 books);
14 x 31.5 cm (unfolds to 196 x 31.5 cm), 31 x 29 cm, 31.5 x 21 cm, 35 x 30 cm
Collection of the artist

ARCHANA HANDE
An Epic, 2003–04
Mini DV (digital video), 27 minutes
Collection of the artist

ARCHANA HANDE
A Tale, 2003–04
Mini DVD, 40 minutes
Collection of the artist

RUMMANA HUSSAIN
Home Nation, 1996
Multipart installation including wooden planks, plastic folders, photographs, glass bottles, cloth;
size variable
Courtesy of the Estate of
Rummana Hussain

NALINI MALANI
The Sacred and the Profane, 1998
Synthetic polymer paint on mylar, steel, nylon cord, electric motors, lights and hardware; 3 x 5 x 11 m
Collection of the Art Gallery of Western Australia

NALINI MALANI
Unity in Diversity, 2003
Video – DVD (pal); 7 minutes, 30 seconds (with audio)
Collection of the artist

NALINI MALANI
Stains, 2000
Video – DVD (pal); 8 minutes
(with audio)
Collection of the artist

OPEN CIRCLE
Bottle Neck Jammed, 2004
Six CDs
Collection of the artists

N. N. RIMZON
Speaking Stones, 1998
Photographs (laminated), stones, resin fiberglass, marble dust (on figure);
90 x 500 cm (diameter)
Collection of the artist

VIVAN SUNDARAM
Memorial, 1993/2000
Mixed media; 18 x 10 m
Collection of the artist

SONADHAR VISWAKARMA
Babri Masjid – Ramjanmabhoomi, 2003-2004
Iron; 175 x 200 cm
Collection of the artist

RECYCLED FUTURES

KAUSIK MUKHOPADHYAY
Assisted Readymades: Alternative Solutions, 2003–04
Handcart, tricycle, assemblages of discarded household objects with manuals; 180 x 306 x 92 cm
Collection of the artist

RAQS MEDIA COLLECTIVE
Global Village Health Manual, Version 1.0, 2000
HTML based CD
Collection of the artists

SHARMILA SAMANT
A Handmade Saree, 1998–1999
Coca-Cola bottle caps, metal shackles, computer prints with wooden frames; 550 x 120 cm
15 x 15 cm (3 units, computer prints)
Collection of the artist

NATARAJ SHARMA
Freedom Bus (Or a View from the 6th Standard), 2001–04
Iron, wood, electrical motor, oil and enamel paint on paper, ink jet prints, rubber tires, electroplating;
103 x 237 x 76 cm
Collection of the artist

NATARAJ SHARMA
Mumbai Structures, 2000–04
Gouache, pencil, and "texture white" on canvas; 32.2 x 27.3 x 3 cm (19 units)
Collection of the artist

K. G. SUBRAMANYAN
Black Boys Fight Demons
Oil on canvas; 94 x 63.5 cm
Collection of the National Gallery of Modern Art, Delhi

K. G. SUBRAMANYAN
The City Is Not for Burning, 1993
Oil on canvas; 121.5 x 121.5 cm
Collection of the artist

K. G. SUBRAMANYAN
Ageless Combat 1, 1999
Acrylic reverse painting on acrylic sheet; 194 x 136 cm
Collection of the Seagull Foundation of the Arts

SUBHASH SINGH VYAM
Untitled (Plane Stuck in a Tree), 2003
Acrylic on canvas; 153 x 243 cm
Collection of the artist

UNRULY VISIONS

ATUL DODIYA
Tomb's Day, 2001
Enamel paint, varnish on laminate;
Three panels, 191 x 129 cm
(each panel, framed)
Collection of the National Gallery of
Modern Art, Mumbai

RANBIR KALEKA
Windows, 2002
Video/sculpture with sound;
243.8 x 121.9 x 121.9 cm
Collection of the artist

RAVI KASHI
Everything Happens Twice, 2002–04
100% cotton rag acid-free paper, gauze
cloth, photocopy transfer and acrylic
lettering, stamps, polyvinyl acetate
glue; 158 x 220 x 2.5 cm
(9 units, each unit 40 x 60 cm)
Collection of Peter Mueller

MALLIKARJUN KATAKOL
Auto Art Series (1-16), 1995–96
(printed 2003)
C-type photographic prints;
30 x 50 cm, 50 x 30 cm, 40 x 60 cm,
50 x 60 cm
Collection of the artist

SURENDRAN NAIR
*Mephistopheles....Otherwise, the
Quaquaversal Prolix
(Cuckoonebulopolis),* 2003
Oil on canvas; 210 x 120 cm
Collection of Usha Mirchandani,
The Fine Art Resource, Bombay

SURENDRAN NAIR
*Precision Theatre of the Heavenly
Shepherds,* 2002–03
Watercolor on paper; 65 x 50.5 cm
Collection of Nitin Bhayana

SURENDRAN NAIR
Zodiac Series Texts, 2002–03
Printed text on paper; 65 x 50.5 cm
Collection of Nitin Bhayana

CYRUS OSHIDAR/MTV INDIA
Video-Filler Compilation
DVD, cigarette/small goods stall road-
side shop (complete), wooden bench,
television monitors;
Duration: 30 minutes (approx.),
Installation: 240 x 126 x 187 cm
Collection of MTV India

GULAMMOHAMMED SHEIKH
Traveling Shrine 1: Journeys, 2000–04
Wooden box, multiple doors, gouache,
casein, acrylic, egg tempera, and
watercolor; 48 x 106 x 40 cm
Collection of the artist

GULAMMOHAMMED SHEIKH
Traveling Shrine 2: Alphabet Stories,
2002–04
Wooden box, multiple doors, gouache,
casein, acrylic, egg tempera, and
watercolor; 39 x 110 x 30 cm
Collection of the artist

GULAMMOHAMMED SHEIKH
Traveling Shrine 3: Mirage (Ayodhya),
2002–04
Wooden box, multiple doors, gouache,
casein, acrylic, egg tempera, and
watercolor; 30 x 106 x 27 cm
Collection of the artist

GULAMMOHAMMED SHEIKH
*Traveling Shrine 4: Musings and
Miscellanies,* 2002-2004
Wooden box, multiple doors, gouache,
casein, acrylic, egg tempera, and
watercolor; 36 x 32 x 136 cm
Collection of the artist

DAYANITA SINGH
Ambedkar, Allahabad, 2000
(printed 2003)
Silver gelatin print; 60 x 60 cm
Collection of the artist

DAYANITA SINGH
Ma Morvi, 2000
(printed 2003)
Silver gelatin print; 60 x 60 cm
Collection of the artist

DAYANITA SINGH
Nehru, Allahabad, 2000
(printed 2003)
Silver gelatin print; 60 x 60 cm
Collection of the artist

DAYANITA SINGH
Subhash Chandra Bose, Calcutta, 1999
(printed 2003)
Silver gelatin print; 60 x 60 cm
Collection of the artist

DAYANITA SINGH
*Bhau Daji Ladd Museum Cabinet,
Bombay*, 2000
(printed 2003)
Silver gelatin print; 60 x 60 cm
Collection of the artist

DAYANITA SINGH
Ghandi Ahmedabad, 2000
(printed 2003)
Silver gelatin print; 60 x 60 cm
Collection of the artist

DAYANITA SINGH
Tagore, Allahabad, 2000
(printed 2003)
Silver gelatin print; 60 x 60 cm
Collection of the artist

DAYANITA SINGH
Taj Mahal, Bombay, 2000
(printed 2003)
Silver gelatin print; 100 x 100 cm
Collection of the artist

DAYANITA SINGH
Ghandi, Trivandrum, 2000
(printed 2003)
Silver gelatin print; 60 x 60 cm
Collection of the artist

DAYANITA SINGH
Kargil weddng tent, 2000
(printed 2003)
Silver gelatin print; 100 x 100 cm
Collection of the artist

DAYANITA SINGH
Bombay Sapphire, Bombay, 1994
(printed 2003)
Digital print on vinyl; 200 x 300 cm
Collection of the artist

L. N. TALLUR
*Made in England – A Temple Designed
for India*, 2001–02
Polyvinyl acetate coated fabric,
compressor; 600 x 300 x 300 cm
Collection of the artist

Artist Biographies

GANGA DEVI BHATT
Born 1970 in Bastar
Lives and works in Kondagaon, Chhatisgarh
Education and training: trained informally by
Raitu Ram at Shilpi Gram, Kondagaon

SWARNA CHITRAKAR
Born 1974 in Naya, West Bengal
Lives and works in Naya
Education and training: trained under elder
artists from her community

MANU CHITRAKAR
Born 1979 in Naya, West Bengal
Lives and works and works in Naya
Education and training: trained under elder
artists from his community

ATUL DODIYA
Born 1959 in Mumbai
Lives and works in Mumbai
Education and training: Sir J.J. School of Art,
Mumbai, B.F.A., 1982; Ecole des Beaux-Arts,
Paris, 1991–92

SHILPA GUPTA
Born 1976 in Mumbai
Lives and works in Mumbai
Education and training: Sir J.J. School of Art,
Mumbai, B.F.A. (Sculpture), 1997

SUBODH GUPTA
Born 1964 in Khagaul, Bihar
Lives and works in Gurgaon and New Delhi
Education and training: College of Arts &
Crafts, Patna, B.F.A. (Painting), 1988

ARCHANA HANDE
Born 1970 in Bangalore, Karnataka
Lives and works in Mumbai
Education and training: Viswa Bharati
University, Kala Bhavana, Shantiniketan, B.F.A.
(Printmaking), 1991; Faculty of Fine Arts,
Maharaja Sayajirao (M.S.) University, Baroda,
M.F.A. (Printmaking), 1993

N. S. HARSHA
Born 1969 in Mysore, Karnataka
Lives and works in Mysore
Education and training: Chamarajendra
Academy for Visual Arts (CAVA), Mysore,
B.F.A. (Painting), 1992; Faculty of Fine Arts,
Maharaja Sayajirao (M.S.) University, Baroda,
M.F.A. (Painting), 1995

RUMMANA HUSSAIN
Born 1952 in Mumbai, died 1999
Lived and worked in Mumbai
Education and training: Ravensbourne College
of Art and Design, London, 1972-1974

TUSHAR JOAG
Born 1966 in Mumbai
Lives and works in Mumbai
Education and training: Sir J.J. School of Arts,
Mumbai, B.F.A., 1988; Faculty of Fine Arts,
Maharaja Sayajirao (M.S.) University, Baroda,
M.A., 1990

RANBIR KALEKA
Born 1953 in Patiala, Punjab
Lives and works in New Delhi
Education and training: College of Art,
Chandigarh; Royal College of Art, London

RAVI KASHI
Born 1968 in Bangalore, Karnataka
Lives and works in Bangalore
Education and training: College of Fine Arts,
Bangalore, B.F.A (Painting), 1988; Faculty of
Fine Arts, Maharaja Sayajirao (M.S.)
University, Baroda, M.A. (Printmaking), 1990;
Mysore University, M.A. (English Literature),
1995

MALLIKARJUN KATAKOL
Born 1967 in Dharwad, Karnataka
Lives and works in Bangalore, Karnataka

SONIA KHURANA
Born 1968
Lives and works in New Delhi and Amsterdam
Education and training: College of Art, Delhi;
Royal College of Art, London, M.F.A.

RAJ KUMAR KORAM
Born 1972 in Bastar
Lives and works in Kondagaon, Chhatisgarh
Education and training: trained in sculpture
under Raitu Ram at Shilpi Gram, Kondagaon;
Certificate course in stone carving, 1993

UMESH MADDANAHALLI
Born 1967 in Bangalore, Karnataka
Lives and works in Bangalore
Education and training: Karnataka Chitra Kala
Parishath, Bangalore, B.F.A. (Sculpture) 1991;
Faculty of Fine Arts, Maharaja Sayajirao (M.S.)
University, Baroda, M.A. (Sculpture), 1993

NALINI MALANI
Born 1946 in Karachi, Pakistan
Lives and works in Mumbai and Pune,
Maharashtra
Education and training: Sir J.J. School of Art,
Mumbai, Diploma (Fine Arts), 1969

KAUSIK MUKHOPADHYAY
Born 1960 in Kolkata, West Bengal
Lives and works in Mumbai
Education and training: Rabindra Bharati
University, Kolkata, Bachelor of Visual Arts,
1986; Viswa Bharati University, Kala Bhavana,
Shantiniketan, M.F.A., 1989

PUSHPAMALA N AND CLARE ARNI
Pushpamala N
Born 1956 in Bangalore, Karnataka
Lives and works in Bangalore
Education and training: B.A. (Economics and
Psychology) 1977; Faculty of Fine Arts,
Maharaja Sayajirao (M.S.) University, Baroda,
B.F.A. (Sculpture), 1982, and M.F.A.
(Sculpture), 1985
Clare Arni
Born 1962 in Scotland
Lives and works in Bangalore, Karnataka

SURENDRAN NAIR
Born 1956 in Onakkoor, Kerala
Lives and works in Baroda, Gujarat
Education and training: College of Fine Arts,
Trivandrum, Kerala, Diploma (Painting), 1981,
and B.F.A. (Painting), 1982; Faculty of Fine
Arts, Maharaja Sayajirao (M.S.) University,
Baroda, Post Diploma (Printmaking), 1986

Open Circle
Artist collective consisting of three members:
Archana Hande, Tushar Joag, and Sharmila
Samant

CYRUS OSHIDAR
Born 1964 in Delhi
Lives and works in Mumbai

SUDHIR PATWARDHAN
Born 1949 in Pune, Maharashtra
Lives and works in Mumbai
Education and training: practicing radiologist
and self-taught artist

RAQS MEDIA COLLECTIVE
Formed 1991
Monica Narula
Born 1969 in Delhi
Lives and works in Delhi
Education and training: B.A. Hons. (English
Literature); M.A. (Mass Communication)
Jamia Millia Islamia, Delhi, 1991
Shuddhabrata Sengupta
Born 1968 in Delhi
Lives and works in Delhi
Education and training: B.A. Hons.
(Sociology); M.A. (Mass Communication),
Jamia Millia Islamia, Delhi, 1991
Jeebesh Bagchi
Born 1965 in Delhi
Lives and works in Delhi
Education and training: B.A. Hons.
(Physics); M.A. (Sociology); M.A.
(Mass Communication), Jamia Millia Islamia,
Delhi, 1991
Mritynjay Chatterjee
Born 1970 in Calcutta
Lives and works in Delhi

N. N. RIMZON
Born 1957 in Kakoor, Kerala
Lives and works in Tiruvanthapuram, Kerala
Education and training: College of Fine Arts,
Trivandrum, B.F.A. (Sculpture), 1982; Faculty
of Fine Arts, Maharaja Sayajirao (M.S.)
University, Baroda, M.A. (Sculpture), 1984;
Royal College of Art, London, M.F.A 1989

SHARMILA SAMANT
Born 1967 in Mumbai
Lives and works in Mumbai
Education and training: Sir J.J. School of Arts,
Mumbai, B.F.A., 1989; L.S. Raheja College of
Architecture, Mumbai, I.D.D. (Diploma in
Interior Design and Decoration), 1990

GULAMMOHAMMED SHEIKH
Born 1937 in Surendranagar, Gujarat
Lives and works in Baroda, Gujarat
Education and training: Faculty of Fine Arts,
Maharaja Sayajirao (M.S.) University, Baroda,
M.A. (Painting), 1961; Royal College of Art,
M.A., 1966

NILIMA SHEIKH
Born 1945 in New Delhi
Lives and works in Baroda, Gujarat
Education and training: Faculty of Fine Arts,
Maharaja Sayajirao (M.S.) University, Baroda,
B.A. (Painting), 1969, and M.A. (Painting),
1971

NATARAJ SHARMA
Born 1958 in Mysore, Karnataka
Lives and works in Baroda, Gujarat
Education and training: Faculty of Fine Arts,
Maharaja Sayajirao (M.S.) University, Baroda,
B.A., 1982, and Post-diploma (Painting), 1988

DAYANITA SINGH
Born 1961 in New Delhi
Lives and works in New Delhi
Education and training: National Institute of
Design, Ahmedabad, Visual Communication,
1980-86, International Center of Photography,
New York, Photojournalism and Documentary
Photography, 1987-88

SUBHASH SINGH VYAM
Born 1970 in Sunpuri, Madhya Pradesh
Lives and works in Bhopal
Education and training: trained informally
under elder artists from his community

K. G. SUBRAMANYAN
Born 1924 in Kuthuparambu, Kerala
Lives and works in Shantiniketan, West Bengal
Education and training: Viswa Bharati
University, Kala Bhavana, Shantiniketan, 1948

VIVAN SUNDARAM

Born 1943 in Shimla, Himachal Pradesh
Lives and works in New Delhi
Education and training: Faculty of Fine Arts,
Maharaja Sayajirao (M.S.) University, Baroda,
B.A. (Painting), 1965; Slade School of Fine Art,
London, Post-diploma, 1968

L. N. TALLUR

Born 1971 in Kundapur, Karnataka
Lives and works in Bangalore
Education and training: Chamarajendra
Academy for Visual Arts (CAVA), Mysore,
B.F.A. (Painting); Faculty of Fine Arts,
Maharaja Sayajirao (M.S.) University, Baroda,
M.A. (Museology); Leeds Metropolitan
University, Leeds, U.K., M.A. (Contemporary
Fine Art Practice)

VASUDHA THOZUR

Born 1956 in Mysore, Karnataka
Lives and works in Baroda, Gujarat
Education and training: College of Arts and
Crafts, Chennai, Diploma (Painting), 1979;
Croydon School of Art and Design, Croydon,
U.K., Post-diploma (Painting), 1980

SONADHAR VISHWAKARMA

Born 1953 in Bastar
Lives and works in Kondagaon, Chhattisgarh
Education and training: trained traditionally by
his father, Cherku Ram Vishwakarma, a well-
known iron craftsman from Bastar

Timeline

Note to reader: Historical and political events appear in black; cultural events appear in gray.

1947

Lord Mountbatten becomes last Viceroy and Governor General of India; presents plan for Partition and schedule for transfer of power (June 3). Pakistan's Constituent Assembly elects Jinnah first President (August 11). Indian Independence Bill passed (August 15). J. L. Nehru becomes first Prime Minister (August 15). Partition riots leave 200,000 dead. Pakistan attacks Kashmir. India signs treaty of accession with Maharaja Hari Singh.

Progressive Artists Group (PAG), Bombay formed with F. N. Souza, M. F. Husain, S. H. Raza, K. H. Ara, H. A. Gade, S. K. Bakre as members.

1948

M. K. Gandhi assassinated by a member of the militant Hindu nationalist movement, the Rashtriya Swayamsevak Sangh (RSS). Limited India-Pakistan war over Kashmir. Indian Army occupies Hyderabad forcing the surrender of the Nizam, the Muslim ruler of Hyderabad.

PAG Bombay holds first show. All India Fine Arts and Crafts Society (AIFACS) exhibition to Afghanistan.

1949

Indian constitution drawn up on British model, includes universal suffrage and equal rights. Ceasefire in Kashmir. U.S.S.R. becomes major trading partner.

PAG exhibition; Souza reformulates ideological position, abandoning social commitment. Souza's paintings removed from exhibition on charges of obscenity, house searched. Leaves for London at year end.

1950

India declares itself sovereign democratic republic (January 26), population 350 million.

Faculty of Fine Arts, Baroda, founded. Indian Council for Cultural Relations established. Ram Kumar, S. H. Raza, Akbar Padamsee go to Paris, inaugurating post-Independence modernists' dialogue with European art.

1951

First Five Year Plan. S. P. Mukherjee starts Bhartiya Jan Sangh as political wing of RSS.

Jehangir Art Gallery (JAG) founded, Bombay.

1952

First general elections. Nehru forms Congress government (May).

First International Film Festival of India (IFFI) in Bombay, Madras, and Calcutta, organized by Films Division. AIFACS exhibition to China; Krishna Chaitanya Hon. Sec.

1953

Sangeet Natak Akademi (SNA) launched to support and fund music and theater. Hermann Goetz joins as director of National Gallery of Modern Art (NGMA) and reorganizes it.

1954

Zhou Enlai visits India. Nehru signs "Five Principles of Peaceful Co-existence" with Mao Zedong in Beijing.

NGMA founded at Jaipur Hopuse, near India Gate. Lalit Kala Akademi (LKA) founded on personal initiative of Nehru, to promote and administer visual arts. Sahitya Akademi founded to look after literary arts.National Museum founded in New Delhi.

1955
Nehru attends Bandung Afro-Asian Conference inaugurating Non Alignment Movement (NAM).

World premiere of Satyajir Ray's *Pather Panchali* at Museum of Modern Art, New York. First National Exhibition of Art, LKA, New Delhi; 250 works accepted out of 1200 entries. British Council Research Scholarship, Slade School of Art, London, to K. G. Subramanyan.

1956
Second Five Year Plan. Public Law (PL) 480 agreement with U.S.A. on import of food grains. States Reorganisation Bill passed. B. R. Ambedkar and 200,000 "scheduled caste" Hindus convert to Buddhism in Nagpur.

1957
Fifty percent increase in food prices over 1955, forcing wheat imports from Australia and aid under PL 480.

Governor's Prize, Bombay Art Society, to K. G. Subramanyan.

1958
First phase of Bhakra Nangal Dam, showpiece of Nehru's government, completed.

K. G. Subramanyan joins All India Handloom Board in Bombay as Deputy Director (Design).

1959
Rourkela and Bhilai steel plants inaugurated, Nehru's "temples of the future." China's suppression of Tibetan revolt forces 14,000 refugees led by the Dalai Lama into India. Chinese model of economic collectivization discredited.
National School of Drama founded. Biren De goes to New York on Fullbright Scholarship.

1960
National Museum opens in New Delhi. Film and Television Institute of India (FTII) founded.

1961
India invades and annexes Goa, Daman, Diu, Nagar-Haveli from Portugese; they are declared Union Territories along with Nagaland.

1962
Indian army routed in border war with China. Congress right wing attacks Nehru for failure of non-aligned policy. Congress Party wins general elections, but significant rise in Jan Sangh and Swantantra Party (founded 1959) reflects merging of pro-liberalization forces with Hindu communalism in opposition to Nehru.

First issue of *Lalit Kala Contemporary* published by the LKA.

1963
Commonwealth Scholarship, Royal College of Art, to G. M. Sheikh. *King of the Dark Chamber*, terracotta relief mural, Rabindralaya, Lucknow, by K. G. Subramanyan.

1964
Nehru dies, L. B. Shastri becomes Prime Minister. Communist Party of India (CPI) splits, major exodus to CPI (Marxist).

National Film Archive of India founded in Pune under Information and Broadcasting ministry.

1965
Second India–Pakistan war over Kashmir since Independence.

Language riots in South India over adoption of Hindi as "Link" language. Television offers daily one hour programming in Delhi. *Art Now in India*, curated by George Butcher, Commonwealth Arts Festival at Royal Festival Hall, London, Laing Art Gallery. Newcastle.

1966

Indira Gandhi becomes Prime Minister after Tashkent talks followed by death of L. B. Shastri. Rupee devalued by 36.5 percent.

John D. Rockefeller 3rd Fund Fellowship, New York, to K. G. Subramanyan. Commonwealth Scholarship, Slade School of Art, London, to Vivan Sundaram.

1967

Congress Party wins National Elections under Indira Gandhi. Congress loses eight of seventeen states. Left United Fronts come to power in West Bengal and Kerala. Dravida Munnetra Kazhagam (DMK) wins Madras on anti-Hindi platform. Naxalbari peasant activism turns violent. Naxalite movement in Andhra Pradesh continues to 1969.

1968

Manifesto for New Indian Cinema movement issued by Mrinal Sen and Arun Kaul, advocating state-sponsored author-cinema. *First Triennale-India*.

1969

Indira Gandhi splits Congress Party, fires Finance Minister, Morarji Desai. Nationalization of 14 banks accounting for 52 percent of national credit. Tarapur atomic energy station operational; Bhabha Atomic Research Centre produces U235.

The function of Indian TV is defined as "to overcome simultaneously India's two major limitations, geographical distance and linguistic diversity." G. M. Sheikh and Bhupen Khakhar start and edit *Vrishchik*, Baroda, 1969-73. Sculpture and reliefs, *India of My Dreams* pavilion, Gandhi Darshan, Rajghat, New Delhi, by K. G. Subramanyan.

1970

Naxalite movement extends to student uprisings in Calcutta. Furious debates about role of art and culture, supportable and objectionable aspects of Indian history, role of petty bourgeoisie; ends in police and military brutality. Indira Gandhi's turn to socialism reflected in new Industrial Licensing Policy, reversing trend toward deregulation.

1971

Pakistan government's crackdown on Sheikh Mujibur Rahman's Awami League leads to war with India and formation of Bangladesh. Indira Gandhi orders elections in which her CongressRequisition (R) faction wins massive majority (March). President's rule in West Bengal. S. S. Ray uses troops to quell Naxalite Movement, 30,000 political prisoners under the Maintenance of Internal Security Act (MISA) by 1973, 2,000 killed. India signs 20 year Treaty of Peace and Friendship with U.S.S.R. following possibilities of Sino–U.S. collaboration with Pakistan (August 9). Effectively ends Nehruvian non-alignment movement.

Second Triennale-India, LKA.

1972

Simla accord between Indira Gandhi and Pakistan's Prime Minister Z. A. Bhutto over Kashmir.

25 Years of Indian Art, curated by K. K. Hebbar for LKA. Rural India Complex, organized by Sankho Chaudhuri on behalf of All India Handicrafts Board, at Pragati Maidan, New Delhi.

1973

Special Constitution Bench of Supreme Court restricts Indira Gandhi's constitutional amendments of 1971.

Contemporary Indian Art, curated by Richard Bartholomew, Renwick Gallery, Washington, D.C. Bhupen Khakhar, Jeram Patel, G. R. Santosh represented.

1974

India conducts "peaceful" nuclear explosion at Pokhran.

1975

Indira Gandhi accused of "corrupt practices" during 1971 campaign in Rae Bareilly, debarred from public office for six years. Internal Emergency, all opposition leaders and thousands of intellectuals and activists jailed. Aryabhata, 300 kg., indigenous satellite launched in U.S.S.R (April 19).

Third Triennale-India.

1976

Civil liberties curtailed under Emergency: Prevention of Publication of Objectionable Matter Act, 42nd Amendment providing for permanent dictatorship. Sanjay Gandhi's National Population Policy envisages sterilization of 23 million Indians in three years; forcible implementation carried out. 700,000 rendered homeless in slum-clearance and beautification in New Delhi. Constitution Preamble amended to "Sovereign Democratic Republic" from "Sovereign Socialist Secular Democratic Republic."

Jehangir Nicholson Museum of Modern Art, Inaugural Exhibition, Bombay. First All India Artists' Workshop, organized by Vivan

Sundaram at Kasauli. K. G. Subramanyan lectures on Indian Art in Canadian universities. World Assembly of World Craft Council at Oaxaca, Mexico. LKA Garhi Studios for Artists opened in New Delhi; first director Sankho Chaudhuri.

1977

Indira Gandhi defeated in general elections (March). Janta Party coalition government under Morarji Desai. Emergency withdrawn.

Coomaraswamy Centenary Seminar, Vigyan Bhavan, New Delhi. Convened by G. M. Sheikh, for LKA and Department of Culture, Government of India.

1978

Indira Gandhi starts the Congress Party (I), for "Indira."

Fourth Triennale-India. Pictorial Space, curated by Geeta Kapur for LKA. Six who Declined to Show at the Fourth Triennale, Kumar Gallery, Delhi. New Contemporaries, curated by G. M. Sheikh for Marg, JAG, Bombay.

1979

Janta Party split. Prime Minister Morarji Desai resigns (June), Charan Singh named as caretaker Prime Minister as elections are announced. Bhaskara-1 built by Indian Space

Research Organisation launched by U.S.S.R. (June 7).

Modern Asian Art -India, China and Japan, Fukuoka Art Museum, Japan. Silver Jubilee Exhibition of Sculpture, LKA, New Delhi.

1980

Congress Party (I) returns to power winning Punjab with Sikh leader Bhindranwale's support. Extreme right terrorism unleashed by Bhindranwale's group and others. Foreign Exchange Regulation Act reduces number of foreign companies from 510 in 1975 to 300 in 1980–81. Rohini 1B launched from Sriharikota, marking India's first successful space launch (July 18).

1981

Indira Gandhi government reverses pre-emergency socialist commitment, embarks upon liberalization of import licences for consumer electronics. Five billion dollar loan from International Monetary Fund, the largest such loan in history. First geostationary telecom satellite APPLE launched for India by European Satellite Agency.

Place for People, exhibition of six painters, JAG, Bombay.

1982

Bombay Textile strike lasts almost a year. INSAT-1A launched from Cape Canaveral (April 10).

Marketing of Indian culture through *Festivals of India* in London, Paris, Moscow. IX Asian Games, New Delhi. *Fifth Triennale-India*. *Six Indian Painters*, selected by Howard Hodgkin, the Tate Gallery, London. *Contemporary Indian Art, Festival of India* exhibitions at Royal Academy of Arts, London. *India—Myth and Reality*, Museum of Modern Art, Oxford. *The Living Art of India*, an exhibition of photographs, *Festival of India*. *The Other India: Seven Indian Photographers*, Museum of Modern Art, Oxford. *Contemporary Indian Art*, selected by L. P. Sihare from the collection of NGMA, New Delhi, Hirshhorn Museum, Washington. Jyoti Bhatt, Shanti Dave, Bhupen Khakhar, Jeram Patel, G. M. Sheikh represented. Inaugural exhibition, Roopankar Museum of Fine Art, Bharat Bhavan, Bhopal. *Journal of Arts and Ideas* commences.

1983

Rampant terrorism in Punjab. INSAT-1B launched through U.S. space shuttle Challenger, inaugurating Special Plan for Expansion of the Television Network.

Tantra: Philosophie und Bildidee exhibition, Stuttgart, Dusseldorf, Oberhausen, Hannover, Bayeruth.

1984

Bhopal disaster: methyl iso cyanate emissions from Union Carbide (India) kill 3,849 and injure 500,000 others. Operation Blue Star: army storms Golden Temple, hideout of J. S. Bhindranwale; 2,000 die including Bhindranwale and a third of the military force. Indira Gandhi assassinated by security guards (October 31). Delhi riots kill 2,717, mostly Sikhs with alleged Congress Party (I) compliance. Rajiv Gandhi becomes Prime Minister.

From the Figure, Ikon Gallery, Birmingham, *Home and Abroad*, British Council and Arts Council of Britain Collections, Serpentine Gallery, London.

1985

Punjab accord signed by R. Gandhi and H. S. Longowal. Longowal assassinated shortly afterward. Public service broadcaster Doordarshan becomes fully commercial.

Indian Artists in France, Festival of India, Paris. *Returning Home*, solo exhibition for *Festival of India* in France, Centre Georges Pompidou, Musee National d'Art Moderne, Paris, by G. M. Sheikh. *Contemporary Indian Art*, from the Chester and Davida Herwitz Family Collection, Grey Art Gallery and Study Center, New York University. *A Journey through Contemporary Art*, curated by Nigel Greenwood, Hayward Gallery, London. Dhruva Mistry represented. *Seven Young Sculptors*, Rabindra Bhavan, New Delhi. Workshop and exhibition organized by Kasauli Art Centre. Workshop for Craftsmen and Artists, Department of Painting, Faculty of Fine Arts (FFA) at Maharaja Siyajirao University, Baroda.

1986

District Judge of Faizabad orders opening of Babri Mosque to Hindus. Babri Masjid Action Committee (BMAC) formed. Kashmir brought under President's Rule, G. M. Shah's ministry dissolved. Muslim Women (Protection of Rights on Divorce) Bill/Shah Bano Bill; Supreme Court accused of interference with Shariyat by Muslim Personal Law Board. Government passes bill taking away all rights from divorced Muslim women to please conservatives.

Exhibition of Paintings, *Festival of India*, Centre Georges Pompidou, Musee National d'Art Moderne, Paris. *Sixth Triennale-India*. First *Bharat Bhavan Biennale of Contemporary Art*, Bhopal.

1987

Arms deals highlight institutionalized corruption and capital flight as dominant political issues. Young widow Roop Kanwar burnt alive in Deorala, reviving Sati after a century-old ban. 300,000 Muslims rally in New Delhi demanding return of Babri Mosque in Ayodhya; militant Hindus gather at Ayodhya to pledge building of temple. Indian Peace Keeping Force (IPKF) to Sri Lanka to support government against Liberation Tigers of Tamil Eelam (LTTE) guerilla movement.

Alekhya Darsan: Young Sculptors and Painters from India, Geneva. *Questions and Dialogue,* exhibition of works by artists, FFA, Baroda. D. Alexander, Anoop B., Anita Dube, T. K. Hareendran, V. N. Jyothi Basu, K. R. Karunakaran, K. P. Krishnakumar, K. M. Madhusudanan, Alex Mathew, K. Prabhakaran, Pushikin E. H., C. K. Rajan participated. *Helpage* exhibition, auction conducted by Christies, London at Bombay. Christensen Fellowship, St. Catherine's College, Oxford, to K. G. Subramanyan. Visiting Artist, G. M. Sheikh, at the School of the Art Institute of Chicago, U.S.A.

1988

R. Gandhi's Defamation Bill seeking Emergency–type curbs on press withdrawn following nationwide resistance. National Front of opposition parties launched in August; Janata Dal led by V. P. Singh revives centrist opposition unity. IRS–1A (remote sensing satellite) launched from Baikanour, U.S.S.R (March 1).

Fairy Tales of Oxford and Other Paintings, exhibition by artist in residence K. G. Subramanyan, Museum of Modern Art, Oxford. *Festival of India* exhibition, Meguru Museum of Art, Tokyo. *The Art of the Adivasi, Festival of India,* Japan. Jyoti Bhatt's photographs exhibited. *Seventeen Indian Painters,* (Twenty-five years of Gallery Chemould), JAG, Bombay. G. M. Sheikh appointed member of the High Powered Committee to review the performance of the National Akademis and the National School of Drama, Ministry of Human Resource Development, Government of India. Report submitted in 1990.

1989

Indira Gandhi's accused assassin hanged (August 14). Safdar Hashmi killed by alleged Congress Party (I) goons (January 1). Safdar Hashmi Memorial Trust (SAHMAT) launches Artists Against Communalism. Agni launched (May 22), inaugurating India's Intermediate Range Ballistic Missile (IRBM) capabilities. Shilanyas (foundation ceremony) for the construction of a Rama Temple at Ayodhya, allowed by Rajiv Gandhi seeking Hindu support. Coalition of Janata Dal (JD) supported by Hindu-nationalist Bharatiya Janata Party (BJP), Communist Party of India (Marxist) displaces Rajiv Gandhi in general elections (December).

Artists Alert, exhibition and auction of works for SAHMAT. *Indian Eclectics,* sponsored by Sanskriti Pratisthan with *Festival of France* in India, New Delhi. *Timeless Art,* exhibition at Victoria Terminus, auction by Sothebys, London and The Times of India at Bombay. Demonstration and protest by Indian Radical Painters and Sculptors Association against *Timeless Art.* Exhibition of works, Indian Radical Painters and Sculptors Association, Calicut, Kerala. First *Bharat Bhavan International Biennale of Prints,* Bhopal. *Figures of Thought,* film by Arun Khopkar, sponsored by Ministry of External Affairs.

1990

Increased reservations for Scheduled Castes/Tribes or Other Backward Classes (SC/ST, OBCs) attacked by upper castes and middle class. L. K. Advani leads Rath Yatra from Somnath to Ayodhya, communal violence en route. JD government arrests Advani, BJP withdraws support in retaliation. Second Shilanyas and Kar Seva at Ayodhya, (October 30); several killed and injured in police action.

1991

Rajiv Gandhi assassinated by Tamil terrorists near Madras (May 21). Rise in foreign debt, systemic dysfunctions lead to economic reforms encouraging foreign investment. U.S.S.R. disintegrates, withdrawal from Afghanistan floods Pakistan with CIA–trained militants armed by U.S.A. Heightened tension between India-Pakistan over Kashmir.

Seventh Triennale-India. Images and Words: Artists against Communalism, traveling exhibition organized by SAHMAT. *National Exposition of Contemporary Art*, NGMA.

1992

India seeks closer ties with U.S.A. Kashmir violence escalates. BJP organizes attack on Babri Masjid, a mosque in Adyodhya destroyed (December 6). Major communal bloodbath in Bombay and elsewhere. A stock market boom leads to the Harshad Mehta scandal when a small number of brokers rigged the Bombay stock exchange.

Charles Wallace India Trust Grant, St. Martins School of Art, London to Pushpamala N.

1993

Bombay is rocked by a series of bomb blasts, notably at the Bombay Stock Exchange and the Air India Building. The attacks are seen as a

Muslim retaliation against the programmatic communal violence of the previous months.

Madhushree Dutta's *I Live in Behrampada* & Suma Josson's *Bombay's Blood Yatra* made as video testimonies of the riots in Bombay. Rupert Murdoch's Asia wide Star TV network takes a 49 percent stake in the Indian Zee TV channel. *India Songs: Multiple Streams in Contemporary Indian Art*, Art Gallery of New South Wales, Australia. *A Critical Difference: Contemporary Art from India*, U.K. *Prospect 93*, Frankfurt, Germany, N.N. Rimzon represented. *Contemporary Indian Art: Glenbarra Art Museum Collection*, Himeji, Japan. *Wounds*, Centre for International Modern Art (CIMA), Calcutta, NGMA, New Delhi. *Souveniers d'en France: An Exposition of Contemporary Indian Art*, Rabindra Bhavan, New Delhi. Riverscapes International Artist's Residency awarded to Vivan Sundaram at River Tees, Clevland, U.K.

1994

Map, Monument, Fallen Mortal, exhibition and installation at South London Gallery, U.K. by Vivan Sundaram. *Realism As An Attitude*, Fourth Asian Art Show, Fukuoka, Japan. *House/Boat*, sponsored by OBORO, Montreal, Canada. Installation by Vivan Sundaram. *Eigth Triennale-India. One Hundred Years of Indian Art*, from the NGMA Collection, curated by Geeta Kapur, NGMA, New Delhi. Attempts to

reconfigure Indian art by seeking alternative views of Indian modernism.

1995

Shiv Sena-BJP coalition wins Maharashtra State Elections (February 12), Bombay is renamed Mumbai. The Shiv Sena objects to a "Nude" advertisement featuring models Madhu Sapre and Milind Soman for Tuff Shoes, starting a series of controversies over obscenity and censorship.

Anand Patwardhan, documentary filmmaker, completes *Father, Son and Holy War*, the last installment of his trilogy exploring communalism in India. Release of Mani Ratnam's *Bombay*, a controversial Hindu-Muslim romance, set in the midst of the 1992-93 Bombay riots. Lakeeren Gallery opens in Mumbai, complementing Gallery Chemould, the city's first forum for new art.

1996

Congress Party (I) suffers worst ever electoral defeat and the government of P.V. Narasimha Rao is ousted. Hindu nationalist BJP emerges as largest single party. BJP government led by Prime Minister Atal Bihari Vajpayee resigns after thirteen days. Haradanahalli Dodde Gowda Deve Gowda (HD Deve Gowda), head of thirteen-party United Front, sworn in as India's eleventh prime minster.

Traditions/Tensions: Contemporary Art in Asia, Asia Society, New York. Section on India. Nalini Malani, N. N. Rimzon, Bhupen Khakhar represented. A branch of the National Gallery of Modern Art opens in Mumbai with a show of the Progressive Artists' Group of the 1940-50s. *Art India* Magazine is launched. Auction house Christie's opens its Mumbai office. Success in "Indipop" and Bhangra Rap worldwide and popularity of satellite TV music channels, like Channel [V] and MTV Asia. A gallery in Ahmedabad showing M. F. Husain's work is vandalized by Bajrang Dal (a militant arm of the complex of Hindu right-wing political parties) activists protesting against a nude painting of the goddess Saraswati made over twenty years earlier. A war of words breaks out between the political right and the left artist and academic community who defend the right to free speech and artistic freedom.

1997

Trade Unionist Datta Samant, leader of 1982–8 3 Bombay textile strike, is gunned down by opponents (January 16).

Sakshi Gallery, originally based in Bangalore, opens in a refurbished mill shed in the industrial Sri Ram Mills compound in Mumbai, becoming India's largest private art gallery. Khoj International Artists' workshop established in New Delhi, marking a major development in artist-led initiatives in Indian art institutions. An affiliate of the Triangle Arts Trust (UK), Khoj continues to conduct an annual workshop emphasizing links between artists from the Third World. Khoj coordinator Pooja Sood participates in setting up a network of artist-initiated workshops in Pakistan, Sri Lanka, and Bangladesh.

1998

BJP forms coalition government under Prime Minister Atal Behari Vajpayee. India carries out nuclear tests at Pokhran, Rajasthan, leading to widespread national and international condemnation. Pakistan retaliates three weeks later. The U.S. imposes sanctions on both India and Pakistan (May).

Pro-BJP Marathi play *Mi Nathuram Godse Boltoi* is banned by the Maharashtra Government. Nathuram Godse was the Hindu fundamentalist who assassinated Mahatma Gandhi in 1948. Mohile Parikh Centre for Visual Art in Mumbai becomes venue for international seminars on art practice and theory. Shiv Sena launches an attack on Canadian filmmaker Deepa Mehta's *Fire*. India Foundation for the Arts (IFA) awards major grant to Mumbai artist Navjot Altaf to work with Adivasi artists at Shilpi Gram, Kondagaon. She and art historian Bhanumati spend extended periods of time in Kondagaon meeting and working alongside Adivasi artists Shantibai, Raj Kumar, Kabiram, and Ghassuram.

1999

Prime Minister Atal Bihari Vajpayee travels to Pakistan to meet Premier Nawaz Sharif and to sign bilateral Lahore peace declaration. Tension in Kashmir leads to brief war with Pakistan-backed forces in Indian-held Kashmir. Cyclone devastates eastern state of Orissa in May, leaving at least 10,000 dead. Shiv Sena BJP coalition lose power to the middle ground NCP-Congress coalition in Maharashtra state elections.

Kala Ghoda Festival is established as a major Mumbai art event. Artist Rummana Hussain dies of cancer. Open Circle formed in Mumbai, a collective of artists with loose links to the Rijksakademie in Amsterdam. The collective begins by organizing a workshop in Mumbai (2000) with artists from nine countries. Subsequent activities of the Open Circle collective take the form of activist public actions, seeking to intervene in contemporary political issues in India and globally.

2000

India marks birth of its billionth citizen (May). U.S. President Bill Clinton makes groundbreaking visit to India to improve ties. Three

new states, Chattisgarh, Jharkhand, and Uttaranchal are created, carved out from the large central Indian states of Madhya Pradesh, Bihar, and Uttar Pradesh respectively.

M.F. Husain completes film *Gaja Gamini*, starring Madhuri Dixit. Hindu fundamentalist mobs burn down the main film set of Deepa Mehta's *Water*, the third installment of her trilogy on the elements. Film production is halted by the government, who claim the shoot is a threat to law and order.

2001

Massive earthquakes hit the western state of Gujarat, leaving at least 30,000 dead (January). Vajpayee meets Pakistani President Pervez Musharraf in the first summit between the two in more than two years (July). Vajpayee's BJP party declines his offer to resign over a number of political scandals and the failure of his talks with Musharraf. U.S. lifts the sanctions it imposed against India and Pakistan after they staged nuclear tests in 1998. India fires on Pakistani military posts in the heaviest firing along the dividing line of control in Kashmir for almost a year. Suicide squad attacks the parliament in New Delhi, killing several policemen. Vajpayee supports the U.S. led war on terror, drawing parallels between the September 11 terrorist attacks against the U.S. and the December 13 attack on the Indian parliament. India imposes sanctions against Pakistan.

Pakistan retaliates with similar sanctions. India and Pakistan mass troops on common border amid mounting fears of a looming war.

The new Tate Modern opens in London with the exhibition *Century City: Art and Culture in the Modern Metropolis*. Geeta Kapur and Ashish Rajadhyaksha curate the section on contemporary Indian art focusing on Bombay/Mumbai in the 1990s.

2002

India successfully test-fires a nuclear-capable ballistic missile—the Agni, with a range of 2,000 km—off its eastern coast (January). Worst inter-religious bloodshed in a decade breaks out after compartments of a train carrying Hindu pilgrims returning from Ayodhya is set on fire at Godhra, in Gujarat. More than 800 people, mainly Muslims, die in subsequent, state-supported revenge killings by Hindu mobs across the western state of Gujarat. Moderate Kashmiri separatist leader Abdul Gani Lone shot dead in Srinagar by suspected Islamist militants (May 21). Pakistan test-fires three medium-range surface-to-surface Ghauri missiles. Retired scientist and architect of India's missile program, A. P. J. Abdul Kalam elected President of India (July 18). Narendra Modi, Chief Minister of the state of Gujarat, wins reelection on a campaign filled with communal rhetoric directed against Muslims.

Apeejay Media Gallery, India's first exhibition space devoted entirely to video and new media art, opens with a show of video works by Nalini Malani, curated by John Pijnappel. *Capital & Karma: Contemporary Art From India*, Kunsthalle Wien, Vienna. Atul Dodiya, Subodh Gupta, Ranbir Kaleka, Sonia Khurana, Surendran Nair, Dayanita Singh, and Vivan Sundaram represented. Raqs Media Collective show at Documenta 11 in Kassel, Germany.

2003

The government initiates an annual conference, the Pravasi Bharatiya Divas, honoring members of the Indian diaspora. The possibility of granting Dual Citizenship to people of Indian origin is brought up. India and China reach de facto agreement over status of Tibet and Sikkim in landmark cross-border trade agreement. At least 50 people are killed in two simultaneous bomb blasts in Bombay (August). India matches Pakistan's declaration of a Kashmir ceasefire (November). India and Pakistan agree to resume direct air links and to allow overflights (December).

body.city: New Perspectives From India, The House of World Cultures, Berlin. The fine art section entitled *subTerrain: artists dig the contemporary*, is curated by Geeta Kapur. Atul Dodiya, Shilpa Gupta, Subodh Gupta, Delhi, Bhupen Khakhar, Sonia Khurana, Nalini Malani, NN Rimzon, Sharmila Samant, Ranbir

Singh Kaleka, Vivan Sundaram and Vasudha Thozhur represented. Artist Bhupen Khakhar dies in Baroda on August 3. A retrospective organized by Usha Mirchandani, is mounted at the NGMA in Mumbai in November. A catalogue collecting critical writings on Khakhar is also produced. Gallery Chemould celebrates its 40-year anniversary with a special inter-generational show of contemporary Indian art at the NGMA, Mumbai, entitled *Crossing Generations: diVERGE*, curated by Geeta Kapur and Chaitanya Sambrani.

2004

Groundbreaking meeting held between government and moderate Kashmir separatists. India holds general elections (May). Results in increased representation for the Left and Centrist parties, at the expense of the Right. A coalition of 15 political parties, the United Progressive Alliance, formed under the leadership of the Congress Party. Dr. Manmohan Singh, who served previously as Finance Minister, is sworn in as prime minister (May 22). India, along with Brazil, Germany, and Japan, launches an application for a permanent seat on the UN Security Council (September). India begins to withdraw some of its troops from Kashmir (November).

Rakesh Sharma releases *Final Solution*, his three and a half hour documentary on the communal violence in Gujarat in 2002. *ZOOM! Art in Contemporary India*, Culturgest Museum / Museo Temporario, Lisbon. Central Board of Film Certification (CBFC) refuses to pass the film. The film *Girlfriend* is released stirring up a controversy about its lesbian content. *CC: Crossing Currents: Video Art and Cultural Identity*, a video exhibition featuring both Indian and international artists curated by Johan Pijnappel, is on view in November at the Lalit Kala Akademi, New Delhi. Nalini Malani, Shilpa Gupta, Umesh Maddanahalli, Vivan Sundaram, and Sharmila Samant represented.

Bibliography

Ahmad, Aijaz, *On Communalism and Globalization: Offensives of the Far Right*, New Delhi: Three Essays Press, 2002.

Akira, Tatehata, et. al., *Private Mythology: Contemporary Art from India*, exhibition catalogue, Tokyo: Japan Foundation Asia Center, 1998.

Anderson, Benedict, *Imagined Communities: Reflections on the Origins and Spread of Nationalism*, London: Verso, 1983.

Appasamy, Jaya, "The Folk inspiration in Modern Indian Painting," *Lalit Kala Contemporary 34*, New Delhi, 1987.

_____, "The painters of the Transition," *Lalit Kala Contemporary 34*, 1987.

Archer, W. G., *India and Modern Art*, London: George Allen and Unwin, 1959.

Art of Bengal Past and Present 1850-2000, Calcutta: CIMA, 2001.

Award Winners: National Exhibition of Art, 1955-1990, New Delhi: Lalit Kala Akademi, n.d.

The Art of Gulammohammed Sheikh, New Delhi: Roli Books, 2002.

The Art of Vivan Sundaram, New Delhi: Roli Books, 2002.

Bean, Susan S., *Timeless Visions: Contemporary Art of India*, Peabody Essex Museum, 1999.

Birdwood, George C. M., *Industrial Arts of India*, published for the Committee of Council on Education, London: Chapman and Hill, 1880.

Borden, Carla, ed., *Contemporary Indian Tradition*, New York: Smithsonian, 1989.

Breckenridge, Carol A., ed., *Consuming modernity: public culture in a South Asian world*, Minneapolis: University of Minnesota Press, 1995.

Chandrashekhar and Peter C. Seel, eds., *body.city: siting contemporary culture in india*, Berlin: House of World Cultures and New Delhi: Tulika Books, 2003.

Clark, John, *Modern Asian Art*, Sydney: Craftsman House, 1998.

_____, "Modern Indian Art: some literature and problematics," Research Institute of Asia and the Pacific: University of Sydney, 1994.

Cohn, Bernard S., *Colonialism and Its Forms of Knowledge: The British in India*, Priceton: Princeton UP, 1996.

Coomaraswamy, A. K., *Fundamentals of Indian Art*, Jaipur: The Historical Research Documentation Programme, 1985.

Dalmia, Yashodhara, et.al., *Contemporary Indian Art: Other Realities*, Bombay: Marg, 2002.

_____, *The Making of Modern Indian Art: The Progressives*, New Delhi: Oxford, 2002.

Dalmia, Yashodhara, and Chaitanya Sambrani, et. al, *Indian Contemporary Art Post-Independence*, New Delhi: Vadehra Art Gallery, 1997.

Desai, Vishakha N., "Engaging 'Tradition' in the Twentieth Century Arts of India and Pakistan," in *Conversations with Traditions: Nilima Sheikh, Shahzia Sikander*, New York: Asia Society, 2001.

Deshpande, Satish, "Imagined Economies: Styles of Nation-Building in Twentieth Century India," *Journal of Arts and Ideas,* nos. 25 -26, December 1993.

Devenport, Rhana, "Phantasmagoria and the Lanternist: the video/shadow plays of Nalini Malani" in *Nailni Malani: Stories Retold*, exhibition catalogue, New York: Bose Pacia, 2004.

Dube, Anita, *Seven Young Sculptors,* exhibition catalogue, New Delhi, 1985.

Questions and Dialogue, exhibition catalogue, Faculty of Fine Arts, March 1987.

Dwyer, Rachel and Divia Patel, *Cinema India : the visual culture of Hindi film*, New Brunswick, NJ : Rutgers University Press, 2002.

Group 1890 exhibition catalogue, Rabindra Bhavan, New Delhi, 1963. Manifesto by J. Swaminathan.

Guha-Thakurta, Tapati, *The making of a new 'Indian' art: Artists, aesthetics and nationalism in Bengal, c. 1850 – 1920*, Cambridge, England: Cambridge University Press, 1992.

_____, Tapati, "Marking Independence: the Ritual of a National Art Exhibition," *Journal of Arts and Ideas*, nos. 30-31, New Delhi, Dec. 1997.

Havell, E. B., *Indian Sculpture and Painting,* second edition, London: John Murray, 1928.

Hobsbawm, Eric and Terence Ranger, eds., *The Invention of Tradition*, Cambridge: Cambridge University Press, 1983.

Hoskote, Ranjit, *Atul Dodiya: Bombay Labyrinth/ Laboratory*, Tokyo: Japan Foundation Asia Center, 2001.

_____, "Bhupen Khakhar: 1934-2003 In Memoriam" *Art Asia-Pacific*, No. 41, Summer 2004.

Jain, Jyotindra, *Ganga Devi: Tradition and Expression in Mithila Painting,* 1997.

_____, *Kalighat Painting: Images from a Changing World,* Ahmedabad: Mapin, 1999.

_____, *Other Masters: Five Contemporary Folk and Tribal Artists of India*, New Delhi: Crafts Museum, n.d..

Jain, Kajri, "Difference, Indifference, Formality: Sonabai at the Asia-Pacific Triennial," *Artlink*, vol. 20, no. 2, July 2000.

_____, "New Visual Technologies in the Bazaar: Naturalist Techniques and the Reterritorialisation of the Sacred in Popular Print Culture," *Sarai Reader 03: Shaping Technologies*, 2003.

_____, "Of the Every-day and the 'National Pencil': Calendars in Postcolonial India," *Journal of Arts and Ideas*, issue entitled *Studies in Modern Indian Art*, ed. Geeta Kapur, nos. 27-28, March 1995.

_____, "Producing the Sacred: The Subjects of Calendar Art," *Journal of Arts and Ideas*, issue entitled *Sites of Art History: Canons and Expositions*, ed. Tapati Guha-Thakurta, no. 30-31, Dec. 1997.

_____, "When the Gods go to Market: The Ritual Management of Desire in Indian 'Bazaar Art,'" *Communal/Plural: Journal of Transnational and Crosscultural Studies*, vol. 6, no. 2, 1998.

Kakuso, Okakura, *The Ideals of the East*, London: John Murray, 1903.

Kapur, Geeta, *Contemporary Indian Artists*, New Delhi: Vikas, 1977.

_____, *K. G. Subramanyan,* New Delhi: Lalit Kala Akademi, 1987.

_____, *Place for People,* exhibition catalogue, Bombay and New Delhi, 1981.

_____, "Riddles of the Sphinx," exhibition catalogue, Gulammohammed Sheikh, *Pathvipath/ Journeys*, New Delhi: CMC Gallery, 1991.

_____, "subTerrain: artists dig the contemporary" in Indira.

_____, "A Stake in Modernity: Brief History of Contemporary Indian Art," in Caroline Turner, ed., *Tradition and Change: Contemporary Art of Asia and the Pacific*, Brisbane: University of Queensland Press, 1993.

_____, *When Was Modernism: Essays on Contemporary Cultural Practice in India*, New Delhi: Tulika, 2000.

Kapur, Geeta and Ashish Rajadhyaksha, "Bombay/Mumbai 1992-2001" in Iwona Blazwick, ed. *Century City: Art and Culture in the Modern Metropolis*, London: Tate Modern, 2001.

Kapur, Geeta and Chaitanya Sambrani, *crossing generations: diVerGE*, Bombay: Gallery Chemould, 2003.

K.G. Subramanyan: Sketches, Scribbles, Drawings, Calcutta: Seagull Books, 1999.

Kramrisch, Stella, "The Present Moment of Art, East and West," *Viswa Bharati Quarterly*, old series, vol. 1, no. 3, October 1923.

Lynn, Victoria, et. al., *India Songs: Multiple Streams in Contemporary Indian Art*, Sydney: Art Gallery of New South Wales, 1993.

Matt, Gerald, et. al., *Kapital and Karma: recent positions in Indian art*, Vienna: Kunsthalle Wien, 2002.

Mishra, Vijay, *Bollywood cinema: temples of desire*, New York: Routledge, 2002.

Mitra, Tarun, "Art and Artists in Twentieth Century Calcutta" in Sukanta Chaudhuri, ed., *Calcutta: The Living City*, Vol II: The Present and Future, Calcutta: Oxford University Press, 1990.

Mitter, Partha, *Art and Nationalism in Colonial India 1850-1922: Occidental Orientations,* England: Cambridge and New York: Cambridge University Press, 1994.

_____, *Indian Art,* New Delhi: Oxford University Press, 2001.

Mohan, Jag, "The Bombay Art Scene in the Late Forties," *Lalit Kala Contemporary 28,* 1979.

Nagy, Peter and Gayatri Sinha, *Atul Dodiya: Broken Branches*, New York: Bose Pacia, 2003.

Nandakumar, R., "Raja Ravi Varma in the Realm of the Public," *Journal of Arts and Ideas*, Nos. 27-28, March 1995.

Nandy, Ashis, ed., *The secret politics of our desires: innocence, culpability and Indian popular cinema,* London and New York: Zed Books, 1998.

Neumayer, E. and C. Schelberger, *Popular Indian Art: Raja Ravi Varma and the Printed Gods of India*, New Delhi: Oxford University Press, 2003.

Pande, Alka, *The Margi & the Desi: between tradition and modernity*, exhibition catalogue, New Delhi: Gallery Espace, 2004.

Panikkar, Shivaji, ed., *Twentieth-Century Indian Sculpture: the Last Two Decades*, Bombay: Marg, 2000.

Postel, Michael and Zarine Cooper, *Bastar Folk Art: Shrines, Figurines and Memorials*, Mumbai: Projecct for Indian Cultural Studies, 1999.

Pushpamala N: Indian Lady, New York: Bose Pacia, 2004.

Rajadhyaksha, Ashish and Paul Willemen, eds., *Encyclopedia of Indian Cinema*, London and New Delhi: British Film Institute and Oxford UP, 1999.

Ramaswamy, S., ed., *Beyond Appearances?: Visual Practices and Ideologies in Modern India*, New Delhi: Sage Publications, 2003.

Roberts, John, "Indian Art, Identity and the Avant-Garde: The Sculpture of Vivan Sundaram," *Third Text 27*, Summer 1994.

Sadwelkar, Baburao, "Bombay Art Society: Story of a Hundred Years" in *Story of a Hundred Years: Bombay Art Society 1888-1988*, Bombay: Bombay Art Society, 1989.

Said, Edward, *Representations of the Intellectual*, Vintage, New York, 1996.

Sambrani, Chaitanya, "Apocalypse Recalled: the historical discourse of Nalini Malani," in *Nalini Malani: Stories Retold*, exhibition catalogue, New York: Bose Pacia, 2004.

_____, "Here, out there (and some-where in between): contemporary art in India," *Australian and New Zealand Journal of Art* vol.3, no.2, 2002.

Sharma, R. C., ed., *Raja Ravi Varma: New Perspectives,* New Delhi: National Museum, 1993.

Sheikh, G. M., ed., *Contemporary Art in Baroda*, New Delhi: Tulika, 1997.

Singh, P., *India's culture: the state, the arts, and beyond*, Delhi and New York: Oxford University Press, 1999.

Sinha, Ajay J., "Contemporary Indian Art: A Question of Method," *Art Journal,* Fall 1999.

Sinha, Gayatri, ed., *Expressions and Evocations: Contemporary Women Artists of India*, Bombay: Marg, 1997.

_____, ed., *Indian Art: An Overview*, New Delhi: Rupa, 2003.

Sinha, Modhurima, *Call of the Real: Contemporary India Artists from Bengal*, Ahmedabad: Mapin, 2003.

Solomon, W. E. Gladstone, *The Bombay Revival of Indian Art*, Bombay: Sir J. J. School of Art, 1924.

Souza, F. N., exhibition catalogue, Progressive Artists Group, 1949.

Subramanyan, K. G., *The Creative Circuit*, Kolkata: Seagull, 1992.

_____, *The Living Tradition*, Kolkata: Seagull, 1987.

Sundaram, Vivan, "The Moment of Group 1890 (1963)," *The India Magazine*.

Swaminathan, J., *The Perceiving Fingers*, Bhopal: Bharat Bhavan, 1987.

_____, "The Cygan: An Auto-bio note," exhibition catalogue, New Delhi: Vadehra Art Gallery, 1993.

Tuli, Neville, *The Flamed Mosaic: Indian Contemporary Painting*, Ahmedabad: Mapin, 1997.

Turner, Caroline, ed., *Tradition and Change: Contemporary Art of Asia and the Pacific*, Brisbane: University of Queensland Press, 1993.

Venniyoor, E. M. J., *Raja Ravi Varma*, Trivuvananthapuram: Government of Kerala, 1981.